Pre-Columbian Art

Pre-Columbian Art

Esther Pasztory

The Everyman Art Library

Acknowledgements

I would like to thank Jennifer Ahlfeldt, Susan Bergh, Karen Butler and
Taryn Matusik for their help with the manuscript.
I dedicate this book to the memory of my mother.

First published in Great Britain in 1998 by
Weidenfeld and Nicolson
The Orion Publishing Group, Orion House
5 Upper St Martin's Lane
London WC2H 9EA

A catalogue-in-publication record for this book is available from the
British Library

ISBN 0 297 82407 4

Series Consultant Tim Barringer (University of Birmingham)
Senior Editor Kara Hattersley-Smith
Designer Karen Stafford
Picture Editor Emma Gregg
Printed in Hong Kong / China

Frontispiece Chavín-style vessel from Tembladera, Peru, 400–200 BC, page 98 (detail)

Contents

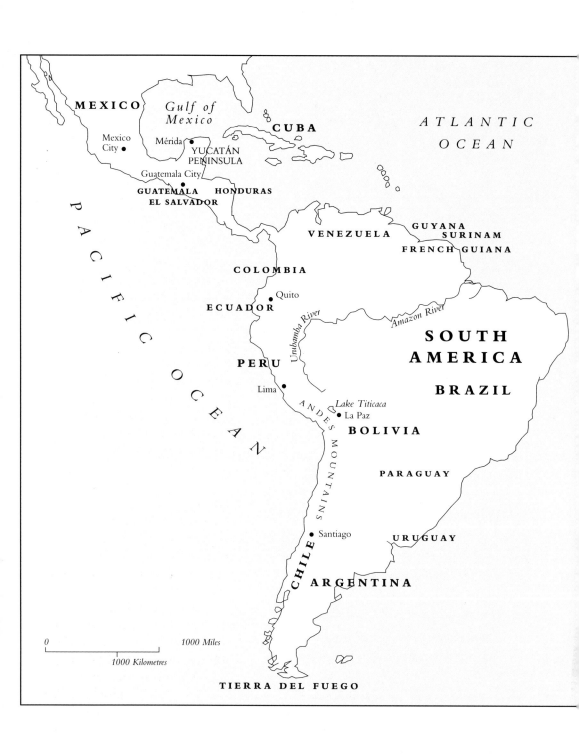

MEXICO *Gulf of Mexico*

Mexico City ●

Mérida ●

YUCATÁN PENINSULA

CUBA

ATLANTIC OCEAN

Guatemala City ●

GUATEMALA HONDURAS
EL SALVADOR

VENEZUELA

GUYANA
SURINAM
FRENCH GUIANA

P A C I F I C O C E A N

COLOMBIA

Quito ●

ECUADOR

Urubamba River

Amazon River

SOUTH AMERICA

BRAZIL

PERU

Lima ●

Lake Titicaca
● La Paz

A N D E S M O U N T A I N S

BOLIVIA

PARAGUAY

Santiago ●

CHILE

URUGUAY

ARGENTINA

0 1000 Miles

1000 Kilometres

TIERRA DEL FUEGO

The Western Discovery of Pre-Columbian Art

Will I have to go like the flowers that perish?
Will nothing remain of my name?
Nothing of my fame here on earth?
At least my flowers, at least my songs!
Earth is the region of the fleeting moment.
Is it also thus in the place
where in some way one lives?
Is there joy there, is there friendship?
Or is it only here on earth
we come to know our faces?

Acoyuan, Aztec poet, c. 1490. Translation in Miguel Leon-Portilla, *Pre-Columbian Literatures of Mexico* (Norman, Oklahoma: University of Oklahoma Press, 1969): 81–2

Christopher Columbus was disappointed with the people he met in the Caribbean on his voyage to the Americas: not sophisticated Chinese or Indians but naked "savages" (FIG. 1). He was, however, very impressed by the region's natural bounty, so suitable for settlement, and by the tantalizing pieces of gold worn by the natives, which seemed to promise future riches. Although Columbus himself never found any great hoard of treasure, succeeding adventurers and conquerors came upon two major civilizations that had huge amounts of gold and silver. The conquest in 1519–21 of the Aztec empire in Mexico by Hernán Cortés and of the Inca empire in Peru by Francisco Pizarro in 1532–5 not only amply fulfilled the dreams of treasure in the New World but also proved what Columbus had failed to discover, the high level of the civilization of its people. Many other searches were undertaken in the Americas, from the deserts

1. Map of Mesoamerica and the Andes.

of the southwestern United States to the tropical forests of the Amazon, but, except in Colombia, no such cultures and riches were ever found again. Neither the Aztec ruler Montezuma II nor the Inca ruler Atahuallpa understood that the alien visitors were intent on territorial conquest, and their attempts to appease with gifts of gold only made the Europeans even more determined. Both rulers died in the course of conquest.

Despite the universal appreciation of the work of the native craftsman, almost all the gold and silver taken from the Americas was melted down into bars and eventually used as currency in Europe. Equally, the conquerors' admiration for the temples, palaces, roads, bridges and aqueducts of the Aztec and Inca did not stop them from destroying the buildings of capital cities and erecting colonial structures in their place. Christian churches were built on the ruins of temples. Being men of practical orientation, the conquerors were most impressed with the native works of engineering, evidence that their makers had skill and knowledge superior to those of natives of the Caribbean or elsewhere in the Americas. None of this admiration stopped them from destruction.

The present Western concept of art dates from the eighteenth century. Thus the sixteenth-century conquerors were often impressed by fine craftsmanship, but their real preoccupation was with religion not art. The Aztec and Inca were regarded as heathens and all their images as devils and satanic idols. From the very beginning, those images that were not destroyed in the conquest were smashed by the missionaries. The conquistadors imposed their regime with brutal immediacy: in Mexico in 1536 a native American could be burned at the stake for owning a codex (manuscript) from his own tradition. The Aztec deity Huitzilopochtli was represented in sixteenth- and seventeenth-century European prints as a horned devil with European features. There seems to have been no interest, either artistic or scientific, in attempting to record the monuments or deities with any accuracy.

Instead, the Spaniards began an extensive process of making a textual record of the cultures they destroyed. With the help of native informants or by reference to such native documents as were available, histories and religious practices were painstakingly reconstructed. The Spaniards wanted to know who these people were, and in particular to understand their religion, a necessary preliminary to conversion. (Where illustrated codices existed, as in Mexico, those were reproduced in the books.) The *Florentine Codex* of Bernardino de Sahagún of Mexico and Bernabé Cobo's *History of the Inca Empire* were two of the largest under-

takings. Their authors were fond of looking for parallels between Christian ritual and mythology and interpreted behavior in terms of acts of the devil. Accordingly they frequently misinterpreted what they saw and omitted to ask questions that would have yielded correct information. Of the many descriptions of religious ritual that have survived, few show any understanding of the deeper aspects of native religious belief. They were written from a European standpoint. Nevertheless, used carefully, they are our most important sources in understanding Pre-Columbian thought and culture. Only a handful of Europeans saw the Aztec and Inca empires as functioning wholes, and then only to witness, within their lifetimes, their destruction, transformation, and relegation to the past.

The conquerors did not know that the Aztec and Inca empires were brief, late manifestations and that a variety of cultures had existed for more than two thousand years before them. Archaeology, begun in earnest only after 1900, was responsible for those discoveries. Archaeology depends a great deal on the types of things that survive. In tropical areas these are mostly of stone, bone, and pottery. In the desert there are also textiles, wooden objects, and sometimes human bodies, perhaps mummified in the dry climate. The distribution of objects is also revealing. Burial sites are sources of information about aspects of social status and the roles of men, women, children, and the elderly. Archaeologists can date objects by inference from the layer of ground from which they are excavated (stratigraphy) and by absolute measurements such as carbon-14 dating. Although they can reconstruct the overall structure of a culture remarkably well, the details of religious ritual, myth or poetry will always elude them. Wherever textual information from eye-witnesses is missing, the story has to be pieced together from images and artefacts. Art has come to play a crucial role in understanding the Pre-Columbian past, but that process raises questions. How can we interpret the art of another place and another era? Are the rituals depicted real or imaginary? Do the works of art merely reflect the cultures that generated them or did they actively help to shape them? As their overt content often eludes us, what meaning is to be found in the underlying content of their structures and forms?

In eighteenth-century European philosophy, religious issues ceased to occupy center stage and as a result art was elevated to a higher role. The term "esthetics" was coined in 1750; the philosopher Immanuel Kant gave esthetics equal status with cognitive reason and ethics. "Divinity" was now found in the creative genius of the artist and his art. Looking at art as a category of universal

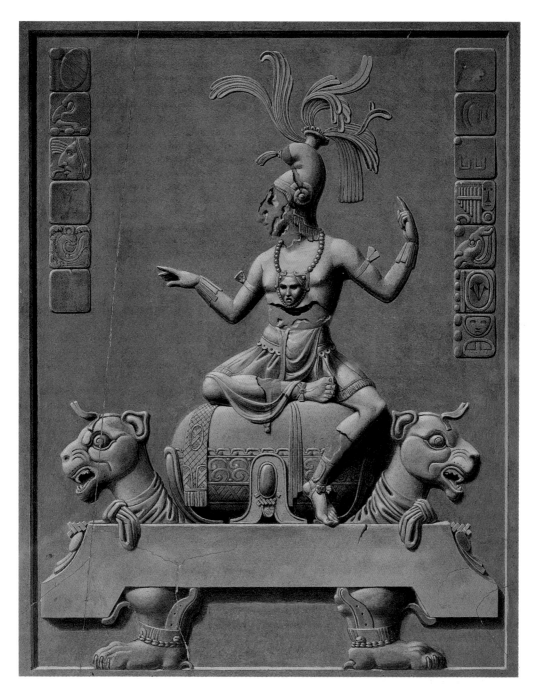

2. JEAN FREDERICK DE WALDECK
The Beau Relief, 1832. Painting. Newberry Library, Chicago.

This relief, formerly located in the Maya city of Palenque, was destroyed soon after Waldeck visited the site. It epitomizes the Maya concept of beauty in art, which apparently looked to Waldeck like Neo-Classical European art. Although Waldeck's interpretation is incorrect in detail, his painting captures the spirit of Maya art.

10 *The Western Discovery of Pre-Columbian Art*

existence and making judgments about the beautiful or the awesome, allowed for the reclassification of formerly heathen idols and devils as works of art capable of appreciation on esthetic grounds, irrespective of their religious content. Thus it became possible to valorize the arts of non-Western peoples, and indeed in the eighteenth century exotic arts, from Chinese to Maori, enjoyed a great vogue among Europeans.

It was in this new atmosphere that in 1790 an enlightened Mexican cleric saved from destruction three statues that had come to light near the cathedral of Mexico City. One of these was the famous Aztec Calendar Stone, which has been exhibited ever since. Another, the colossal statue of the goddess Coatlicue (meaning Serpent Skirt in Nahuatl), was reburied for almost another hundred years for fear of inspiring a revival of idolatry. The third was the Stone of Tizoc. These finds encouraged the practice of collecting native artefacts in Mexico.

In Europe ruins became a source of fascination with the excavation of Pompeii and Herculaneum in the 1760s and Napoleon's military and scientific adventure in Egypt at the end of the century. There was a rush to visit, draw, and bring back fragments from the great ancient civilizations. In the New World the emphasis was on the Maya ruins recently surveyed by government agencies. Three early travelers are important in illustrating the differing interests of Europeans.

The remarkably long-lived Jean Frederick de Waldeck (1766–1876) was an artist who claimed to have studied with David and who decided to make his fortune by drawing and publishing the arts of the recently discovered Maya site of Palenque (FIG. 2). His drawings have always been scorned for being inaccurate, which they certainly are. But Waldeck's importance lies in the fact that as an artist of Neo-Classical sensibility he found Maya art harmonious with European ideals of art. In his eyes Maya art was "beautiful" and "sublime." Although Waldeck had little influence on his own time, he can now be recognized as one of the major figures in the categorization of Pre-Columbian art as "art."

John Lloyd Stephens and Frederick Catherwood were the most successful travelers in search of ruins in Maya country. They recorded their experiences in *Incidents of Travel in Central America, Chiapas and Yucatan* (2 vols, 1841) and *Incidents of Travel in Yucatan* (2 vols, 1843), illustrated by Catherwood's drawings. Although these are often picturesque and romantic in style, the monuments are correctly drawn (FIG. 3). He used a camera lucida (a drawing device by which the image of an object is made by reflection to look as if projected on the paper) to help him

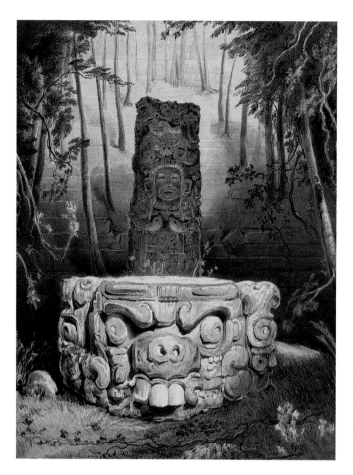

3. FREDERICK CATHERWOOD
Drawing of a Copán stela
with skull altar in the front.

Though truer to life than
Waldeck's painting,
Catherwood's work, with its
menacing jungle setting for
the Copán sculptures,
creates an exaggerated
impression of their
fearsomeness.

achieve accuracy. Stephens's text is a model of scientific rigor. He concluded that the builders of the monuments were neither the Egyptians nor the Lost Tribes of Israel but the ancestors of the contemporary Maya. During the second half of the nineteenth century explorers with cameras – Claude-Joseph-Désiré Charnay, Teobert Maler, Alfred P. Maudslay – documented the ruins and inscriptions precisely. Their works formed the rudiments of modern scientific exploration.

Andean exploration proceeded much more slowly. The great site of Machu Picchu was discovered only in 1911 by Hiram Bingham of Yale University. Some of the most fascinating architectural ruins in the eastern slope of the Andes, for example Pajatén, had to wait until the 1950s to be discovered, photographed, and published by explorers such as Gene Savoy. These sites are still remote and difficult of access.

In terms of its influence on Western art, Pre-Columbian art never had a single great moment equivalent to the "discovery" of African art around 1905. Generally, it was current European styles that determined which aspects of Pre-Columbian art were picked up. The more realistic and "classical"-looking styles, such as those of the Maya and the Moche, came to be appreciated earliest and remain popular favorites. The French painter Paul Gauguin (1848–1903), who was born in and spent a part of his childhood in Peru, made self-portrait jugs in imitation of Moche portrait vessels.

The more angular and stylized traditions of Mesoamerica and the Andes were of interest to Modernist artists during the first half of the twentieth century. The British sculptor Henry Moore (1898–1986) and the American architect Frank Lloyd Wright (1867–1959) were directly inspired by Mesoamerican art and archi-

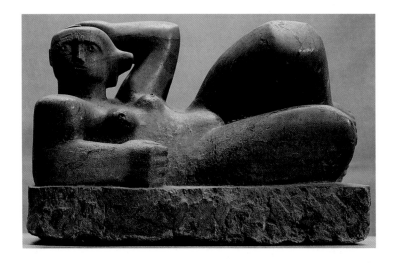

tecture. Moore imitated the *chac mool* sculptures (reclining figures used as ritual furniture or altars; FIG. 4) and Wright was inspired by the mosaic architectural decor of the Yucatán.

Recently, the prominence of Minimalism and Conceptual art has brought the art of the Andes to the artistic fore. Though they lack many of the big anthropomorphic monuments of Mesoamerica, the Andes have a vast road system and the famous mysterious lines made on the surface of the desert of the Nazca plateau, many of which are visible only from airplanes. Fascination with them is coincident with the "earth art" of artists such as Michael Heizer and Robert Smithson and Conceptual artists such as Barry Le Va and Sol La Witt. Against this background, Westerners can now appreciate Andean art not simply as "beautiful" but as concept and system. New movements in Western art are likely to bring our attention to hitherto neglected aspects of Pre-Columbian art.

The growth in appreciation of Pre-Columbian art has regrettably been accompanied by an increase in looting. In the beginning, looters were drawn to gold and silver because of the preciousness of the material alone. Pre-Columbian works were being looted for the art market, particularly favorite styles such as Maya pottery or Andean north coast ceramics. Looting brings to light many fantastic objects but it destroys forever their archaeological context and what may be learnt of their origin and significance. Since the nineteenth century the confusion of the historical record has been compounded further by the creation of fakes. Some of the illustrations in this book depict objects the precise origin of which has been lost in the course of changes of hands between discoverers, museums, and private collectors.

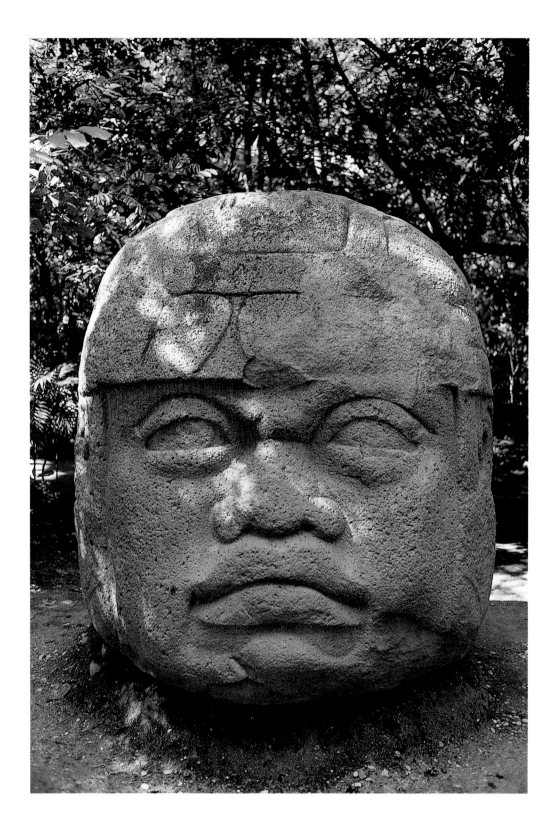

Mesoamerica and the Andes

There were two major foci of civilization in the New World – Mesoamerica and the Andes – and it is their later cultures – respectively the Aztec and Inca – that are best known. Mesoamerica consisted of central and southern Mexico, Guatemala, Belize, western Honduras, and western El Salvador. The Andean cultural area essentially covered present-day Peru and western Bolivia. Like the states of Europe in their time, the polities of Mesoamerica and the Andes were interconnected by trade, war and marriage alliances. Although they shared similar social and political ideas and even religious practices, they usually remained separate rather than merging into one large state, and they retained important regional differences. As it happened, the Aztec and the Inca empires both existed at the time of European conquest. The Inca empire, about 3,000 miles (4,828 km) long, was the largest in America.

Mesoamerica and the Andes were in many ways diametrically opposite in art and culture. The major aim of this book will be to describe and compare these two very different cultural traditions within their historical and social context. Interestingly, each area had one important culture whose art "went against the grain" of the tradition of its own area. This raises questions about the nature of "tradition" and how artistic innovation takes place within it.

If you look in any museum or any book on Mesoamerica, or at any site, you will find faces staring at you, people engaged in various activities or enacting mysterious rituals (FIG. 5). Some of the faces look almost like portraits. The Western viewer establishes an immediate bond with these human figures. Mesoamerican architectural sites are inhabited by such sculpted figures.

5. Olmec colossal head from La Venta, c. 1000 BC. Basalt, height 9′4″ (2.85 m). Museo-Parque La Venta, Mexico.

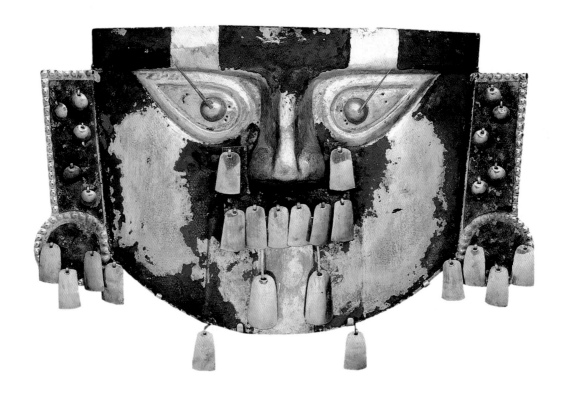

6. Sicán mask, C. AD 850–1000. Hammered gold, paint, 11½ x 19½″ (29.2 x 49.5 cm). The Metropolitan Museum of Art, New York.

By contrast, the architecture of the Andes yields a paucity of human images. Instead, wildly extraordinary, conventionalized, and stylized figures are found on textiles, gold, and pottery (FIG. 6). If there are faces, they are enigmatic and masklike, or actual masks attached to funeral bundles. The art of Mesoamerica seems to deal with the world of people, while the art of the Andes deals with the interrelationships of the cosmos. It is not surprising that the more naturalistic and narrative Mesoamerican arts found favor among Westerners before the more abstract Andean ones.

The architecture reveals other differences. In Mesoamerica most structures were built from a rubble core faced with a retaining wall of stone (FIG. 7). This is mostly how the restored ruins can be seen today. Originally, however, these stones were covered with a smooth, thick layer of plaster and painted all over in one color or even with murals. In some instances deity faces were sculpted out of plaster and added as decoration. Because of the coating of plaster and the color, the structural features of Mesoamerican architecture were not usually visible. Architecture was treated as a form of sculpture or as a decorated stage set. Mesoamerican

builders appear to have been more interested in dramatic appearances than in revealing inner structures.

In stark contrast, Peruvian architecture tended not to use rubble cores. Walls were of solidly constructed masonry, revealing a love of precise joinery and a pleasure in different-sized and colored stones such as are evident in many examples (FIG. 8). Plaster was used, but the stonework was often visible. Andeans appear to have been interested in the essence of materials – whether stone,

7. Maya pyramid at Kohunlich, Mexico, c. AD 800 (detail). Rubble core covered with masonry retaining wall and limestone plaster coating, ornamented with large plaster faces, set on top of a 197′ (60 m) hill, and rising another 49′ (15 m) above it.

The construction of this building is characteristic of Mesoamerica and suggests a preoccupation with external appearances.

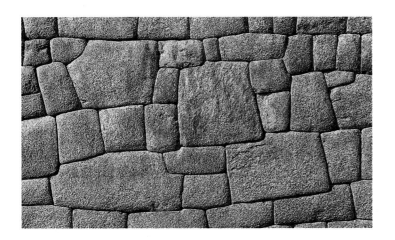

8. Masonry wall at the Inca city of Machu Picchu, Peru. c. AD 1450 (detail). Granite.

Most Andean walls are unornamented solid masonry and not a knife-blade can be inserted between the stones. The stone had symbolic value.

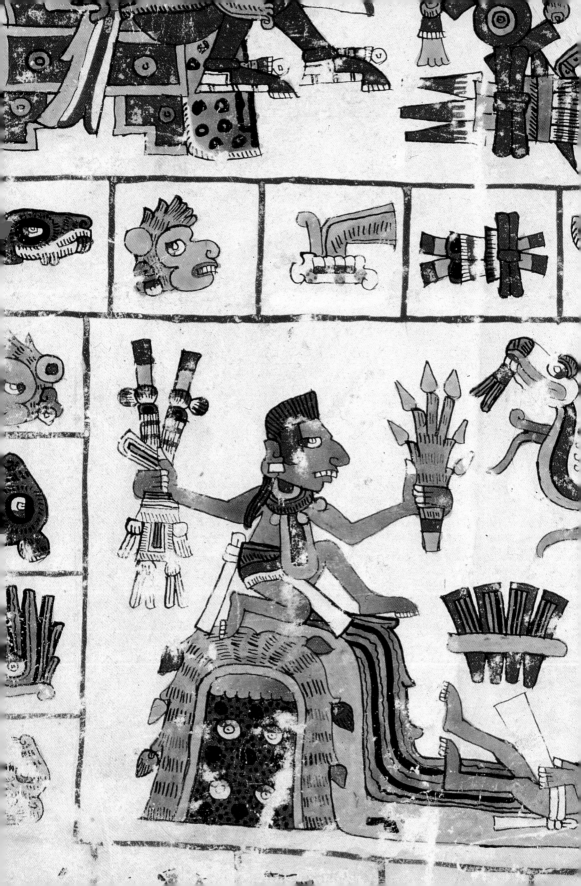

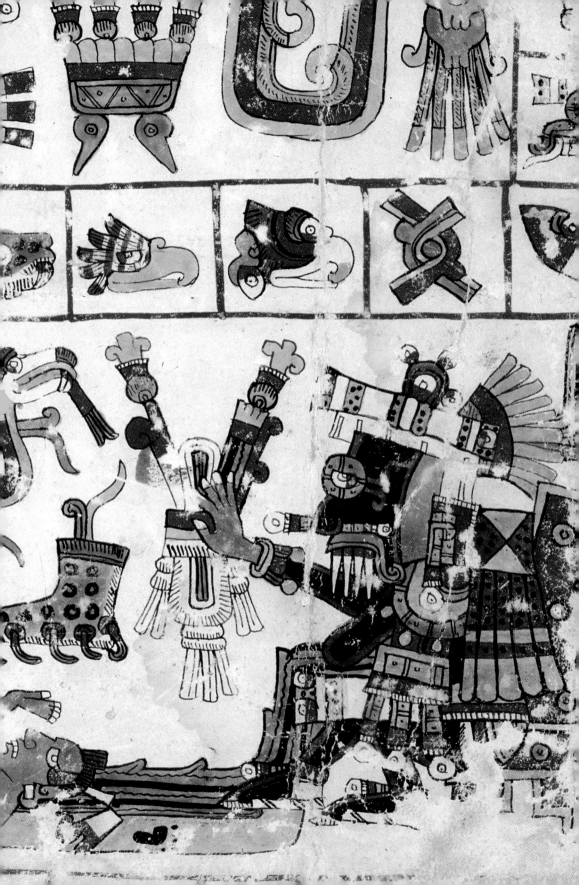

Previous pages
9. Codex Borgia, from Mexico, 1421–1521 (detail). Mineral and vegetable pigments on animal skin, whole page 10.6 x 10.4″ (27 x 26.5 cm). Biblioteca Apostolica Vaticana, Rome.

A handful of manuscripts were sent back to Europe by Cortés as curiosities in the sixteenth century. A few have survived. This one was owned in the eighteenth century by Cardinal Stefano Borgia and passed down through the family. The scene shows a section of the divinatory calendar. The rain god Tlaloc presides over the seventh week with a stream of water flowing from him. The day signs of the calendar are in sections on the top. A priest probably interpreted good and bad omens from the combinations of the signs for a given day.

yarn or metal – rather than in their external appearance. Although gold was sometimes painted, as in masks, its essence remained trapped inside. Similarly, fine masonry existed under plaster. Andeans appear to have been fascinated by structure and left it visible.

Perhaps the most striking differences between the Andes and Mesoamerica have to do with the manner of recording information. Mesoamericans had books – ritual calendars, histories, tribute lists, maps, and astronomical computations (FIG. 9). These too were based on images, with the addition of glyphs some of which were also derived from images, sometimes of phonetic value. There were many writing systems, but the image was at the basis of most and related quite naturally to the rest of the art. In the Andes there was no writing system based on images. Information was kept on the quipu, a mnemonic device of knotted string (FIG. 10). Information was kept in a decimal mathematical form, which depended on the position, shape, color, and order of the knots on the string. The principle behind the quipu is spatial and involves the visualization of abstract networks. While a Mesoamerican codex can be appreciated visually without knowledge of its meaning, a quipu affords much the same visual experience as a string mop. Perhaps it can be enjoyed as a piece of conceptual art – intellectually, certainly, rather than esthetically.

Such differences are also evident in many aspects of culture. The political systems of the Aztec and Inca especially have been frequently compared. The Inca empire has often been called totalitarian because it was centrally organized, with production and distribution overseen by the state and the lack of a market system. The emphasis appears to have been on efficient organization. The Mesoamerican Aztec empire, on the other hand, was a tribute empire in which the central power coerced goods from conquered territories at the cost of constant war. Markets and money formed the bases of exchange. Dramatic interaction seems to have been valued more than efficiency.

Swimming against the tide in the Andes were the Moche, who developed an art with portraits, narrative scenes, and the glorification of conflict that would have sat more comfortably in a Mesoamerican context. Their counterparts in Mesoamerica, Teotihuacan, developed an abstract, impersonal style without a recognized writing system that would have been more at home in the Andes. These two instances indicate that, however powerful a cultural tradition may be, it is possible to strike out in a new direction and to create "experiments in living."

Despite the differences, Mesoamerica and the Andes share a surprising number of similarities, many as a result of a shared

history. When the large Paleolithic mammals that had been hunted in the Americas died out about 8000 BC, people turned to smaller animals that could be domesticated and to discovery and cultivation of plant foods. Beans, cotton, gourds, peppers, tomatoes, potatoes, and maize were among the wide variety of foods that were eventually grown for food. The only large animal that could be domesticated was in the Andes – the llama. Too small for a man to ride, it was an excellent animal for carrying goods over long distances. Settled life began about the same time in both areas. By 3000 BC there were permanent settlements and pottery was common. The earliest cultures that erected monumental architecture and created works of art on a large scale also more or less coincided, between about 1500 and 1000 BC. In both areas these early cultures were followed by a period of regional diversity, in which art played a very important role in the first millennium AD. The role of art in society seems to have declined somewhat in the last five hundred years of history before the conquest, whether in type, quality, or quantity, although there were important exceptions. The latest empires, the Aztec and the Inca, did not attain great power until about AD 1450, and it took them less than a hundred years to build and carve the astonishing monuments that are still standing today. Both were empires built on conquest, with great weaknesses in their internal organization that made them easy prey for Europeans. While there is little demonstrable historical connection between the Andes and Mesoamerica, it is striking that in general their development should be so similar. Clearly some ideas were transmitted slowly across the mountains of Central America and Ecuador or by sea-going raft. Nevertheless, in view of the large distance between the two areas, they necessarily developed for the most part quite independently.

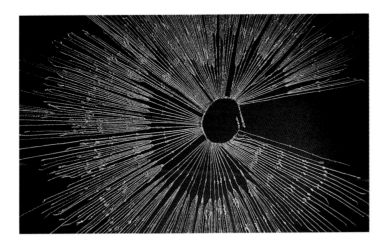

10. Inca quipu, c. AD 1500 (detail). Yarn. Museo Nacional de Antropolgía, Archeología y Historía, Lima.

The Inca quipu worked on a decimal principle, its colored knots being used to record information in a mathematical form. Although the content is often supposed to be confined to economic or demographic data, it has been suggested that histories and poems were recorded as well.

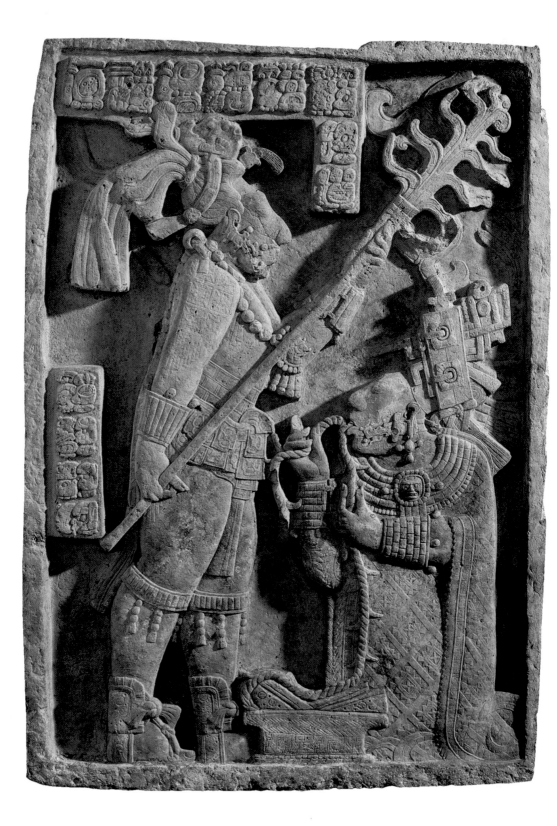

Mesoamerica: Man in Time

11. Maya Lintel 24, from Structure 23, Yaxchilan, Mexico, AD 725. Limestone, 43 x 30½" (109.7 x 77.3 cm). British Museum, London.

Lady Xoc, the wife of Shield Jaguar (ruler of Yaxchilan), is shown drawing blood from her tongue. The elite drew blood on some important ritual occasions. Aristocratic women played a major role in alliances between sites and in elite ritual. Rarely rulers, they are often shown as wives and mothers. The woman's ornate garment indicates the lost art of Classic Maya weaving.

I n ancient times the large area that was Mesoamerica did not constitute a single state or empire but was, like Europe, divided into many polities and different cultural zones (FIG. 12). As in Europe, these polities traded with each other, went to war and cemented alliances by marriage. They shared the elements of a calendar system, religion, and world view. This diversity in Mesoamerica was fostered by the geography, which varied from cool, arid highlands to tropical lowlands. Both the Olmec and the Classic Maya lived in a tropical lowland, which, apart from some medicine-yielding plants, had few natural resources. Cotton grew only in the warm climates of the lowlands. The highlands of central Mexico, by contrast, are rich in basalt and obsidian, from which basic tools and household utensils were made, and, with the use of irrigation, can successfully support intensive agriculture. Ringed by the majestic volcanoes Popocatepetl and Ixtaccíhuatl, the central Mexican area, near Mexico City, was always the political power center of Mesoamerica. This is where Teotihuacan and the Aztec empire were located. Another important but smaller highland zone was in Oaxaca with the major sites of Monte Albán and Mitla. Differences in altitude also create diversity: a variety of items can be produced under different conditions of terrain, soil, and climate, within relatively short distances of each other, thus encouraging trade.

Mesoamerican history is divided into three main periods: the Preclassic (also known as the Formative), the Classic and the Postclassic. These divisions are based on the Maya, whose dated monuments, AD 300–900, delimit the Classic period. The time before that, starting with the rise of stratified societies about 1500 BC, is called Preclassic, while the cultures from AD 900 to

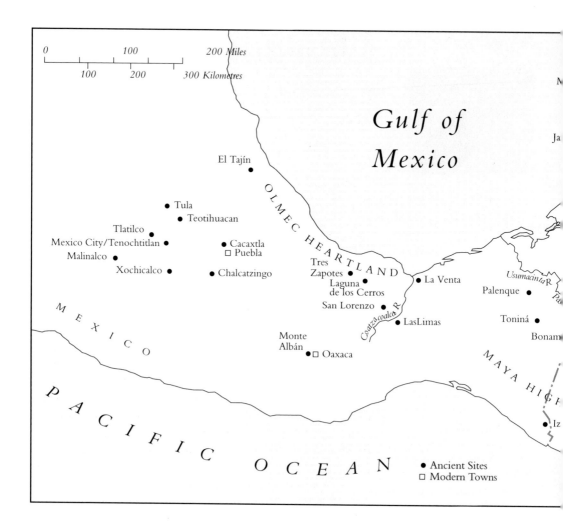

Gulf of
Mexico

OLMEC HEARTLAND

El Tajín

Tula
Teotihuacan

Tlatilco
Mexico City/Tenochtitlan
Malinalco
Xochicalco

Cacaxtla
Puebla

Chalcatzingo

Tres Zapotes
Laguna de los Cerros
San Lorenzo
LasLimas

La Venta

Usumacinta R

Palenque

Toniná

Monte Albán
Oaxaca

MEXICO

PACIFIC OCEAN

MAYA HIGH

Iz

Ja

Bonam

• Ancient Sites
□ Modern Towns

12. Map of Mesoamerica showing sites discussed in the text.

the Spanish conquest are called Postclassic. Art had an especially important role in the cultures of the Classic period.

The art of Mesoamerica focuses on the drama of conflict in which human figures are the actors and the events unfold in an elaborately ordered framework in time. Human sacrifice was a quintessential expression of this idea of conflict. The conquerors and missionaries in Mexico were utterly horrified by the Mesoamerican practice of human sacrifice, in which the heart, still beating, was torn out of the living victim. This is not to say that Europeans were not used to atrocities. Renaissance warfare and punishment, to say nothing of the tortures of the Inquisition, were fully the equal of the Mesoamerican sacrifices in cruelty. What was anathema to European eyes was the presentation of sacrifice as a positive act in the context of sacred theater. As the Aztec lords and priests explained, the gods too had sacrificed themselves so

that people could live, and human sacrifice was a "gift" offered in return. The sun was imagined in one body of myths as a young warrior who died every night in a battle with the forces of darkness and the underworld and was reborn every morning from the earth mother to ascend triumphantly into the daytime sky.

The major metaphor for life in Mesoamerica was conflict; all the gods had cycles of death and rebirth; conflict was that critical moment in which various forces came together and transformation occurred. Mesoamericans imagined political life on earth also as constant conflict, in which power and strength are measured against each other over and over again. They did not create harmoniously ordered empires, but situations in which every tribute might have to be acquired at the cost of battle. Battle was a ceremonial affair in which the participants marched in elaborate, heavy, fantastically decorated feathered gear. War too was theater.

A second metaphor was sacrifice. When a Mesoamerican ate maize, he was literally eating the flesh of the maize god. The sun too, according to various myths, was a deity who had to sacrifice himself in order to give light to man. The sacrificial victim participated in another form of exchange between the forces of the natural and supernatural worlds. Presented on the top of platforms in a theatrical setting, the sacrifice ritual acted as a force for cohesion, involving the entire community.

All those spectacular Mesoamerican sites – Teotihuacan, Tikal, Palenque, Monte Albán, Chichén Itzá – to which tourists now flock were once ritual theaters. They are laid out with plazas for people to stand and watch, pyramids and platforms on which the various dramas and sacrifices were performed. This theatricality is one of the most important characteristics of Mesoamerican life. The sites are giant stage sets, and a tremendous amount of attention went into the costume and dress of the participants. Most of life was organized as a series of dramas, with performers and an audience.

The protagonists of these dramas were men and women. The gods – no mere remote forces of nature – were impersonated by men and women, including priests and future sacrificial victims. Their lives and deaths have the pathos of humanity. Performances were also created by rulers and the lords in their courts, who, in some cultures, took on the roles of deities. The ancestors too were impersonated by masked humans, either in life or as death effigies. This emphasis on the human in a narrative and

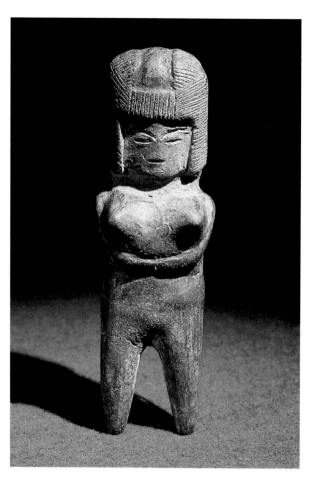

13. Valdivia female figurine from Ecuador, c. 2300 BC. Clay, height 3¼" (8.3 cm). National Museum of the American Indian, New York.

These figurines with cap-like hair are among the earliest works of art surviving in permanent media in the Americas. The importance of women in the early arts suggests a small-scale village context in which the well-being of women was ritually assured by means of the figurines. In later arts male figures predominate.

dramatic setting is evident in the various works of art representing these heroic figures in scenes.

Mesoamericans were also equally obsessed with time. Past, present, and future and the passage of time were measured in a variety of calendars. A ritual cycle of 260 days (13 numbers x 20 day signs) was used to foretell the future and the will of the gods. A 365-day cycle measured the months of the agricultural year. The names of people, gods, and eras were taken from the calendars. The Maya had a special calendar, which measured time elapsed since a fixed point, 13 August 3114 BC. The Maya are famous for having made calculations both into the past and into the future in thousands and even millions of years. On Quirigua stela D (a stela is an upright stone slab, often bearing incised inscriptions or carvings), there is a reference to a time 400 million years in the past. People and events were therefore always situated in a temporal framework. Although certain spacial entities such as cities were important enough to have glyphs representing their name, it was time that fascinated the Mesoamericans. The major dramas of the Mesoamerican imagination – death and rebirth, conquest and submission – were by nature temporal.

It is hard to know when this Mesoamerican pattern of thinking evolved. The earliest arts, which may have been in perishable materials such as wood, cloth, or basketry, no longer exist. The earliest surviving works date from about 2500 BC and are in clay, both pottery objects and small, handmade clay figurines. Some of the earliest clay figurines in the Americas come from the site of Valdivia (FIG. 13) on the coast of Ecuador and are remarkably similar to the early figurines of Mesoamerica, such as those of Tlatilco (FIG. 14). They usually represent women with beautiful bodies – high breasts, wide hips – and full hair, but devoid of any context. The few male figures that exist show men wearing masks or high-status clothes and pursuing typically male activities.

The figures are mostly naked with indications of body paint. Many are lifelike but some have two heads or two faces, suggesting a supernatural significance. Most lack any iconographic features that would indicate whether they are human or divine, or of high or low status. Nor is there anything to suggest how they might have been used. They have been found in refuse mounds, in burials, and in buildings, and thus perhaps had multiple functions. This was the only time in the history of Mesoamerica when female images outnumbered those of men. Whether they celebrate the capacity of women to bear children or, by analogy, the ability of nature or agriculture to bear fruit, these female figures indicate a concern with something other than the political power that later became the essence of Mesoamerican arts.

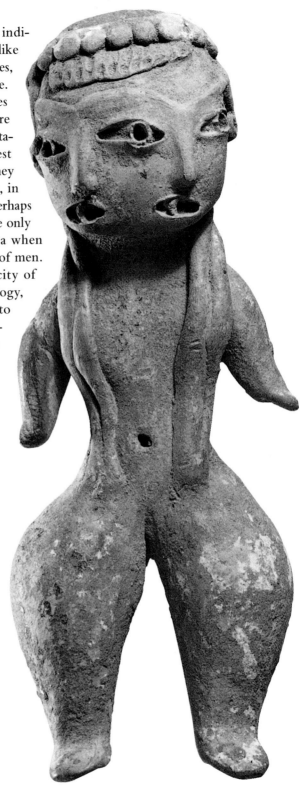

14. Female figurine from Tlatilco, Mexico, 900 BC. Clay, height 4½″ (11.5 cm). Museo Nacional de Antropología, Mexico City.

These figurines, dubbed "pretty ladies," are part of the same widespread curing and household cult as the Valdivia figure. Most figures are not supernaturals. Sometimes babies are shown with mothers. A few are unusual in having double faces, such as this "Picasso" one. Their meanings are unknown.

Figurines continued to be made in later periods, but these were more often than not household or folk items, mass-produced in molds. Many still represented women and are believed to have been connected with issues of family or kinship. The female body was perhaps a metaphor for the most private, most intimate, and least status-conscious aspects of life. The earliest figurines were associated with relatively small-scale village life. With some exceptions, most later Mesoamerican art represented men on a monumental scale, usually in stone, in the larger stratified context of chiefdoms and states.

The Olmec: The Power of the Body

The name "Olmec" is derived from a group who lived in the area of the Gulf Coast in Mexico in Aztec times. We do not know to what ethnic group the Olmecs belonged, what language they spoke, nor what they called themselves. Olmec culture was discovered largely during the middle of the twentieth century. The Olmec lived in scattered villages around several large ceremonial centers such as San Lorenzo, La Venta, and Laguna de los Cerros. They farmed the rich soils of river-banks periodically under flood.

When Olmec art first came to light, it was difficult for Western scholars to believe that this was the earliest artistic tradition of Mesoamerica because of the impressively carved colossal heads and the remarkable naturalism of the three-dimensional figures. According to the European paradigm, art in its earliest manifestations is stiff, rigid, and unschooled, like that of ancient Egypt; only after long development does it become naturalistic and full of movement, like that of ancient Greece. Yet in sculptures such as San Lorenzo Monument thirty-four figures are portrayed twisting about their axis. Olmec stone art is not, so far as is known, the culmination of a stylistic evolution, but appears in the historical sequence quite suddenly, with no known predecessors at all. Moreover, generally, the more naturalistic pieces are the earliest: over time the tendency was towards greater conventionalization rather than less.

Olmec sculptures were set up on sites with plazas and pyramids, built out of earth decorated with colored clays. Stone was not available locally but brought from a distance of perhaps 50 miles (80 km). Clearly these centers, of which San Lorenzo, La Venta, Laguna de los Cerros, and Tres Zapotes were the most important, represent stratified powers with control over the labor of their populations. While the early clay figurine cultures appear to

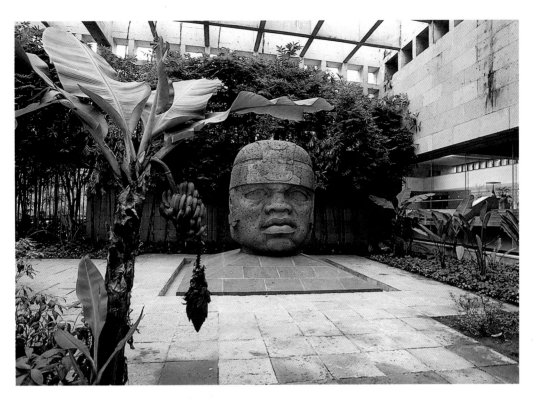

have been mostly villages, the Olmec were large chiefdoms or small states. By 1500 BC chiefdoms had begun to emerge throughout Mesoamerica, but the Gulf Coast Olmec area produced some of the richest, owing to the flooding of the rivers that made them prime areas for agriculture. While there were chiefdoms in the Valley of Mexico, in the state of Guerrero, and in Oaxaca, the most spectacular works of art come from the Gulf Coast.

No modern viewer can fail to be astonished by the colossal sculpted heads of this area, often 6½ feet (2 m) or even 10 feet (3 m) high and weighing more than ten tons, whose faces evoke a living, breathing person (FIG. 15). Seventeen of these heads are known. They all have powerful, scowling facial features and wear a tight-fitting helmet. Details such as pupils in the eyes and the slightly parted and asymmetrical lips suggest life, but it is the modeling of the cheeks and fleshy areas of the face that is especially realistic. A similarity with African facial types has been noted, although the features also resemble those of native peoples in the area.

No one knows whom the heads represent, but most scholars think that they are commemorative portraits of Olmec rulers, probably the current ruler or his predecessor, and set up at an accession or a funeral. They were probably made on the orders of

15. Olmec colossal head from San Lorenzo, Mexico, 1100 BC. Basalt, 9′ (2.75 m). Museo de Antropología de la Universidad Veracruzana, Xalapa.

This 16-ton head was floated down a raft more than 50 miles (80 km) from the quarry to the site. It was carved with stone tools. This head is the most naturalistic depiction of sixteen known heads, and probably represents a ruler. At the sites, the heads were set up in rows, making a most impressive and perhaps fearsome display.

16. Olmec kneeling figure, Monument 34, from San Lorenzo, Mexico, c. 1100 BC. Basalt, height 31" (79 cm). Museo Nacional de Antropología, Mexico City.

This figure is remarkable for the sophisticated twisting motion in the torso and legs. The importance to the Olmec of movement is evident from the arm sockets that once held movable arms. It is not known whom the figure represents but body and costume suggest that it is human.

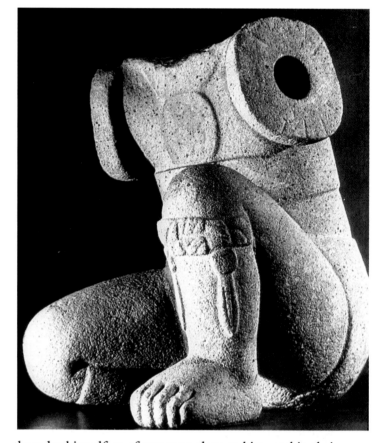

17. Olmec standing figure in cape, from Laguna de los Cerros, Mexico, c. 1100 BC. Basalt, height 5' (1.52 m). Museo de Antropologia de la Universidad Veracruzana, Xalapa.

This unique figure, dubbed "Superman," may have represented a ruler. Many sculptures lost their heads, in Olmec times or later. The Laguna de los Cerros figures were re-erected in the Late Classic period (AD 600–900).

the ruler himself or of someone close to him, and in their own time they must have been as awesome as they are now. While there is nothing expressly intimidating in the heads, their very size suggests great power. In the sacred centers at which they stood, little would have seemed to escape their gaze. Presumably, in the light of the tradition of clay modeling, Olmec artists modeled the faces in clay, to be copied in stone by carvers. No earlier prototypes in stone were needed.

Life-size stone figures, seated cross-legged or kneeling, as at La Venta and San Lorenzo (FIG. 16), or standing, as in one case at Laguna de los Cerros, also appear to have represented humans, although mutilation at various times has removed many of the heads. A comparison with the figure on La Venta Altar 4, the head of which is intact, suggests that they were human and might even have worn headdresses. Again, these may have been rulers. What characterizes all of them is a powerful physique, unobstructed by much clothing or symbolic insignia. The figure from Laguna de los Cerros, dubbed "Superman" because of his cape, is a good example (FIG. 17). The body, including the powerful

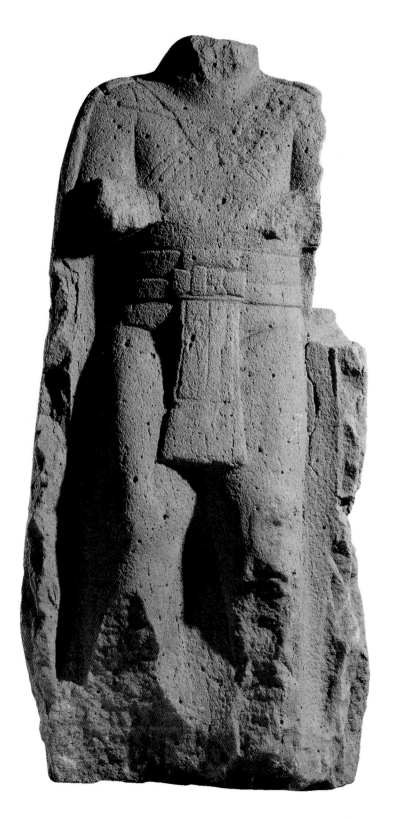

18. Olmec seated figure holding a child supernatural, from Las Limas, Mexico, c. 900 BC. Greenstone, height 21½" (55 cm). Museo Nacional de Antropología, Mexico City.

When this figure was discovered by villagers in 1965 it was set up in a shrine and worshipped as the Virgin Mary. The theme of a man holding a grotesque jaguar-baby is common in Olmec art. Until the find of this sculpture, all jaguar–human combinations were thought to be the same. The Las Limas figure has four masks incised on the shoulders and knees of the figure that show different facial features suggesting different beings. The Las Limas figure is often thought of as the "Rosetta Stone" of Olmec iconography.

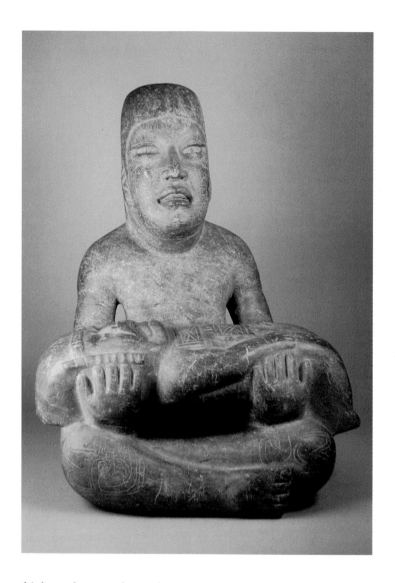

thighs and pectoral muscles, is modeled in the round and stands out against the flat loincloth and cape. The Olmec rulers represented their power literally as the physical power of the nearly naked body and of the strongly expressive face. This body is quintessentially male. The emphasis on the body suggests that the Olmec rulers felt secure in their own power, however they came by it, and did not devise elaborate mythological ways of legitimizing it.

The other metaphoric system that permeates Olmec art is the supernatural, often represented as a mask, which may be an actual mask in greenstone or wood, or the head of a very stylized figure. The rules that apply to this type of figure are completely different from those that pertain to the ruler representa-

tions. The little individual in the arms of the human figure from Las Limas is made up of rubbery body parts instead of well-muscled limbs (FIG. 18). These figures are often called "were-jaguars" because they seem to combine human and jaguar forms. In particular, the squarish, protruding mouths are believed to represent the snout of the jaguar. The jaguar was the largest mammal in Mesoamerica and a symbol both of rulership and of many supernatural spirits. Lengthy analysis has been unable to establish whether this is one supernatural with many aspects or many supernaturals with multiple interrelationships. Four masks are incised on the shoulders and the knees of the Las Limas figure, which is an indication that the mask form in general signifies the supernatural, while the particular eye and mouth shapes identify a specific spirit (FIG. 19).

The proliferation of Olmec-style masks suggests that masking must have been important to the Olmec and perhaps even more so to the village cultures preceding it. Masquerades are usually

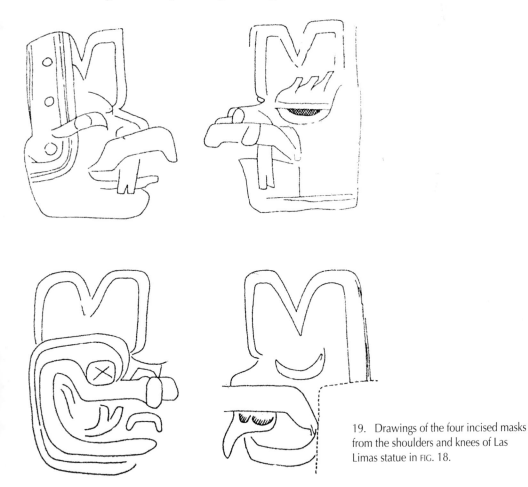

19. Drawings of the four incised masks from the shoulders and knees of Las Limas statue in FIG. 18.

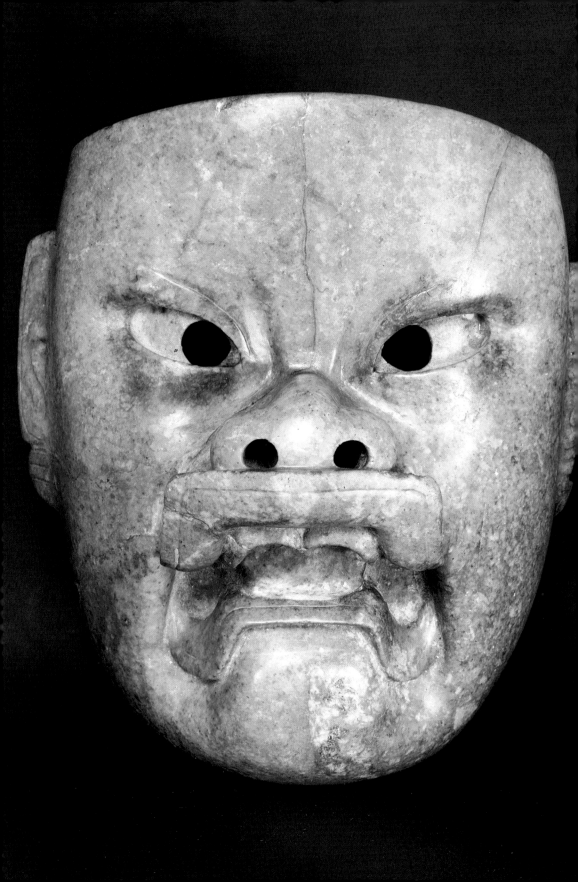

characteristic of relatively egalitarian societies in which the spirits of ancestors and of nature are impersonated by masked beings in community festivals. These masks not only entertain but also dispense justice and effect a sort of social control. As the Olmec polity was probably a chiefdom, ruled by a chief and titled officials, masks were probably appropriated for court ritual. Olmec rulers wore masks on their pectorals and headdresses and on death went to the afterworld wearing masks of the ancestors or spirits above their face. These masks were made out of hard-to-cut and sumptuous materials, such as greenstone and jade.

It is characteristic of masks that they represent either smooth and beautiful human faces, suggesting social harmony, or grotesque, animalistic, powerful ones referring to conflict (FIG. 20). Many Olmec deity masks represent a figure with a snout like an animal's and frightening features. While attempts have been made to classify the different types of masks, scholars are hampered by the loss of the stories and myths that were associated with them. We do not know for sure whether the grotesque child in the Las Limas sculpture is dead or alive or indeed in some way part of a death and rebirth cycle. Olmec art may look very true to life, but it is rarely narrative. It assumes a local audience who understand the subjects and for whom no explanations are necessary.

Olmec mask designs from the Preclassic period have been found all over Mesoamerica on pottery and cylinder seals. As already noted, masks had specific symbolic features that distinguished them from each other. The Olmec do not appear to have had a writing system, but once it developed, in post-Olmec times, a profile mask-face played an important role in it. Many basic Maya glyphs, such as those they used for numbers, are based on a mask-like face that ultimately derives from the Olmec.

How can we reconcile the presence of the naturalistic portrait and the stylized mask (not the only components of Olmec art, but its two principal strands) in the same culture? Whether in a mask or a portrait, the Olmec suggest that powers have faces of various sorts. The colossal stone heads seem sufficiently lifelike to be images of actual persons, yet the similarity between them suggests that they may also have been "masks" in the form of portraits. The grotesque masks were presumably worn by humans to hide their own features and to transform them into supernaturals, but they were meant to be the "portraits" of the supernaturals. In Mesoamerican symbolism the face is very important as the seat of the self. Later Aztec poems refer to the necessity of "knowing one's face." For the Olmec, the human body was a metaphor for political and supernatural power.

20. Olmec jaguar-human mask, 800–400 BC. Jadeite, 8 x 7 x 4¼" (20.8 x 17.8 x 10.8 cm). Dumbarton Oaks Research Library and Collection, Washington, D.C.

The function of this mask is not known, but it is carved out in the back, so it could have been worn. It represents a jaguar–human supernatural.

Izapan Arts: Time and Space in Two Dimensions

In the Late Preclassic period there were many regional cultures in Mesoamerica with different artistic styles. A number of these resemble the arts of Izapa in southern Mexico and hence the name "Izapan" has been given to this period.

Fully three-dimensional Olmec art was limited mostly to the Gulf Coast region and disappeared by about 500 BC. Although Olmec art began with the most naturalistic figures and in time became progressively more stylized and flat, relief was common in late Olmec art. The arts outside the heartland and following that of the Olmec usually consisted of sculptural relief. They were carved either on natural rocky outcrops, as at Chalcatzingo, in central Mexico, or on vertical stones set up as monuments (these are known as stelae, the word for Greek funerary monuments). At first glance, it would appear that these relief sculptures are much less well made than the Olmec ones, and it is hard to see in what ways they suited the concerns of their makers better, but the two-dimensional format clearly provided possibilities that the three-dimensional did not. Indeed, two-dimensional art remained the dominant form in Mesoamerica for over a thousand years, until the Toltecs and Aztecs again brought three-dimensional art to the fore.

This is easy to see in the relief of Chalcatzingo, which is probably as old as Olmec art, but is from outside the Olmec heartland (FIG. 21). The figure in the center is known as "El Rey," although it is not clear if it is male or female. It is immediately striking that the figure is small in comparison to the composition as a whole. The focus is not on the body. The person sits in a trefoil enclosure that has generally been taken to be the mouth of a cave. An actual relief of a monster mask with an open maw, which is a doorway, indicates that this interpretation is correct (FIG. 22). Almost all viewers have interpreted the rectangular elements above the figure as "clouds" and the little forms falling from them as "rain." While the scrolls are not

21. Figure seated in a cave, Chalcatzingo, Mexico, c. 1000 BC. Drawing of stone, relief carving, total carved area 10'6" x 8'10" (3.2 x 2.7 m).

This relief shares many elements with the Olmec art of La Venta but also prefigures the Izapan style. It is uncertain whether the seated figure is dressed in male or female clothing.

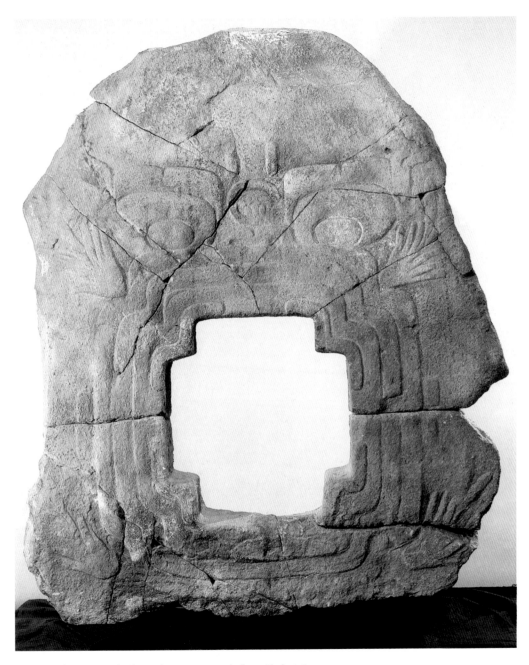

22. Cave doorway, in the form of a monster mask, from Chalcatzingo, Mexico, 700–500 BC. Grandiorite, 72 x 56 x 6″ (182.9 x 142 x 15.2 cm). Munson-Williams-Proctor Institute, Museum of Art, Utica, New York.

Mesoamericans imagined that they would be swallowed by a great, gaping monster maw, as they went through the gateway to the underworld. Such gateways were also symbols of transformation from one state of being to another.

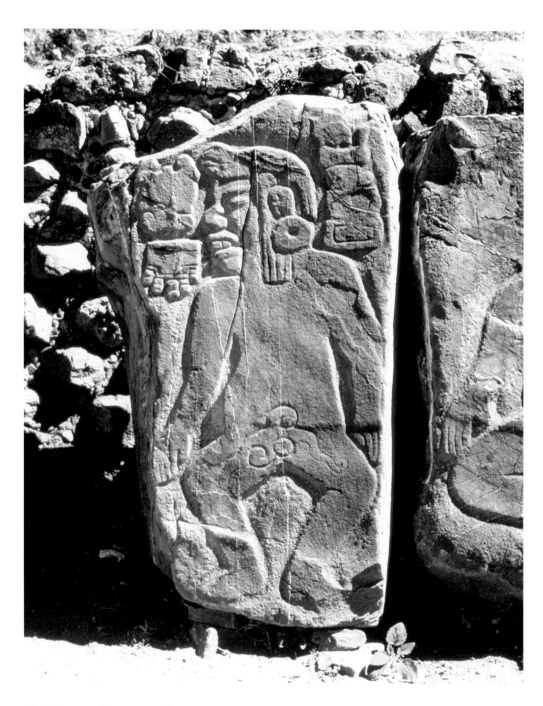

23. "Danzante" figure, Monte Albán, Mexico, c. 500–300 BC. Stone, figure 40½ x 46½ x 17¾" (103 x 118 x 45 cm).

Naked figures of this type were once thought to be dancers, hence their name. In fact they represent conquered enemies who have been genitally mutilated. Their place of origin or name is usually indicated by a glyph in front of their face.

clear – they could be sound, water, smoke, or metaphoric features – the relief is usually read as a scene in which the setting is important, in this case the cave and the rain. The Chalcatzingo relief emphasizes not only context but also furniture, costume, and insignia. The person sits on a throne and holds a rectangular object with an S-shaped design. While the person's proportions and shapes are Olmec, the body makes less of an impact on the viewer than does the headdress. Because of the profile position and the setting, the figure does not appear to look at the viewer directly. There is no emotional confrontation with a powerful being, as with the colossal heads; instead, the Chalcatzingo image is to be "read." It poses no great difficulties in the way of reading: it is easier to see what is going on than in the Las Limas figure holding a supernatural child.

While the Chalcatzingo relief revealed an emphasis on setting and space, other Mesoamerican reliefs were beginning to show a concern with time and with written notations associated with human figures. Ancient Oaxaca was the first site to make glyphic inscriptions in stone. Characteristically, figure and glyph appear together. The famous carvings of the "Danzantes" at Monte Albán, representing captives taken in wars, are carved quite crudely on to irregular slabs of stone (FIG. 23). The figures often have blood in place of their genitals, indicating mutilations. While the Olmec focused their power imagery on dignified rulers, at Monte Albán images of the rulers are absent, and instead the conquered victims are commemorated, not only in corporal form but also by their name glyphs (or the names of their cities), which are carved near their faces. These names probably relate to the signs of the 260-day calendar in that they consist of a day sign, such as a house, flower, or monkey, and a number from one to thirteen. In some areas of Mesoamerica, people were given the signs of the day on which they were born as names. People were thus in a sense segments of time.

The Chalcatzingo and the Monte Albán reliefs both indicate a different approach to the stone from that given to the monuments of the Olmec. In the hands of an Olmec carver, the stone became the equivalent of the body and took on the essence of the subject's being. In the reliefs, however, the stone is a kind of background, like a sheet of paper, on which various figures, settings, or purely imaginary designs such as glyphs can be placed in different arrangements. The importance now lies not so much in the figure but in the relationship between the various elements. The figure loses its centrality but it becomes encased in a web of relationships. It is quite clear that in this manner a great deal

more can be "said" in a composition than in a single figure. The significance of two-dimensionality is precisely that a great deal more information of a greater variety of types can be given than in three-dimensional art. The progression here in Mesoamerican art has been from embodying beings to illustrating ideas about them.

The possibilities of two-dimensional design were used differently by different centers. By 200 BC many centers in Mesoamerica were big and powerful enough to leave carved records on rock faces and on stelae. There was no uniform style but there were certain shared motifs and preoccupations, and clearly some generic roots in Olmec forms. Izapa is one of the best-known of these sites, with over fifty carved stelae, each of which depicts a different fascinating scene. They are particularly noteworthy because they show figures in action and interaction and the beginnings of narrative. On stela 21 a striding figure holds the decapitated head of a victim who lies at his feet. Blood spurts from the severed neck. This is the first actual representation of sacrifice in Mesoamerican art. The entire scene looks at first like a ritual, perhaps even the ballgame ritual (see next section) in which decapitation was the sacrifice, but figures in the background suggest a possible mythical context. In the absence of glyphs on any Izapa stelae, and given the rich variety of the scenes and actions, it is hard to tell if the protagonists are humans performing rituals or mythic heroes from sacred stories. This ambiguity between the human and the divine is characteristic of Izapan art.

Many other Izapa stelae have cosmic subjects in which a man – or a hero – participates. On stela 25 a human figure stands holding a staff with a fantastic bird perched on it, confronting a crocodile with its snout on the ground and its tail vertically in the air (FIG. 24). It is immediately evident that the crocodile can also be read as a tree, its teeth and claws being the roots and its tail is turning into leafy branches. To complete the illusion, a little bird sits on one of the branches. While we cannot interpret this scene in detail, we know that in Mesoamerica the crocodile generally represented the earth, and that this crocodile is a kind of world axis with its

24. Stela 25, Izapa, Mexico, 100 BC–AD 100. Stone, 50½ x 41½ x 19¾" (128 x 105 x 50 cm).

According to some myths the earth is likened to a large crocodile floating in a pond. In this relief an earth-crocodile has been turned into a tree with birds in its branches.

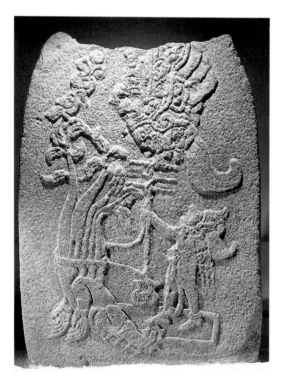

head in the earth and its tail in the sky. This is one of many examples of the art of Pre-Columbian America for which scholars can proffer no adequate interpretations, given the lack of information, and we must instead fall back on the rich imagination and the mythology behind such representations. It is worth noting, however, that the man depicted in this work has an important position facing this cosmic creature on the ritually important right side. To the modern Western eye, this relief has a quality of liveliness and humor. The crocodile-tree is a visual pun, one of many in Izapan art. Another potentially humorous stela represents a skeleton with a long phallic extension.

In the Gulf Coast area and in the Guatemala highlands and Pacific slope a new type of ruler figure emerged on stelae that was to be the antecedent of Maya representations. The new type usually consisted of a profile of an individual in a walking position, elaborately dressed, and holding symbolic objects, such as the "ceremonial bar" and "manikin scepter." While the details vary from place to place, the figures are remarkably similar in basic concept. The Kaminaljuyú stela is an example (FIG. 25). It takes a while for the viewer to find the Olmec-derived contours of the figure under all the ornaments. It is even harder to find the face, which is encased in a helmet, part of a towering headdress. There can hardly be a greater contrast with the stern yet inviting gaze of the Olmec colossal heads, or of the life-size figures; by comparison, the bodies of these personages are nearly invisible. The concept of power appears to have been redefined away from the body and towards the costume and insignia. The ruler on the Kaminaljuyú stela carried what have been called "eccentric flints" – that is, elaborately carved flint knives – symbolic of his

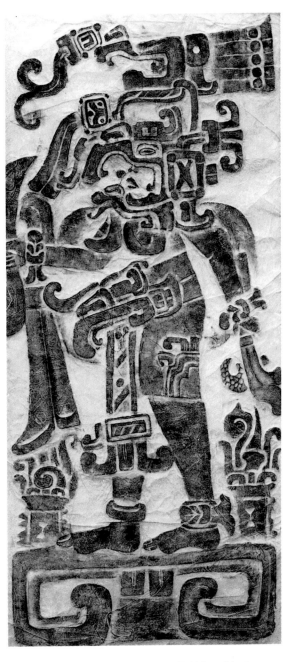

25. Rubbing of the Izapan Kaminaljuyú stela, 100 BC–AD 100. Stone, 72 x 27½ x 11¾" (183 x 70 x 30 cm). Museo Nacional, Guatemala City.

The ruler stands between two incense burners.

power and signifying perhaps his role of performer of rituals, evidenced also by the fact that his feet are between incense burners. Above him is a small figure looking down, possibly an ancestor. The entire relief appears to be about legitimacy – his right to rule derived from the ancestor, represented by the symbols of his dress and headdress, which indicate the nature of his rights and titles, and the services he is to perform. The emphasis is on the office rather than on the man. The kind of cosmic information that was on the Chalcatzingo relief and the Izapa stelae is now literally worn by the ruler so that he as a person is totally hidden by it. Such representations suggest vastly more elaborate justifications and rituals of rulership. With the addition of written texts, some of these stelae became the prototypes of Maya representation. A Maya stela at Tikal, for example, is Izapan in its derivation with its emphasis on costume, insignia and symbolic detail (see FIG. 33).

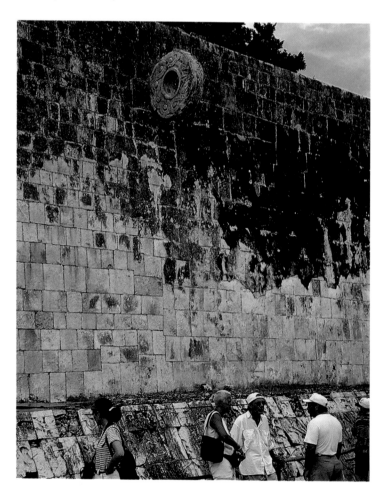

26. Ball court with ring from the Great Ball Court, Chichén Itzá, Mexico, AD 600–900. Stone, length 492' (150 m).

Getting a solid rubber ball through the hoop with a thrust from the hip was so rare that it immediately halted the game and the winner was proclaimed.

Ballgame Arts: The Hero in Action

Sixteenth-century Europeans were fascinated by the bouncing properties of a ball made from the latex (rubber) of a native tropical tree and by the various games that could be played with it. Aztec ballplayers were taken to Europe to demonstrate the game to Charles V in Brussels. Players had to stoop down low to hit the ball, for which they could use only hips, elbows, or knees. Points were thus hard to score, and it is amazing to think that a thrust from the hip could propel a ball through a ring set high in a wall, as at Chichén Itzá (FIG. 26). The heavy rubber ball could cause injury and various types of protective padding were worn by the players. Mesoamericans may have played ballgames since the earliest times, ranging from children's throwing games to ritual games played in stone courts in the ceremonial precincts of cities.

In the late Classic and early Postclassic periods, AD 600–1200, a remarkable amount of art and ceremonialism was dedicated to the ballgame in various parts of Mesoamerica. The principal figure depicted was the ballplayer, a muscular young man. On Bilbao Monument 3, one of eight monuments representing ballplayers, the athletic build and knees wrinkled with calluses identify the figure as a player (FIG. 27).

27. Ballplayer on Monument 3, from Bilbao, Guatemala, c. AD 600. Stone, height 9'6" (2.9 m). Museum für Völkerkunde, Berlin.

The calloused knees of the ballplayers, visible in this relief, show that players frequently fell on their knees during the game in order to return a ball.

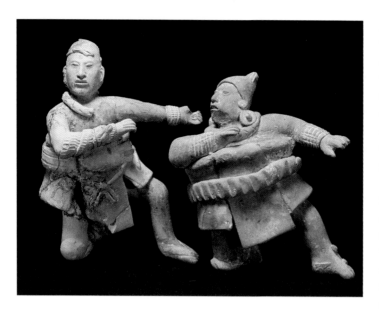

28. Ballplayers, Jaina Island, Mexico, AD 600–800. Clay with pigment, height of left figure 6" (15 cm), height of right figure 6¼" (16 cm). Museo Nacional de Antropología, Mexico City.

Around his waist he wears the most important item of ballplaying gear, a yoke. This rigid object ornamented with the snout of a serpent-like creature is similar to many stone yokes found in archaeological contexts. Some examples now in museums are made from colored or semiprecious stones and are too heavy to have been worn, so the one worn by the figure from Bilbao was presumably made of wood or another lighter material. Some Maya ballplayer figures look as though they had layers of material wrapped around their midriffs (FIG. 28).

The Bilbao figure is making an offering of a heart to a deity above him, and next to him a smaller, skeletal figure is making a similar offering and wearing a similar yoke – a dead ballplayer, perhaps, or the spirit of a player, or the spirit of death itself. The ballgame was fully integrated into the theatrical–sacrificial complex of Mesoamerican ceremonial life.

The theme of the ballgame is one of the few that is explained by a Pre-Columbian myth, which was written down as the *Popol Vuh* in the seventeenth century and comes from the Maya area. It tells the story of young male twins who were playing ball, and whose equipment was coveted by the lords of the underworld. The lords asked the young men to come down to the underworld and play a game with them. The young men accepted but were tricked and killed. The head of one was set into a calabash tree. A young daughter of one of the underworld lords walked by it and became miraculously pregnant from its spittle. She was expelled from the underworld and escaped into the world of men, where she gave birth to a second set of twins. These twins clearly represent reborn versions of the earlier ones, but this time they have magic powers. Once more they play ball and the lords of death invite them into the underworld. This time, however, the hero twins outfox the lords of death and kill them instead. At the end of the myth the heroes are turned into heavenly bodies – either the sun and the moon or the sun and Venus.

This is a quintessentially Mesoamerican story in that it deals with the alternation of life and death. In the first half, the twins die and death is victorious. In the second half, death is conquered by life. Such alternations could refer to many features of nature significant to Mesoamericans: the daily cycle of the sun, the alternation of rainy and dry seasons, and the various phases of the planet Venus as evening and morning star. It is also clear from the story that the ballplaying equipment ranked high in importance

Who, then, is the heroic young man on the Bilbao stela? Because he makes an offering to a deity above, it is assumed that he is a human ballplayer, and not one of the mythical twins. However, this is not certain. It is quite possible that the players in the special ritual games represented in sculpture impersonated the heroes of the myth and were therefore both human and divine. Such ambiguity is similar to and derived from the Izapan tradition of representation. The significance of the skeletal figure with the yoke is hard to determine but, since death is a crucial element in the myth, not surprising. Skulls and skeletons are in fact frequent in ballplayer imagery.

The actual sacrifice of a player is shown on one of the reliefs of the Tajin ball court (FIG. 29). The scene takes place within the benches characteristic of ball courts, represented on the two

29. Relief depicting a scene of sacrifice from the South Ball Court at Tajin, Mexico, AD 300–900. Stone, 5½' x 6'6" (1.56 x 1.98 m).

The losing ballplayer is sacrificed in this scene. This may be an interpretation of the story of the *Popol Vuh*, in which hero twins play ball with the lords of the underworld. It is hard to tell in this relief whether the sacrifice is by decapitation, usual in ballgames, or by the tearing out of the heart. All three figures wear ballplaying gear.

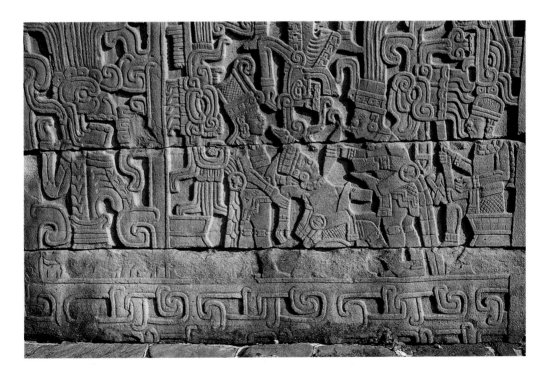

sides of the relief. In the center there are three figures. The one on the left holds the arms of the victim, while the one on the right holds a knife to his throat. All three are dressed as ballplayers with knee-pads, yokes, and palmate objects set into the yokes. There are usually no glyphs with ballplayer scenes, since the figures represent cosmic forces, not individual powers. At the same time, the artist has gone to considerable trouble to represent the sense of motion and lively postures associated with an athletic game.

A question often asked is, who was sacrificed in a Mesoamerican ballgame, the loser or the winner? In the relief from the Great Ball Court of Chichén Itzá, the decapitated ballplayer, still kneeling heroically, has serpents and flowering waterlily tendrils emerging from his head (FIGS 30 and 31). There can be no more graphic a depiction of life, usually symbolized as a plant, emerging from death. The serpents are metaphors for blood. Scholars suppose that the victim was always the losing player, but that it was the gods, rather than the skill of the players alone, that determined the outcome of the game. It is likely that the players impersonated characters out of a myth such as the *Popol Vuh*, in which the twins sometimes lose and sometimes win. Fertility and life are the result in either case. The Chichén Itzá ballplayer with the snakes and flower, dead yet alive, represents the Mesoamerican concept of sacrifice – the figure lives through death. It also indi-

30. Relief depicting a ballplaying scene from the Great Ball Court, Chichén Itzá, Mexico, AD 600–900. Stone, height 4'1" (1.5 m).

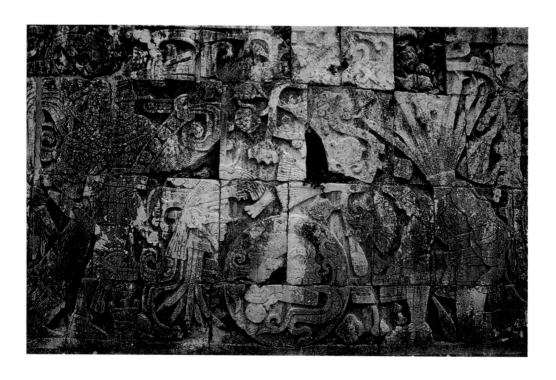

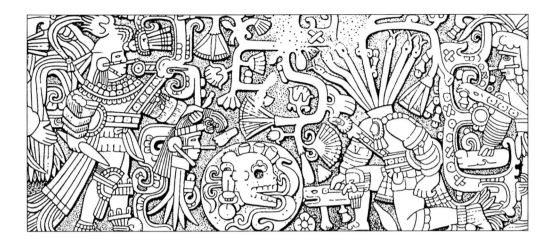

cates that in Mesoamerican thought life and death were not two entirely separate states, but conceptually interwoven.

The ballgame ritual is one of the few practices that cut across the various Mesoamerican cultures. Matches may well have been held not just within centers but between centers. The two teams in the Chichén Itzá ball court scene wear different costumes, which may indicate either ritual dress or ethnic differentiation. We know from textual sources at the time of the conquest that the ballgame could take the place of a battle. Two cities could settle a dispute on the outcome of a game. The game represented the hostility or rivalry of teams and cities, required manly athletic skill, and might end in sacrifice: in all these ways it was certainly a substitute for combat. On the other hand, this combat was highly ritualized and structured and watched by an audience. It is not known where the audience was placed, since only relatively few people could stand on top of the walls looking down at the mortal combat below. Others could have waited outside the walls to hear how the game turned out and perhaps to see the sacrifice.

31. Drawing of a relief depicting a ballplaying scene from the Great Ball Court, Chichén Itzá, Mexico.

A vine sprouts from the decapitated head of the ballplayer, suggesting that life and fertility were expected to be the result of the sacrifices of the ballgame.

The Maya: Esthetes in Power

Maya civilization was discovered by travelers and government agencies mapping ruins in the late eighteenth and nineteenth centuries. Classic Maya culture, which once spread across the middle Yucatán peninsula, lowland Guatemala, and western Honduras, had collapsed by AD 900; thus, the conquerors never heard of the Mayans. Nor did they see any of the great monuments: the area was uninhabited and covered by jungle. Because the style of Maya art is so reminiscent of Classical Greek and Roman and, especially, of Neo-Classical art at the beginning of the

nineteenth century in Europe, it is the style most easily appreciated in the West. Explorers were particularly attracted to the Maya ruins and fantasized about their meanings. Moreover, the Maya had a more elaborate writing system and many more public inscriptions than any other Mesoamerican culture. In 1894 a librarian in Dresden, Ernst Forstermann, deciphered the numerical aspect of the writing system, from which study it became evident that many Maya monuments had calendrical dates on them. The dating system differed from that used in the rest of Mesoamerica, in that it began with a fixed point in the past and was therefore not purely cyclical. Nevertheless, it was related to the other calendars, and was one more indication of the importance of time for Mesoamericans.

32. View of Maya Temple II in the foreground and Temples V and IV in the background, Tikal, Guatemala, AD 600–900.

The roof elongations –"roof combs" – tower above the 100'-high (30 m) jungle. These were the funerary temples of the rulers of Tikal.

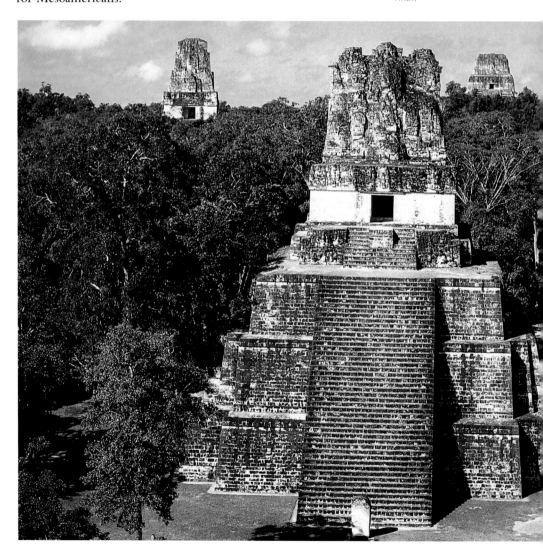

There is probably little more fascinating and tantalizing to a scholar than an undeciphered writing system. Throughout the twentieth century Maya writing has been analyzed and various decipherments have been made. There are about eight hundred known Maya glyphs, of which nearly five hundred have been deciphered. A major breakthrough was the recognition that many Maya glyphs are phonetic or have phonetic components. The rest are logograms, in which a symbol stands for a word. Many of these are derived from images; for example, human, animal, and deity heads and human hands are common. On the Maya monuments inscriptions usually consist of a date, a verb (such as "acceded to the throne"), a name (usually that of a ruler, such as "Shield Jaguar"), a place (such as Yaxchilan), and various titles (such as

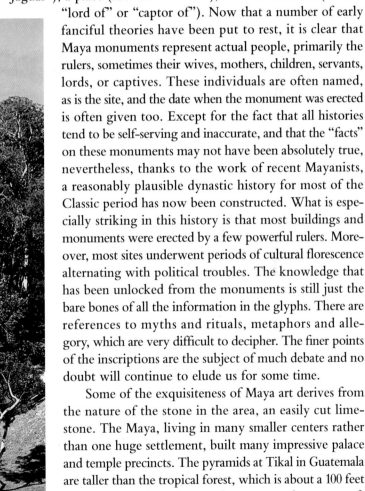

"lord of" or "captor of"). Now that a number of early fanciful theories have been put to rest, it is clear that Maya monuments represent actual people, primarily the rulers, sometimes their wives, mothers, children, servants, lords, or captives. These individuals are often named, as is the site, and the date when the monument was erected is often given too. Except for the fact that all histories tend to be self-serving and inaccurate, and that the "facts" on these monuments may not have been absolutely true, nevertheless, thanks to the work of recent Mayanists, a reasonably plausible dynastic history for most of the Classic period has now been constructed. What is especially striking in this history is that most buildings and monuments were erected by a few powerful rulers. Moreover, most sites underwent periods of cultural florescence alternating with political troubles. The knowledge that has been unlocked from the monuments is still just the bare bones of all the information in the glyphs. There are references to myths and rituals, metaphors and allegory, which are very difficult to decipher. The finer points of the inscriptions are the subject of much debate and no doubt will continue to elude us for some time.

Some of the exquisiteness of Maya art derives from the nature of the stone in the area, an easily cut limestone. The Maya, living in many smaller centers rather than one huge settlement, built many impressive palace and temple precincts. The pyramids at Tikal in Guatemala are taller than the tropical forest, which is about a 100 feet (30 meters) high (FIG. 32). The Maya made stone roofs by the use of corbel vaults and many of these buildings have lasted into the nineteenth and twentieth centuries.

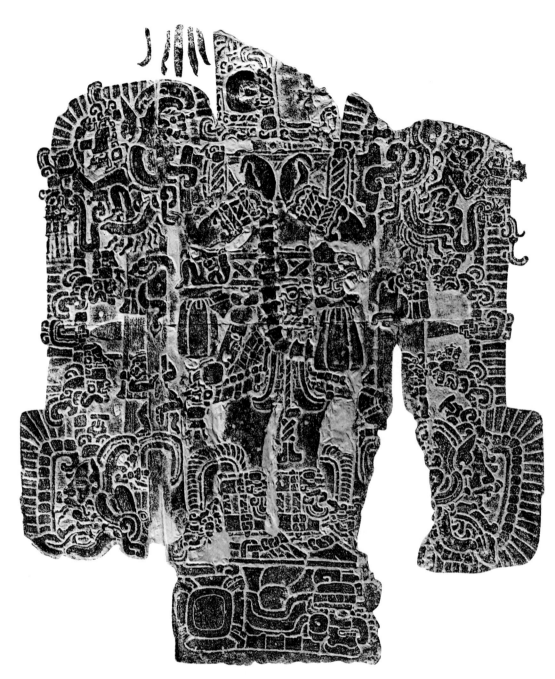

33. Rubbing of Maya Stela 1, Tikal, Guatemala, AD 451.
Limestone, reconstructed height 7′6″ (2.28 m), width 2′1″ (0.64 m). Tikal Museum, Guatemala

The ruler Stormy Sky stands holding a ceremonial bar with deity heads and covered with jade insignia. Such ornate designs are characteristic of early Maya art from the period AD 300–600.

Corbel vaults consist of walls with increasingly projecting stones so that a capstone can span the distance at the top. The technique produces narrow chambers with peaked roofs. Consistent with the emphasis on dynastic subject-matter is the importance of large palaces and administrative quarters at most sites. Sometimes, as at Palenque, the palace is nearer to the center of the site than the pyramids.

The tropical forest is not as naturally advantageous for high civilization as the other areas discussed, from the highlands of Oaxaca and Guatemala, to Veracruz and the Pacific slope, where irrigation could result in great yields of grain. In tropical areas long fallow periods are needed for the soils to replenish their richness and irrigation is often not practicable. Some types of ridged fields, canals, and terracing have been found recently, indicating forms of intensive agriculture, that helped support the Maya population at its peak. While the Maya region was inhabited early, it was mainly around the time of Christ that social stratification and building became significant. The Maya always depended on trade with the rest of Mesoamerica, and their florescence was part of a similar wider development in the Classic period in Mesoamerica. The Maya collapse between AD 800 and 900 may have been due to the exhaustion of the land's agricultural potential and the end of elite culture.

Monument-building in the Maya area began a few centuries before the time of Christ. Many platforms were then built with masks, similar in concept to the one at Kohunlich. The Maya did not begin making their characteristic stone sculpture until about AD 250, apparently using Izapan sculptures as models.

Tikal Stela 1, representing a ruler whom Mayanists have called Stormy Sky because of his name glyph, is a good example of an Early Classic stela and of the point close to when the tradition of sculpture began (FIG. 33). It is in low relief, and so completely covered with ornament and insignia that at first it is almost impossible to tell what it represents. A figure standing in profile but with the shoulders frontally is eventually visible, and seems similar in basic concept to the Kaminaljuyú Stela (see FIG. 25). It is the figure of a man, but he is hidden by little masks, jade ornaments, and feathered ruffs, carved in delicate detail. He holds a long bar ending in two open maws of creatures. This object, known as a ceremonial bar, is often held in the hands of Maya rulers and seems to signify one of the powers of rulership. Little grotesque figures emerge from the open maws. One of them (called God K by Maya scholars) has an axe in his headdress. He is often found in scenes of rulership. His image is actually on the side of the stela,

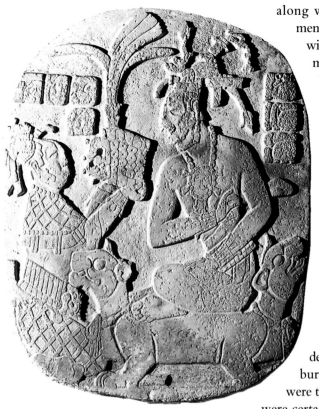

along with a big, feathered back ornament with more little grotesque figures within it. Except for the large earplug, much of the figure's face has been broken. A short inscription is on the back.

A striking feature of Maya art, as seen on this early stela, is the large and impressive size of the human figure and the small size of the grotesque figures, which presumably represent the supernatural. The ceremonial bar would seem to bestow on the Maya ruler the power to communicate with and perhaps control the supernatural world. Clearly the focus is primarily on the world of man and only secondarily on that of the gods. There has been much debate about whether the Maya kings, buried in those impressive pyramids, were thought of as "divine" or not. They were certainly no ordinary mortals. Perhaps they were regarded as embodying aspects of the divine. Certainly the ritual and artistic focus among the Maya in the earliest times seems to have been the ruler who was in touch with the supernatural.

Later, however, the human aspect of the Maya lords was further developed in art. The scene on the Oval Relief at Palenque of Zac Kuk presenting the crown to her son, Pacal, is immediate and affecting (FIG. 34). The mother sits on the ground, while he is elevated on a double-headed jaguar throne. Her gown is all covered in jade, while he is scantily dressed. For a moment we feel that we have peeked in on a royal ritual. Unlike in the early art of Tikal, the figures are not covered over with ornament. The viewer, focusing on their elegant silhouettes, may feel like something of an intruder on a private moment and may wonder if there is a significant glance in the eyes of mother and son. This relief is still set in the wall of House E in the Palenque Palace and was once over an actual throne (FIG. 36).

The very naturalness of the Maya figures, of course achieved by artifice, indicates that the Maya, engagingly, loved to appear simple and unpretentious. Piedras Negras Stelae 12 (FIG. 35) and

34. The Oval Relief found inside House E of the Maya Palace, Palenque, Mexico, c. AD 650. Limestone, 46 x 37½" (117 x 95 cm).

The ruler Pacal sits on a double-headed throne and his mother Zac Kuk offers him a headdress, thus passing rulership to him. His mother was regent during her son's minority and her rulership is indicated by the fact that she has a male hairdo. The glyphs represent their names and titles. The relief is not dated. Accession rituals may have taken place in front of this relief.

35. Maya Stela 12, from Piedras Negras, Guatemala, c. AD 800 (detail). Limestone, 10'4" x 3'5" (3.15 x 1.04 m). Museo Nacional, Guatemala City.

This detail shows the seated Mayan ruler at the top in the position of "royal ease" overseeing a group of prisoners below. He wears an unusual puppet-like pendant on his chest.

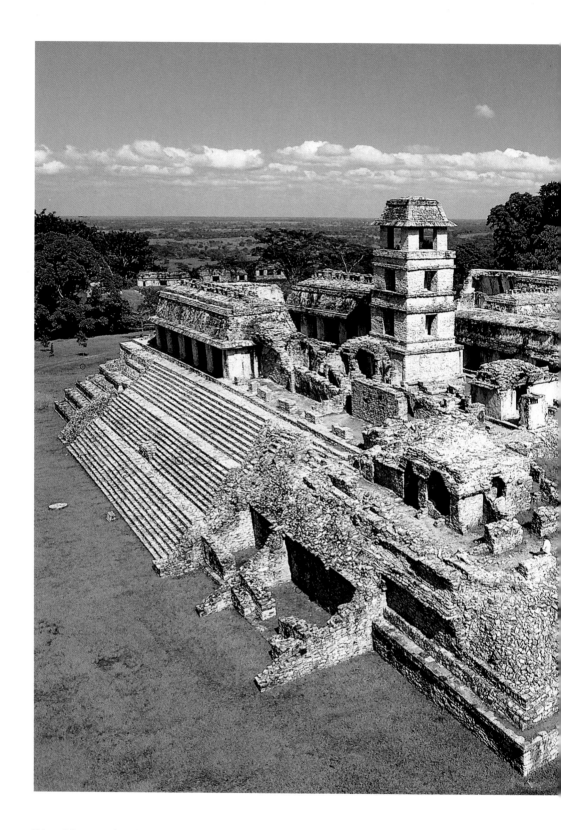

36. View of the Maya Palace, Palenque, Mexico, AD 600–900.

Placed at the very center of the site, the palace at Palenque is noted for its well-engineered vaults and spacious galleries. The tower may have had both astronomical and military significance.

37. Rubbing of a tablet relief from the Maya palace at Palenque, Mexico, AD 720. Limestone, 8'2" x 8' (2.49 x 2.44 m). Museo Regional de Palenque.

Kan Xul is shown with his parents Pacal and Ahpo Hel. The long text consists of full-figure glyphs in the date on the left and a genealogy of the Palenque rulers.

40 bear other examples of Maya rulers represented with aristocratic ease and natural grace. It is not obvious from the ruler's demeanour that he is watching a grisly scene of punishment of prisoners, nor that on Stela 40 he may have just drawn his own blood to offer in sacrifice.

Yet the ease and the elegance are deceptive on other grounds as well. The Palenque scene in which the parents of the new ruler present him with the crown is repeated with small variations on a number of other reliefs, and is as much a conventional type as a unique creation based on observation from life (FIG. 37). The exquisitely ordered position of the ruler, with one hand at his chest

and one on his thigh, is also repeated, not only on reliefs but also on a number of jade and shell ornaments meant to be worn. The gesture therefore appears to be characteristic of accession representations in various media. Maya art appears to be free, but is governed by conventions nevertheless.

Maya art revolves preponderantly around three major themes: the accession or establishment of the ruler, which can be a full scene, as at Palenque, or simply a figure holding insignia; warfare and the acquisition of captives; and the drawing of blood by the ruler and his family as an indication of commitment to the service of the cosmos. Scenes with prisoners allowed the Maya artist certain freedoms that he could not enjoy in representing rulers who, with a few exceptions, had to be portrayed as handsome, elegant, and ageless. Prisoners, such as the ones in the murals of Bonampak (FIG. 38), could be depicted sitting or lying, in a wide variety of postures, and expressing their pain and distress

38. Maya mural painting from above door in Room 2, Structure 1, Bonampak, Mexico, AD 790 (detail). Fresco, entire wall 17 x 15' (5.18 x 4.57 m).

A naked prisoner is shown beseeching the standing Lord Chaan Muan and his retinue. The mural shows the spectacular colors, fabrics, hides and jades worn by the Maya.

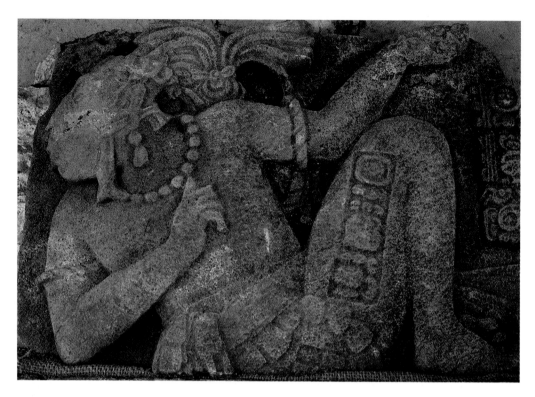

39. Maya Monument 122 from Tonina, Mexico, c. AD 715. Stone, 23¼ x 32½" (59 x 83 cm). Instituto Nacional de Antropología y Historía, Mexico City.

Kan Xul of Palenque was captured and killed at Tonina and commemorated in this relief with his name. It has been suggested that Palenque artists were required to carve it as a mark of further humiliation.

after torture or when facing death. The artist seems sometimes to have been more interested in the representation of the victims than of the victors. Their names and cities are often indicated in glyphs. This emphasis on the persona of the victim, seen also on the "Danzantes" at Monte Albán (see FIG. 23), is one of the characteristics of Mesoamerican art. In the "dance of life and death" in which Mesoamericans were involved, victims as well as victors were essential. Moreover, it was always assumed, that next time round, somewhere else, the aristocratic lord may be the one to sit naked with his headdress removed, staring at the blood on his fingers. These images are about power, and about the fickleness of power. We know that the rulers known as 18 Rabbit (a "day" name related to the individual's date of birth) of Copán and Kan Xul of Palenque were captured and sacrificed at a smaller neighboring site (FIG. 39). Such changes in fortune were the rule rather than the exception in Mesoamerican politics.

This sense of mortality, of chance inherent in life, in games, and in politics, gives an edge to the representation of those beautiful, idealized Maya faces. The Maya ideal is an overtly asexual, but probably male, young face, long and oval, with slightly slanting eyes, an elongated and curving nose, and fleshy lips. The idealized face might represent a lord, a lady, or a specific deity, such as the young maize god, known for his beauty (FIG. 40). It

40. Maya maize god head, from Temple 22, Copán, Honduras, c. AD 700–750. Trachyte, 15 x 12½ (37.8 x 31 cm). Dumbarton Oaks Research Library and Collection, Washington, D.C.

Maize god figures making elegant hand gestures once ornamented the roof area of this much damaged temple. The youthful maize god represents the Maya beauty ideal, also expressed in the portraits of rulers.

41. Portrait of Pacal, from Palenque, Mexico, c. AD 600–700. Stucco with remains of red paint, height 15_" (39 cm). Museo Nacional de Antropología, Mexico City.

This head was found in the burial chamber of Pacal in the Temple of the Inscriptions and presumably taken from an earlier building. It is remarkable in showing the Maya beauty ideal, as well as the long face characteristic of Pacal in his other representations.

may have been carved as architectural decoration in trachyte, the soft stone of Copán, or painted on a pottery vessel. These faces bear a vague resemblance to the Lacandón and other Maya people living in Mexico and Guatemala. Idealization suggests that the Maya entertained a concept of bodily perfection, which was mimicked in art.

Most Maya representations followed the ideal, but at various times and places, patrons and artists evidently wanted the actual appearance of certain individuals to be recorded. The ruler portrayed on a Tikal lintel has a huge belly and other fat people can be seen on reliefs. Most fascinating, however, are the possible true likenesses. By studying the ideal representations, scholars have detected deviations, which suggest that portraiture was practiced at various sites. At first, the differences appear slight: a face that is longer or wider than another, bigger or smaller eyes, thicker or thinner lips. At Palenque there is quite clearly an attempt to individualize representations. The stucco head found in the Temple of Inscriptions is believed to be a portrait of the ruler Pacal (FIG. 41).

The quantity of Maya art is astonishing: hundreds of stelae and lintels, thousands of surviving pottery vessels. Not all of these items were in visible places where the "subjects" could have been awed by the magnificence of the rulers. Many were inside small rooms or on somewhat inaccessible lintels. If scenes depicting capture or the drawing of blood by a noblewoman were meant to instruct, to instil pride in certain values, then their audience must have been mostly the elite (see FIG. 11). Some scholars make distinctions between "vertical" propaganda, put out by the elite for the consumption of their subjects, and "horizontal" propaganda, practiced between the members of the elite. Maya art has both, but a remarkable amount of it is "horizontal" propaganda. So the modern viewer contemplating this art is indeed intruding into some private scene.

What is revealed is a fascination with the beautiful. If the Olmec were interested in the power of the body, the Maya were interested in its beauty. Clothes, insignia, and glyphs, themselves objects of beauty, further enhanced the loveliness of the body. The small Maya states are now believed to have ruled through dynastic spectacle, much as did Versailles in the eighteenth century and Bali in the nineteenth century. Such "theater states" acquire power not through economics or war, but through the prestige of the beautiful. Esthetics, among the Maya elite, may have been a matter of life and death. It was their investment. The Maya is the only Mesoamerican culture that seems to have glorified

42. Rollout photograph of Maya fineline vase, C. AD 550–950 (detail). Ceramic with pigment, height 4″ (10.5 cm).

Maya vases were painted with figures with an exquisite use of line. Often the individual hand of an artist can be recognized.

the artist in the way that has sometimes happened in Western culture (FIG. 42). The importance of the Maya artist may also have been attributable to the fact that many were junior members of elite families. Evidence of the high status of the artist includes images of the patron god of artists, possible names of artists on pottery, and a number of representations of the artist's hand holding a brush. An example on the incised bone from the Tikal royal burial shows the hand emerging from a monster maw – much like the deities that emerge from the ceremonial bar (FIG. 43). It seems to suggest that creation is "divine." Everywhere else in Mesoamerica the artist worked in a guild or a workshop and was neither represented nor, apparently, considered in such an exalted manner. The very importance of the artist to the Maya indicates that art played a vital role in the creation of power.

Maya art is the most elaborate manifestation of the Mesoamerican emphasis on man as the hero of narrative scenes and portraits, within a family, within a political setting, with enemies and captives. It is recorded twice: once in images, and second in texts. The two are not exactly the same, more factual information being found in the texts, and precisely because of this, the images become freer. No longer the sole bearers of factual information, they now begin to communicate esthetic information. It is thus the high development of Maya writing that makes the esthetic richness of Maya art possible. Artists and patrons seem to have been

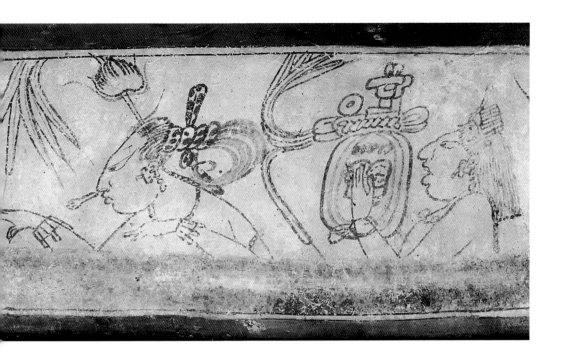

more concerned with the appearance of an image than with its meaning. They admired the virtuosity of the artist who could sketch the profile of a figure with a single expressive line. Such values are so similar to the Western tradition of esthetics that we have no difficulty in appreciating them.

Maya art perhaps created the illusion of splendor in the society and the polity: the actual Maya states were fragile. There were times political conditions were so troubled that even the elite lacked the incentive or the resources to erect monuments. The works of most sites belong to the era of a few powerful rulers. When Maya elite culture collapsed, from the ninth century onwards, the area was eventually entirely abandoned. Since then, the region has never been more than scantily populated.

43. Incised bone from Maya Burial 116 in Temple 1, Tikal, Guatemala, c. AD 700.

The artist's hand emerging with a brush from the jaws of a supernatural serpent suggests that the Maya may have regarded artistic creation as of divine inspiration.

TWO

An Alternative Path in Mesoamerican Art

Teotihuacan: The Cosmos is the Hero

Unlike some other sites in Mesoamerica, which may have been concealed by jungle for centuries, Teotihuacan (AD 1–750) has always been visible. Its two big pyramids, about 30 miles (50 km) north of Mexico City, are close in size to the pyramids of Egypt (FIGS 45 and 46). Very little is known about its people, however, because there seems to be so little surviving art. While most other Mesoamerican sites are "peopled" by hundreds of monuments and almost unlimited stone relief sculptures, Teotihuacan has nothing of this sort. No tradition of representing the human figure in scenes of power has come to light. There are no images that can be identified as captives. Nothing suggests portraiture. Most mysterious of all, there are very few signs of the glyphs or writing that were so characteristic of southern Mesoamerica. This is the more mystifying because monuments outside Teotihuacan, at Monte Albán in Oaxaca and Tikal in the Maya region, represent Teotihuacan-style figures and symbols, thus indicating diplomatic or dynastic contact.

There is one mysterious structure at the southern part of the site, known as the Temple of the Feathered Serpent. It is ornamented with large stylized heads projecting from a feathered serpent body. One of the heads is that of a feathered serpent, the other is of a goggled, scaly creature, which scholars cannot identify. Marine shells surround the creature. The temple was in the center of a walled compound with palaces and a plaza big enough to contain all the adult population of Teotihuacan at the same time. Recent excavations into the pyramid have uncovered the skeletons of eighty young men dressed as soldiers, who were evidently sacrificial victims either for the dedication of

44. Mask from Teotihuacan, Mexico, AD 200–750. Serpentine with remains of iron pyrite, 8½ x 8" (21.6 x 20.5 cm). Dumbarton Oaks Research Library and Collection, Washington, D.C.

Such masks were affixed to images and probably dressed. The eyes were inlaid with iron pyrite.

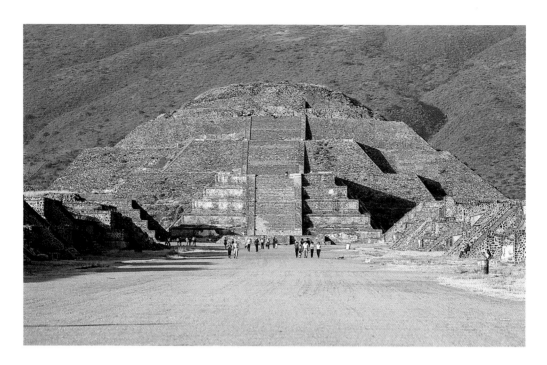

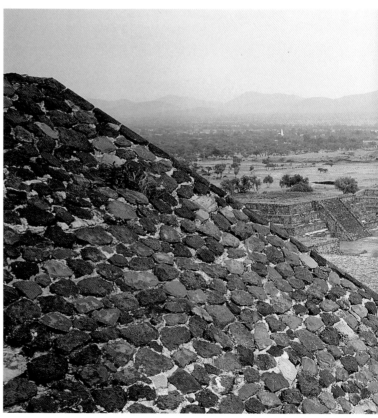

Above

45. View of the Avenue and the Pyramid of the Moon, Teotihuacan, Mexico, AD 1–750.

The largest city in Classic Mesoamerica, Teotihuacan had a population of about 200,000.

the building or for the funeral of an important ruler. What is striking in the Temple of the Feathered Serpent is that the imagery is of animals rather than people.

Teotihuacan was, economically and perhaps politically, the dominant power in the Classic period. With a population of two hundred thousand, it was the largest city in Mesoamerica and one of the largest in the world. Only the Aztec capital would rival it, eight hundred years later. Unlike elsewhere in Mesoamerica, where people lived in cities surrounded by villages and hamlets, in the Teotihuacan area almost the entire population lived in the city. A huge avenue, more than a mile (1.6 km) long and often 55 yards (50 m) wide, bisected the city. All cities in Mesoamerica were aligned astronomically, and Teotihuacan was planned so that its "north" was 15°25″ east of true north. After AD 250 permanent compounds of residential apartments were built, taking the place of the earlier perishable houses. The compounds each housed an extended family or corporate group of sixty to a hundred people who often pursued craft activities. These planned multi-family apartments were also unique in Mesoamerica.

Below

46. The Pyramid of the Sun (center) viewed from the Pyramid of the Moon Teotihuacan, Mexico, c. AD 1–100. Total surface area 2427.5 square feet (225.6 square meters), height 206′8″ (63 m).

The Pyramid of the Sun is the second largest pyramid in Mesoamerica after the one in Cholula. It is as big in mass, though not in height, as the great pyramid at Gizeh in Egypt and is built over a cave.

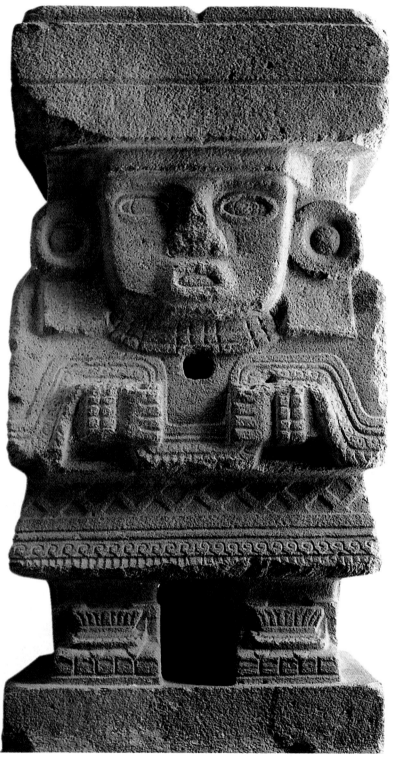

47. Colossal sculpture of a woman, from Teotihuacan, Mexico, AD 200–750. Basalt, height 12′9″ (3.9 m), weight 22 tons. Museo Nacional de Antropología, Mexico City.

This figure, one of the few sculptures in stone at Teotihuacan, may have represented a nature goddess.

There are two colossal sculptures in Teotihuacan style and they are remarkable in that they represent women rather than men. One of these wears female dress ornamented at the borders with geometric designs (FIG. 47). Unlike the art discussed so far, the figure is decidedly non-naturalistic and all parts of the body are reduced to simple geometric shapes. The angularity and architectonic quality make it similar to the pyramids. The face is distant like a mask. Flatness, angularity, and geometric abstraction characterize the art of Teotihuacan.

Since the days of the early villages, such as Tlatilco, when clay figurines of women were common art forms, women were rarely represented in Mesoamerican art, which deals mainly with themes of political power. The wives and mothers of Maya rulers were sometimes the subjects of works of art, but even so the emphasis was on the male ruler. Who then is this colossal woman at Teotihuacan and why is a woman so important? The possibilities are that she is a deity or a founding ancestress. More will be said on this later, after other examples of Teotihuacan art have been adduced.

While sculpture is rare at Teotihuacan, hundreds, perhaps thousands, of greenstone and alabaster masks are known (see FIG. 44). Their eyes were once inlaid with shell and pyrite and the masks were not meant to be worn by the living, nor are they found in the context of burials. Very likely they were attached to a bust, as in the clay object recently excavated at Teotihuacan (FIG. 48). Perhaps they were dressed in splendid garments and headdresses like the figures in the murals. These may have been deities or ancestors. It has even been suggested that they were mummy bundles, in which case they were set up in temples to be venerated as spirits. (In some parts of Pre-Columbian America the seated corpse was wrapped in many layers of cloth to create a "bundle.")

The masks are the faces of the people of Teotihuacan, as they represented themselves; as such, they suggest both anonymity and multiplicity. Teotihuacan art in its elegant abstraction is designed

48. Bust with a mask from Teotihuacan, Mexico, AD 200–750. Clay, height 21½" (55 cm). Museo Arqueológico de Teotihuacan.

This bust with a separately attached mask indicates how masks were used. The figure may have represented a venerated spirit.

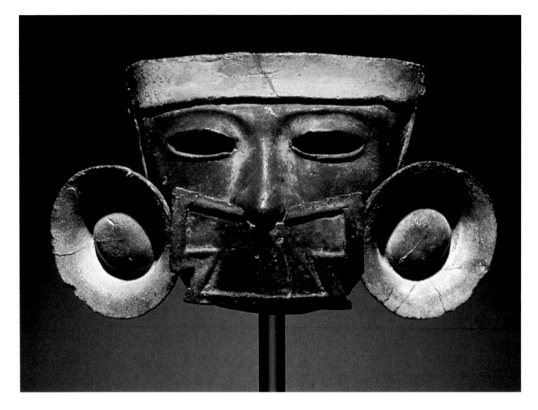

49. Teotihuacan censer mask from San Miguel Amantla, Mexico, AD 500–650. Ceramic with pigment, 4 x 7" (10 x 18 cm). Museo Nacional de Antropología, Mexico City.

The nose bar was an adornment frequently worn by the elite and the supernaturals in Teotihuacan representations. The geometric shapes are characteristic of Teotihuacan art.

to give as little information as possible. Rectilinear nose bars hide the mouths of many masks and figures and make them look even more inaccessible (FIG. 49).

The best route to understanding Teotihuacan is not via the ruling elite, who, unlike the Maya, seem not to have represented themselves, but by way of the mural paintings of its apartment compounds (FIG. 50). Like ancient Pompeii, much of Teotihuacan was painted. There were great distinctions between rich and poor, and perhaps between people who cared for murals and those who did not. The murals vary in style and quality, but share certain features. Like wallpaper, they consist of flat, repeated designs on the porches of the rooms. The roofs of the porches provide protection from rain, but because the porches are open the light is admitted. The mural colors are mostly bright reds, blues, greens, and yellows. The subjects are supernaturals, animals, humans, and symbols. Human figures are usually depicted in profile in procession or converging on a frontal figure or symbol. These anonymous humans may be the elite of Teotihuacan shown as a group.

So far there appear to be two major identifiable supernaturals at Teotihuacan. One is a goggled figure called the Storm God, easily identified with the Aztec rain god Tlaloc. The other is a masked

figure in female dress known as the Goddess. She is shown with claws or giving water, indications that this being had great power. With its masklike face, the colossal female sculpture may represent the Goddess. Most of the imagery in mural painting at Teotihuacan deals with water and vegetation and spirits bestowing bounty. The Goddess from Tetitla is shown with outstretched hands, offering jades. The colossal sculpture seems also to be benign, lacking any overt images of death or aggression. Whereas in the rest of Mesoamerica, conflict was the metaphor for life, at Teotihuacan the metaphor was evidently order, harmony, and benevolence.

Notwithstanding the emphasis on harmony, war and sacrifice did occupy a place in Teotihuacan art. Instead of depicting a captive with his name, as was common in Monte Albán and among the Maya, in Teotihuacan mural art the heart was shown either on the knife of an anonymous elite figure or in front of the mouth of a serpent, raptorial bird, or feline. Animals often seem to have stood in for human figures and to carry weapons. Conflict was not personified in individuals; and the use of animals shifted the emphasis from the human to the cosmic.

50. Mural from the Tetitla apartment compound at Teotihuacan, Mexico, AD 650–750 (detail).

A richly dressed female figure, perhaps a goddess, is shown scattering jades, symbolizing riches and fertility, with her hands.

Not only were elites not represented in stone, but complete human figures too were absent from much of Teotihuacan art. The masks are a part of a composite object. In the murals, figure parts, flora and fauna, and symbols are combined in compositions. Fragmentation is seen at its most dramatic, however, in the ceramic incense burners with *adornos* – mold-made clay pieces with symbolic designs glued to the frames – attached to them (FIG. 51). These incense burners, no two of which were alike in design or composition, date from the time when the apartment compounds were built. They seem to have been used on the central shrines in the courtyards and were subsequently often buried with an important man in the compound. Like the proscenium arch of a theatre, clay panels framed a central opening in which a mask was placed. Usually human but sometimes animal, this mask, with a nose bar hiding the mouth, was very similar to the images of spirits in mural painting. The frame was covered with *adornos*, which were mass-produced. Like the apartment compounds, which were planned on a grid pattern, these *adornos* were all the same, and yet were personalized.

In the art of southern Mesoamerica the human body was portrayed as a whole and representing a participant in dramas. In the art of Teotihuacan the body was fragmented, attaining some sort of cohesiveness only in allegorical diagrams; and, in place of glyphs, which signified dynastic history, symbols were favored.

The unique features of Teotihuacan art evidently derived from a social system and ideology that differ from patterns found elsewhere in Mesoamerica. Time and energy were devoted not to rulers but to the reality of building housing and to a collective ideology shared by the population of the city as a whole. Moreover, instead of images that glorified the acts of male rulers, the most important image is that of a woman. Since nothing suggests that Teotihuacan had female rulers, the female figure is likely to be symbolic, representing cosmic rather than political significance. Plants, animals, and symbols were also represented in a way that related more to the cosmos as a whole than to man as an individual.

Teotihuacan culture thus went against the grain of Mesoamerican tradition, in creating one huge city with a complex collective organization; an art based on a pair of male/female nature deities; an abstract rather than a naturalistic style; an emphasis on the cosmos rather than on humankind, and on harmony rather than conflict; and an art of fragmentation rather than wholeness. With the preeminence of masks or masklike faces, Teotihuacan art is the opposite of the humanist art of the Olmec and the Maya, manifested in their portraiture.

51. Teotihuacan censer cover with mask, from La Ventilla, Mexico, 500–650. Polychrome clay with mica inlay, height 14½" (37 cm). Museo Nacional de Antropología, Mexico City.

In this "theater"-type incense burner a mask was flanked by panels bearing symbols. In this example birds and butterflies predominate.

Why Teotihuacan developed so differently is not known. One theory is that a volcanic eruption in the basin of Mexico in about 50 BC buried the center of the former city of Cuicuilco under several meters of lava. The rulers of Teotihuacan may have thought that a well-organized single city would be a protection from the anger of the gods and a way of keeping the population under control. The power of the elite was not promulgated in art and art was accessible to the whole population. By this formula a sophisticated and highly motivated citizenry were created, who had colonies and trading and political contacts throughout Mesoamerica.

The causes of the collapse of Teotihuacan are equally unknown, but they appear to be internal, not the result of invasions. The collapse precipitated realignments in trade and politics that also affected the Maya centers, which themselves began to decline after AD 800. The experiment of living in a large city was abandoned and people reverted to the dispersed way of life that had remained the custom in the rest of Mesoamerica.

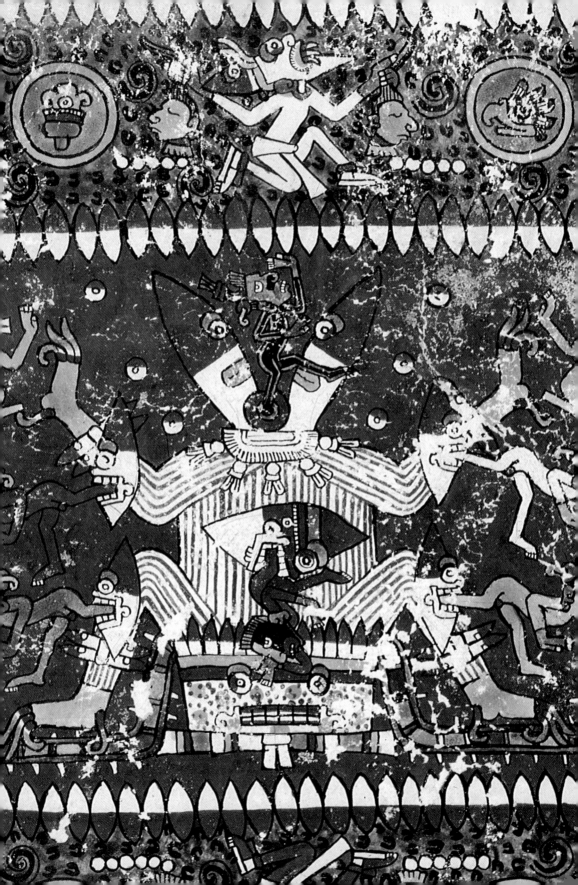

THREE

Eclectic Synthesis

I n the Classic period (AD 300–900), Mesoamerica was divided into many regions. They shared a similar calendar, the same basic religion and many rituals. For example, the ballgame was common to most. They traded with and visited one another. They warred with and took captives from each other. At the same time, they were consciously developing styles of art that differed from those of their neighbors. The result was a vast variety of stylistic traditions, ranging from the naturalism of the Maya to the abstraction of Teotihuacan. Certain cultures can be clearly identified with certain art styles and subjects. The apparent contradiction between the search for unique individual identity and extensive interaction is a source of great richness in the arts of the Classic period.

Another feature of the art of the Classic period is its great quantity. There was much more monumental architecture and figurative art in the Classic than in either the Preclassic or Postclassic periods. In the polities of the Classic period art was essential as a means of contacting the supernatural and of influencing society. Whether depicting enthronements, sacrifices, or deities, art was a way of comprehending and controlling the world. In that sense art was effectively a "technology."

One of the most striking aspects of the Postclassic period (AD 900–1521) is the comparative paucity of its output of art and architecture, to judge from what has survived. Examples from this period are characteristically less complex in form than those from the Classic period. Moreover, instead of the Classic-period desire for uniqueness, the arts of the Postclassic period reveal a predilection for eclecticism and synthesis, notably the arts of Chichén Itzá and of the Aztecs. At many sites, elements from var-

52. Page 32 of the Mixteca-Puebla manuscript known as the Codex Borgia, from Mexico, 1421–1521 (detail of FIG. 55). Mineral and vegetable pigments on animal skin, page 10.6 x 10.4″ (27 x 26.5 cm). Biblioteca Apostolica Vaticana, Rome.

This page is from the so-called Venus sequence, in which scenes of sacrifice and perhaps the underworld are linked in a narrative.

53. Mixtec ornament from Tomb 7, Monte Albán, Mexico. Mixtec culture, c. 1200–1500. Gold, height 8½″ (21.9 cm). Museo Regional de Oaxaca.

Bells and symbols such as the ball court and sun disk are joined in this ornament. The wax in the model was so thin that it may have been extruded into water and not rolled by hand. Metalwork became known in Mexico only after AD 800. The techniques came from Central America.

ious regions are brought together in one monument. At Xochicalco and Cacaxtla in central Mexico, for example, Maya, Monte Albán, Veracruz and Teotihuacan features are clearly visible. Those great ancient centers held on to their prestige even after their collapse, because none of the new ones could compare with them; even in their ruined state, they were still visited and admired. The awe inspired by the old monuments infiltrated every subsequent culture.

Although the arts of the Postclassic period thus reflected a wide range of sources and influences, an overall "Postclassic style" is identifiable. This general style, known as Mixteca-Puebla style, was found with minor regional variations from the Yucatan to the state of Sinaloa in the far northwest. There are several reasons why Mixteca-Puebla style developed. One seems to have been the growth of long-distance trade; another was perhaps the change wrought in a society in which the elite no longer exerted control by means of art. Many scholars have surmised that in the Postclassic period Mesoamericans adopted a more practical manner of dealing with life's problems, rather than relying so exclusively, as hitherto, on art and ritual. Moreover, polities tended to be small, lacking both the desire and the resources to build and create images on the scale of the Classic cultures.

Mixteca–Puebla: The Dominance of Books

With the exception of a few sites such as Chichén Itzá and Tula, very little monumental art was made in the Postclassic period. Most art was small, even miniature, in scale. The period yielded exquisitely painted pottery and lapidary arts. This was also the time when metalwork first appeared, metallurgy having been introduced from Central America into Mesoamerica about AD 800–900. The Central American pieces were melted down and reworked into new types of gold and silver jewelry. Some of the most spectacular jewelry was made by the Mixtecs of Oaxaca, a highland area in southwestern Mexico. Mixtec artisans also went to the Aztec capital and worked in gold there. Probably many of the gold pieces that Cortés collected were made by Mixtec craftsmen and looked like the pendant illustrated here (FIG. 53). Separate symbols – a ball court, a solar disk, and two creatures are hinged together in series with bells at the bottom. Interestingly, these symbols are very similar to and perhaps derived from representations in books. The pottery designs also seem to have books as their prototypes. In all instances the motifs are completely standardized, parts of an image system that was pan-Mesoamerican.

It is very likely that the Classic period had books too, but owing to the wet climate they have not survived. It is believed that one of the surviving Maya books, the Codex Dresden, may be a copy of a Classic-period book. There are Maya vases painted like the later codices (manuscript volumes), suggesting a lost codex art. Similarly, even though Teotihuacan did not have glyphic inscriptions in murals and stone, it may have had books of some kind for keeping records. The Aztecs had books for many different purposes: histories, religious calendars, maps, and tribute books being the most basic types. All of these had probably existed earlier in one form or another.

Fourteen original codices have survived, either because they were sent to Europe and were preserved in libraries, or because they were handed down through native hands. (There is also a large corpus of copies made in the colonial period.) By chance, all the non-Maya books (eleven out of the fourteen) come from the region occupied by the Mixtecs in Oaxaca and near the city of Puebla, whence the style of these manuscripts and of all the arts associated with them has come to be called Mixteca-Puebla. Made of native paper from the bark of a fig tree or deer hide, the codices are all long strips that were folded like an accordion (screenfolds) and painted in bright colors.

The Codex Zouche-Nuttall was discovered by the nineteenth-century scholar Zelia Nuttall (FIG. 54). The manuscript, formerly in an Italian library, was sold to an Englishman and is now in the British Museum. The Codex may have been given to Cortés by Montezuma and sent back as a curiosity. The hero of a large portion of the Codex Zouche-Nuttall is the ruler of Tilantongo, called 8 Deer (the calendrical day sign and number on which he was born) and Tiger's Claw (his appellative "first" name). Several other codices tell his story, which consists mostly of genealogy and conquest. Mixtec royal histories usually begin with the gods and the creation of the world and move on to the genealogy, marriages and children of the hero of the codex. A lot of space is devoted to accounts of conquests, and, if the subject of the conquest is very important, the sacrifice of conquered rulers. Most Mixtec cities were less grand than the Maya ones and the stories are not carved into stone; but in general content and purpose the accounts are quite similar. The codex is, of course, small and perishable. Moreover, only the privileged few would have been able to sit close enough to be able to see it while someone recited the story orally. To that extent the Mixteca-Puebla arts were quite exclusive.

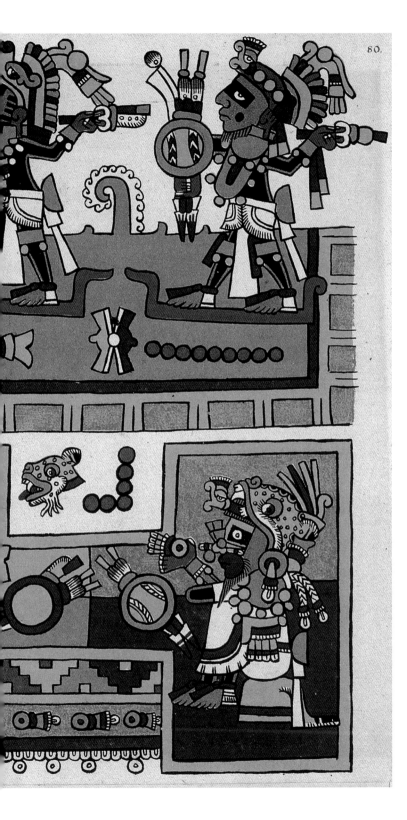

80.

54. Folio 86 of the Mixteca-Puebla manuscript known as the Codex Zouche-Nuttall, from Mexico, c. 1421–1521. Animal skin and pigment, 7½ x 10″ (19 x 25.5 cm). British Museum, London.

The rulers of Tilantongo, 8 Deer and 4 Jaguar, are shown on a journey to the sacred oracle, the solar god 7 Motion. They stop in a ball court and then cross a body of water, perhaps a river.

The decorative style of the books is reminiscent of the art of Teotihuacan, but the dynastic narrative is not. The entire symbol system is standardized. Human figures have a few basic postures, and their headdresses and costume often indicate their name, such that they literally wear their identity. Three types of glyphs appear: the name glyphs of the individuals, the dates when events take place, and the names of places, often shown in the form of a stylized mountain. When shot through with an arrow, a place sign signifies conquest. A historical codex is a continuous narrative. Trained historians probably once provided an oral commentary that elaborated on what was in the books.

The codices are visually concerned primarily with meaning and communication and only secondarily with style or esthetic effect. Naturalism was not sought. Nevertheless, the artist sometimes played some delightful visual games that display a humorous imagination. On folio 860 of the Codex Zouche-Nuttall two rulers (8 Deer and 4 Jaguar) dressed in military costume, with shields and weapons in front of them, sit in a ball court. The court is shown in plan and as a frame for the figures, thus creating a self-contained picture on the page. Two other self-contained elements are mountain-shaped place signs on the left. The dates and glyphs are on the "empty" background portions of the page. The most striking scene on the page is another square that represents a body of water, as indicated by a shell and fish. Stylized waves shoot up between the figures in the miniature boats. Although the images are all standardized and stylized, the scene is full of liveliness and invention. According to current interpretations the three figures (here 8 Deer, 4 Jaguar, and 9 Water) are on a sacred voyage down a rushing river to visit an oracle.

A number of religious codices also survive. These books probably belonged to priests and diviners because most deal with the ritual calendar. The Codex Borgia is the most elaborate (FIG. 55 and see FIG. 52). Unlike the historical codices, the ritual ones are usually not narrative. They consist of the diagram-like depiction of time periods or regions of the world with the various gods associated with them (see FIG. 9). The pages often have sequences of the day signs, each in its own little grid section. The 260-day cycle is variously divided, most commonly into twenty 13-day periods called *trecenas* in Spanish. These are found in most ritual manuscripts. Each *trecena* had its own deity, such as the rain god Tlaloc. Each deity is shown as a human figure with his or her characteristic features evident on the face, headdress or costume – much as the human elite were represented. While the rulers were the heroes of the historical manuscripts, the gods were the heroes of the religious codices.

By the Postclassic period the deity patrons of the twenty *trecenas* had become largely standardized in central Mexico. Not only did most codices have the same sequence of deities, but their appearance and features were much the same too. This suggests that matters of religion and ritual may not always have been determined in individual centers but were spread beyond the province of the political elite, much like trade.

It is not known exactly how priests used these books. Each day sign and number combination was taken to indicate a good or a bad fortune and the will of the gods was consulted in all mat-

55. Page 32 of the Mixteca-Puebla manuscript known as the Codex Borgia, from Mexico, 1421–1521. Mineral and vegetable pigments on animal skin and paint, page 10.6 x 10.4″ (27 x 26.5 cm). Biblioteca Apostolica Vaticana, Rome.

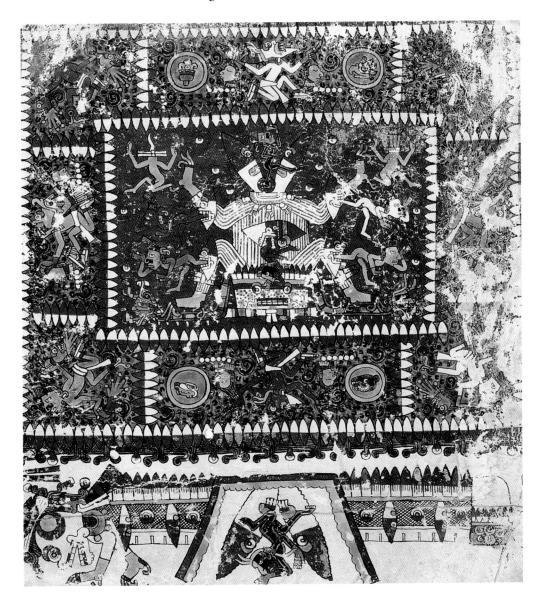

ters from marriages to the mounting of a trading mission. The calendar was not specific to any one year. It seems to have laid out significant features of the supernatural like a map. In the Codex Borgia Tlaloc is surrounded by other symbols – a stream of water flows from him and various mysterious-looking items to us are painted in front of him. These are not to be read as a single "picture," but as a series of symbols of use to the diviner in various interpretations. The Codex is a kind of "encyclopedia," to be consulted on various matters rather interpreted as a whole.

The Codex Borgia, alone of all the ritual manuscripts, has a section that has been interpreted as a narrative. Each page is a separate unit, but a little person seems to pass through a "hole" in the body of a goddess from one page to the next. An early suggestion was that this section represented the underworld journey of the planet Venus, following the Mesoamerican belief that Venus appears twice as a morning and evening star, and during its period of invisibility, makes a journey to the underworld. Whatever the correct interpretation of the Codex, it gives us an insight into some of the more complex ritual depictions. Sequences such as this seem to be pictorial treatises on a religious topic. Each of the "Venus Sequence" pages seems to deal with the subject of death, darkness, and sacrifice (thus, perhaps, of the underworld). They also tell us something about native mysticism and speculation, topics which the sixteenth-century friars did not enquire into. But what are modern Westerners to make of a strange, decapitated sacrificial victim with knives for a head, already dead, who is undergoing further ritual disfigurement at his joints by little figures? The meaning of the picture and the contemporary concept of sacrifice must necessarily remain obscure.

In the late Postclassic period both the style and subject of representation were derived largely from manuscript illustration, which erased many of the Classic-period differences in art in favor of a pan-Mesoamerican tradition. When the Aztecs came to power, many of the images they carved in stone were enlarged versions of manuscript illustrations, and their own books often copied the format and subject of Mixtec books.

The Aztec: The Servants of the Gods

The Aztecs were a Nahuatl-speaking people who lived in Central America at the time of the conquest. One group, who lived in the capital city of Tenochtitlán, called themselves the Mexica. It was they who ruled Mexico, but together with their neighbors they are now collectively called "the Aztecs." The Aztecs came to

power only about a hundred years before the Spanish conquest. A great deal is known about them because they were the subject of extensive Spanish inquiry. According to their historical traditions, they migrated into the Valley of Mexico area as a group of nomads. It is not known exactly when. They were used as mercenaries in the local wars by the petty chieftains and eventually rose to power. According to legend, their god Huitzilopochtli led them on their migration and foretold their greatness (FIG. 56). He told them to settle where they saw an eagle on a cactus. They settled on islands in the Lake of Texcoco, which happened to be the only available place in which they could settle in the crowded valley. Here the Aztecs built a city, eventually connected to the mainland by causeways and drawbridges, and had aqueducts bringing fresh water from the springs. They created artificial land called *chinampas* for the cultivation of plants and later for habitations to extend the size of the original islands. Such was their engineering success that, by the time Cortés and his men saw it in 1519, Tenochtitlán was a city of close to 200,000 people, with streets and canals like Venice. Nor was Tenochtitlán the only major settlement: there were three or four very large cities and many small towns, villages, and hamlets, making the Lake Texcoco region a veritable "metropolitan area." It is estimated that it was not until around 1900 that the population of the region again equalled the level it had attained in Aztec times.

56. Codex Boturini, from Mexico, sixteenth century. Amatl paper, screen folded, painted on one side, height 7¾″ (19.8 cm), entire length 18′ (549 cm). Museo Nacional de Antropología, Mexico City.

In an incident during the migration, a tree broke in half near a group of Aztecs celebrating around the image of Huitzilopochtli. This was interpreted as a sign for the Mexica to separate from the rest of the Aztecs and go on their own conquering mission.

The Aztecs were not absolute rulers of all this. They ruled with two other cities in a "Triple Alliance" and they maintained a tribute empire, not a territorial one. Usually the conquered provinces were left under local rule and it was tax collectors who tried to requisition the cloths, foodstuffs, precious stones, and metals that would meet the terms of the treaty. Very often provinces refused to pay: constant war and instability were the result. Each ruler had to fight a battle before his coronation. Itzcoatl (1428–40), Montezuma I (ruled 1440–68), Axayacatl (1468–81) and Ahuitzotl (1486–1502) were all known as great warrior rulers. Tizoc (1481–86) has gone down in history as a coward whose reign did not last long. Montezuma II (1502–20) had a vacillating temperament and it is possible that he was killed by one of his own people in the midst of the conquest, as a consequence of his lack of leadership. Close to Tenochtitlán was the city of Tlaxcala, which was never conquered and with which there was a tradition of ceremonial warfare. The Tlaxcalans became major allies of Cortés and helped destroy the Aztec empire.

Cortés tried to explain to the Spanish emperor Charles V that he had to destroy Tenochtitlán in order to conquer it. He had to destroy the city step by step, he wrote, until it was razed to the ground, because the defenders were undaunted by superior force. Over the ruins of the center of Tenochtitlán, the modern colonial settlement of Mexico City was built. The lake was drained. The main square (Zocalo), cathedral, and national palace occupy the site of the ancient center. Excavations and repairs in these areas continue to bring to light sculptures and artefacts; the main Aztec temple (known as the Temple Mayor) has recently been excavated and restored.

With the exception of the much-ravaged main temple, Tenochtitlán can be visited only in the imagination, with the help of sixteenth-century guides, such as the friar Bernardino de Sahagún (1499–1590), whose works are indispensable (FIG. 57). The central temple precinct consisted of a number of temples, including a twin pyramid dedicated to the patron god Huitzilopochtli and the water deity Tlaloc. The Aztecs saw Tlaloc as the ancient fertility deity associated with settled farmers and Huitzilopochtli as their god of nomadic origin. The concept of the twin pyramid was new among the Aztecs and their neighbors and suggests that the Nahuatl-speaking conquerors of the Valley of Mexico sought consciously to unite the old and new cultural elements – yet to keep them separate. It is evident from contemporary texts that the Aztecs were insecure in their role as outsiders and conquerors. Moreover, all about them they saw the magnificent ruins

of ancient civilizations such as Teotihuacan, Tula, Chalcatzingo, and Xochicalco. Doubtless aware of the challenge of the past, they emulated it nonetheless. While in architecture they were restricted by space and resources, in sculpture they hoped to rival or outdo past achievements.

In the Postclassic period only a few sites had monumental art, most significantly the early Postclassic (AD 900–1300) sites of Chichén Itzá and Tula. These centers were historically related, in a way that is indeterminate. The relationship is evident in the sculpture and architecture, some of which is remarkably similar. Chichén Itzá spanned the late Classic and early Postclassic times. Itzá culture was both eclectic and extremely innovative, reviving three-dimensional sculpture, which had been infrequently made since Olmec times, as architectural furniture. Images of standard bearers were built into stairways, serpents became columns in door-

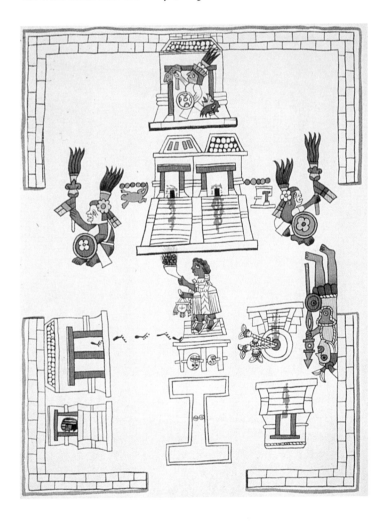

57. Main Aztec temple at Tenochtitlán from Bernardino de Sahagún's *Primeros Memoriales*, 1559–61. European paper. Real Casa, Patrimonio Nacional, Palacio Real, Madrid.

This is one of the two surviving sketches of the temple center.

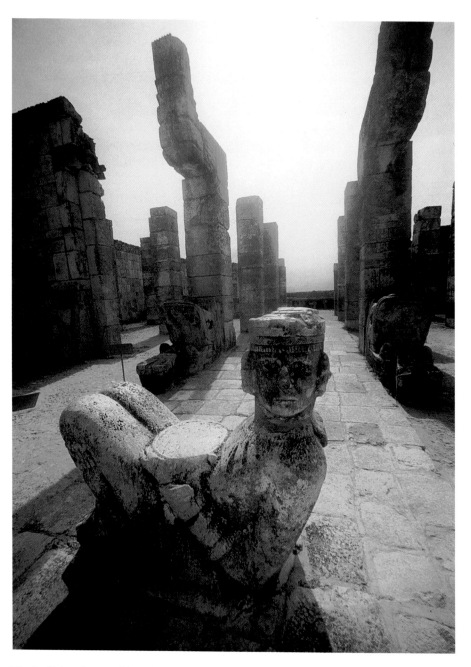

58. Reclining *chac mool* from the Temple of the Warriors, Chichén Itzá, Mexico, 800–1000. Limestone, height 3′7″ (1.1 m).

The term *chac mool*, meaning "Red Jaguar" or "Jaguar King" in Maya, was given to the first of this type of sculpture found by Augustus Le Plongeon in 1875 at Chichén Itzá. He had concocted a fantastic story of the adventures of "Chacmool" and his "Queen Moo." In fact, there are many *chac mools*, which are pieces of ritual furniture or altars. Offerings of incense or hearts were placed in the dish on the stomach area.

ways, atlantids held benches in temple rooms, and the famous reclining *chac mools*, perhaps as offering altars, lay in front of doorways (FIG. 58; compare with FIG.4). The sculpted humans were not specific lords or deities; they seemed to be a kind of everyman, often in military dress, performing services. Nonetheless, they are large and dramatic human representations, and they continue the focus on the human that is characteristic of the art of Mesoamerica. Although the art of Tula (900–1200) is cruder in execution, grace, and finish than that of Chichén Itzá, it is otherwise remarkably similar (FIG. 59).

It is unlikely that the Aztecs were familiar with Chichén Itzá, which was outside the borders of the Aztec empire, but they idealized Tula as the place where civilization had had a golden age. They excavated in the ruins and brought some sculptures to Tenochtitlán. When they embarked on imperial expansion and their program of building monuments, they began by imitating the sculptures of Tula. The Templo Mayor excavations brought to light a Tula-style *chac mool* (not illustrated here) set in the doorway on the Tlaloc side of one of the earliest twin pyramids, still with its original colors. (All Pre-Columbian sculpture was painted in bright colors like the murals and codices.) In less

59. Reclining *chac mool*, from Tula, Mexico, 900–1200. Basalt, height 26″ (66 cm).

A sacrificial knife is strapped to the arm of the figure.

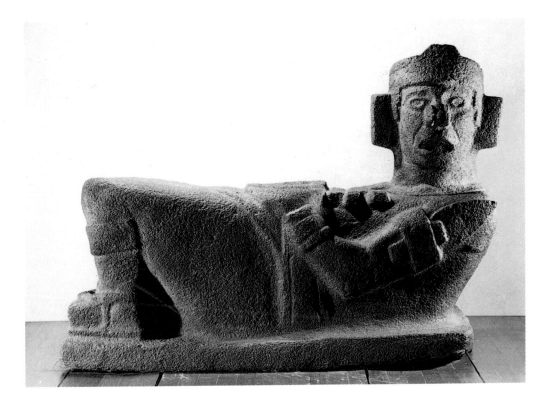

than fifty years, Aztec patrons and sculptors transformed this crude style into a rich and unique tradition. A later *chac mool* illustrates that Aztec art evolved towards greater naturalism in the modeling of the body and the development of complex iconographic detail. This *chac mool* carries a sacrificial vessel and wears the eye goggles characteristic of Tlaloc (FIG. 60). That he is an "old" deity is also indicated by the fact that he wears a necklace with an heirloom pendant, of the kind the Aztecs collected and buried as offerings in the Templo Mayor.

Many iconographic designs came from the Mixteca–Puebla-style codices. Two large cylindrical stones are known with conquest scenes of the rulers Montezuma I and Tizoc (FIG. 61), shown holding the hair of a conquered warrior and with a place glyph indicating the city from which he comes. This looks exactly like a codex page carved into stone and conforms with the southern tradition of the ruler as conquering hero. By cleaving to the Tula and Mixteca–Puebla traditions the Aztecs participated fully in an art that focused on man, celebrating both his impressive physical body and his actions. Aztec rulers are also sometimes

60. Aztec rain god *chac mool*, from Tenochtitlán, Mexico, c. 1502–20. Basalt, 21¼ x 30¾″ (54 x 78 cm). Museo Nacional de Antropología, Mexico City.

The figure holds a sacrificial vessel bordered by hearts.

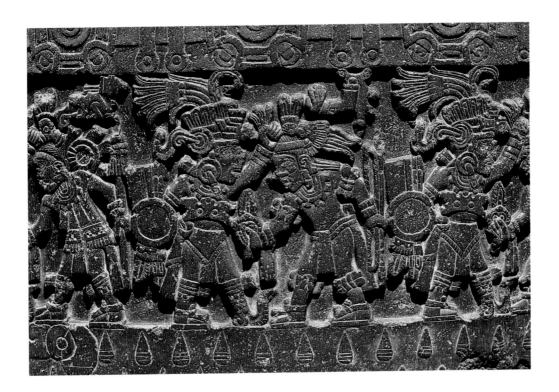

portrayed in the act of drawing blood from their ear or leg, as on the Dedication Stone and the Temple Stone. These images are accompanied by glyphs such as the names of the rulers near their faces. Writing provides dynastic legitimacy.

Important as these Aztec rulers are – they even had their portraits carved into the cliffs of Chapultepec – their images are puny in comparison to those of a few colossal and terrifying women. One is a naked, dismembered woman carved on a stone ten feet (three meters) across at the foot of the Huitzilopochtli temple (FIG. 62). The others are decapitated women with bared breasts and wearing skirts of serpents or hearts. Each woman is both a victim and a monster, a creator and a destroyer. These figures were not derived from earlier art, but from the Aztecs' own legends and preoccupations. The Mexica, rulers of Tenochtitlán (who used the name to distinguish themselves from the other Aztecs), created images around their patron, Huitzilopochtli. In the myth of his miraculous birth, it is, strangely enough, not Huitzilopochtli who is represented, but the women.

According to this myth an elderly woman called Coatlicue (Serpent Skirt) was sweeping a temple courtyard when she picked up a piece of down and put it in her bodice. She became miraculously pregnant, whereupon her daughter, Coyolxauhqui (She

61. Aztec conquest scene, Stone of Tizoc, from Tenochtitlán, Mexico, 1481–86 (detail). Basalt, 35½ x 106¼" (90 x 270 cm). Museo Nacional de Antropología, Mexico City.

The ruler Tizoc is shown fifteen times grasping the hair of a conquered victim. A glyph to the right of each victim indicates the name of his city. In this detail, the conquered figure in the center is from Acolhuacan.

62. Aztec oval relief of Coyolxauhqui (She of the Golden Bells), from Templo Mayor, Tenochtitlán, Mexico, possibly 1469. Stone, diameter 10'10" (3.3 m). Museo del Templo Mayor, Mexico City.

The discovery of this relief in 1971 during electrical work near the Cathedral led to the excavation of the Templo Mayor which proved to contain more than six thousand offerings.

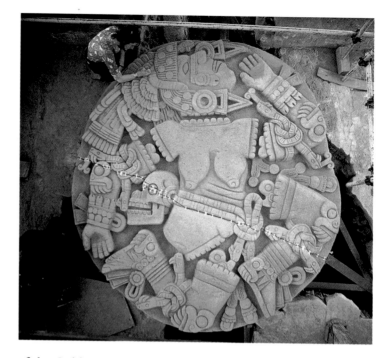

of the Golden Bells) and her four hundred sons planned to kill her. However, Huitzilopochtli emerged from her womb fully dressed for war, chased away the four hundred sons and cut off the head of his sister. This myth is usually interpreted cyclically in a very Mesoamerican sense: Huitzilopochtli is the sun being born from the earth at dawn; he must fight a battle with the forces of darkness, then he must scatter the stars (the brothers) and get rid of the moon (the sister).

The story also has a political aspect: it represents the legitimate birth of Huitzilopochtli and the conquest of his enemies. The presence of the sculpture of a colossal woman cut in pieces at the foot of the temple must have been a graphic warning of what would happen to the enemies of Huitzilopochtli and, by extension, of the Aztecs. It is a cautionary and horrifying image. It is of course significant that the "enemy" is represented as a woman, with the possible implication that the enemies of the Mexica will not only be vanquished, but that they resemble "women" in the pejorative sense. Yet the woman in the myth was once powerful and threatening, and even in her death, represented in stone at the Templo Mayor, she is the biggest sculpture. The conclusion must be that the Aztec view of women was highly ambivalent.

Another terrifying image capable of multiple interpretations is the sculpture of Coatlicue, the mother of Huitzilopochtli (FIG. 63). Head and feet are cut off. Serpent heads both repre-

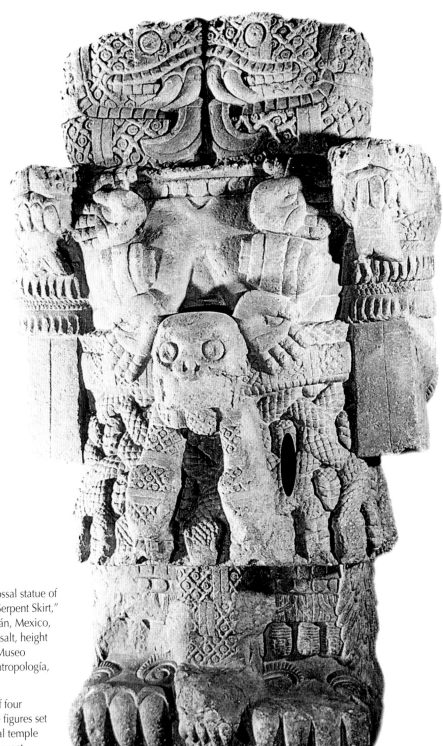

63. Aztec colossal statue of Coatlicue, or "Serpent Skirt," from Tenochtitlán, Mexico, 1487–1520. Basalt, height 11'6" (3.5 m). Museo Nacional de Antropología, Mexico City.

This was one of four colossal female figures set up in the central temple precinct. Their exact locations are not known.

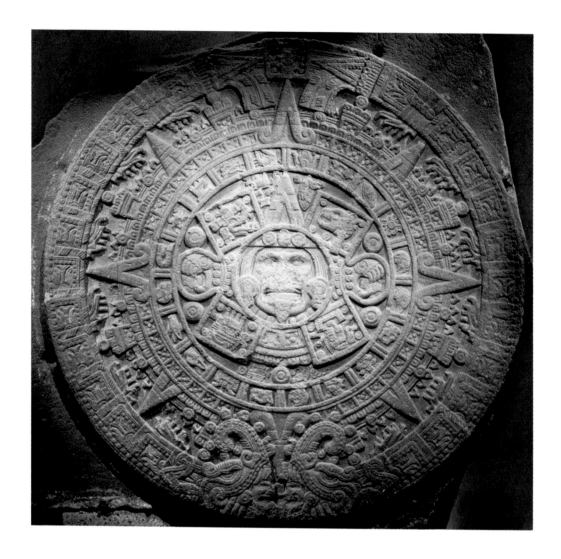

sent the blood and create a substitute face and hands. Her bare breast is surrounded by a necklace of hearts and hands. Although as mother she is the victim and nurturer, she is also a conglomeration of threatening symbols. Because of the fully rounded three-dimensionality and the realism of the details, the juxtapositions of the good and the cruel are bizarre and striking. Originally four such large sculptures existed.

The Aztecs developed a double strategy in which they honored their rulers but made them secondary to the powers of the cosmos, which they imagined as horrible and violent and, in a number of cases, female. It is well known that the Aztecs justified their sacrifices to the Spanish by explaining that they were living in the fifth and last of world eras, the last four of which

had been destroyed. Their own era was also to be destroyed by earthquake on the date 4 Movement. The sacrifices were intended to keep the world itself from being destroyed too. They claimed that at midnight after the destruction of an era terrifying female monsters descended to earth to devour its inhabitants. Coyolxauhqui and Coatlicue are aspects of such devouring females. The images carry extraordinary emotional power.

The same theme of the sun and its destruction exists on the famous Calendar Stone, but here it appears in the guise of a pragmatic chart, rather than as a deeply felt image (FIG. 64). The central image represents the date 4 Movement with the face of the sun in the earth or perhaps the earth itself. It is surrounded by symbols of the four previous destructions of the world. The myth of the five eras is not unique to the Aztecs but was shared by most Mesoamerican cultures and is part of their preoccupation with time and the calendar. No one chose to make an artistic representation of the myth, however, until the Aztec Mexica. On this monument they effectively claimed time for themselves. By putting the glyphs of Montezuma II and the date of the beginning of their migrations in small spaces on the wheel, they were in a sense claiming that they, the Aztecs, were maintaining the universe and creating the last human era.

Still stronger evidence exists on a stone in the shape of the temple that may come from Montezuma's palace and was perhaps a throne (FIG. 65). On the back there is a sun disk similar to that on the Calendar Stone, with Montezuma II on one side and Huitzilopochtli on the other, holding the implements for drawing blood. The human figures are small, while the solar emblem is big and central. The human figures, seen in profile, convey a

Opposite

64. The Calendar Stone, from Tenochtitlán, Mexico, 1502–20. Stone, diameter 11′10″ (3.6 m). Museo Nacional de Antropología, Mexico City.

The Calendar Stone is a complex design of various historical and cosmic glyphs. Representations of the four previous eras (in square frames) that have been destroyed are shown surrounding the fifth, current era (in the centre), which is destined to end in an earthquake. The day signs of the calendar ring the cosmic eras. Also included are glyphs important in Aztec history and the name glyph of Montezuma II. The reading of the glyphs may suggest that the current cosmic era is supported by the Aztec state.

65. The Temple Stone, front view, probably originally from Montezuma's palace, Tenochtitlán, Mexico, 1502–20 (detail). Basalt, 47¼ x 36¼ x 39″ (120 x 92 x 99 cm). Museo Nacional de Antropología, mexico City.

Montezuma II on the right and probably the patron war god Huitzilopochtli on the left hold bloodletting instruments and face a solar disk design similar to that of the Calendar Stone. Priests, rulers and the elite drew blood from the ear, leg, or penis as offerings to the gods.

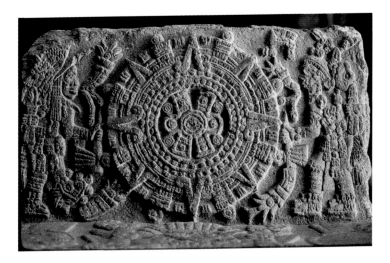

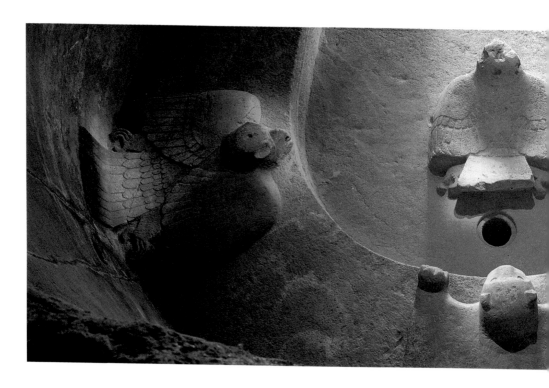

66. Aztec temple interior, Malinalco, Mexico, fifteenth century.

The eagle and jaguar pelts carved inside the rock-cut temple of
Malinalco give some idea of the look of Aztec architecture, with its
large, three-dimensional sculptures.

67. Underside of coiled serpent, from
Tlalpan, Mexico, 1400–1521. Porphyry,
height 7″ (18.3 cm), diameter 24″
(60.6 cm). Dumbarton Oaks
Research Library and
Collection, Washington,
D.C.

The complex scales on the
underside of the serpent
came as a surprise
compared with the simple
upper half. Undersides
were sometimes carefully
carved because the design was
believed to be in communication
with the earth it rested on.

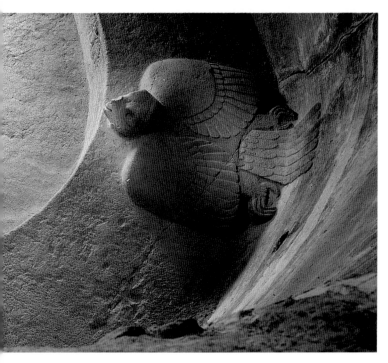

sense of penitence and servitude: the Aztec rulers are presented as dynastically important, yet at the same time as servants of the cosmos. While some of this is reminiscent of Teotihuacan, the cosmos there was represented as a benevolent, giving entity, whereas here it is threatening and destructive. Such messages may have been attempts to project power by the insecure Aztec state.

Not all Aztec images were terrifying. There were many sculptures of deities, figures, and animals in which beautiful curving shapes and simple meta-

68. Coiled serpent, from Tlalpan, Mexico, 1400–1521. Porphyry, height 7″ (18.3 cm), diameter 24″ (60.6 cm). Dumbarton Oaks Research Library and Collection, Washington, D.C.

phors were emphasized (FIG. 66). Even the rattlesnake, a symbol of predatory forces, could be represented as a series of neatly arranged, bulging forms, with an exquisitely carved underside of overlapping scales (FIGS 67 and 68). Many Aztec images were carved on the bottom with images of the earth as a monster, but this iconographically simple but esthetically complex design is a beautiful variation of that practice.

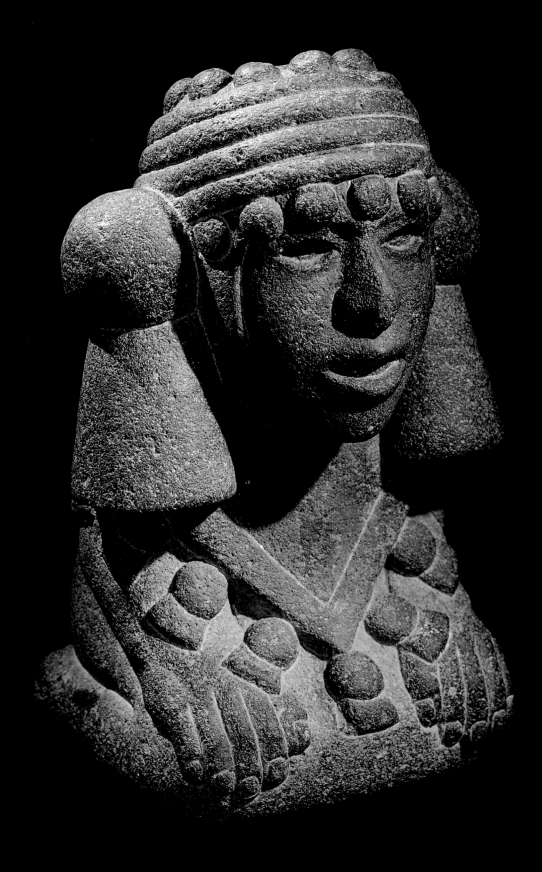

Women too could be beautiful and non-threatening, as in the image of the kneeling water goddess whose demure behavior was the Aztec ideal of proper womanhood (FIG. 69). Small sculptures of gods such as Tlaloc (the rain god), Ehecatl (the wind god), Chalchiuhtlicue (the water goddess), and Chicomecoatl (the maize god) were likewise non-threatening images, made for regional temples and shrines in great numbers. These were the figures with which most Aztecs would have been particularly familiar. The frightening images were intended for the Templo Mayor and the main temples as public statements. Other cults and activities required different types of images. Aztec culture was sufficiently rich and diverse to encompass many artistic variants. Nor was all elite Aztec culture concerned only with violence and power. According to sixteenth-century sources, aristocratic men were given to writing philosophical poetry. Further down the social scale and away from the center, the images become increasingly benign. The art of the rural villagers consisted mainly of female figurines with children in their arms, like the ones made at Tlatilco more than two thousand years earlier.

69. Aztec water goddess, from Mexico, 1400–1521. Basalt, height 12″ (30 cm). Museum für Völkerkunde, Basel.

This goddess represents the Aztec ideal of a modest female beauty.

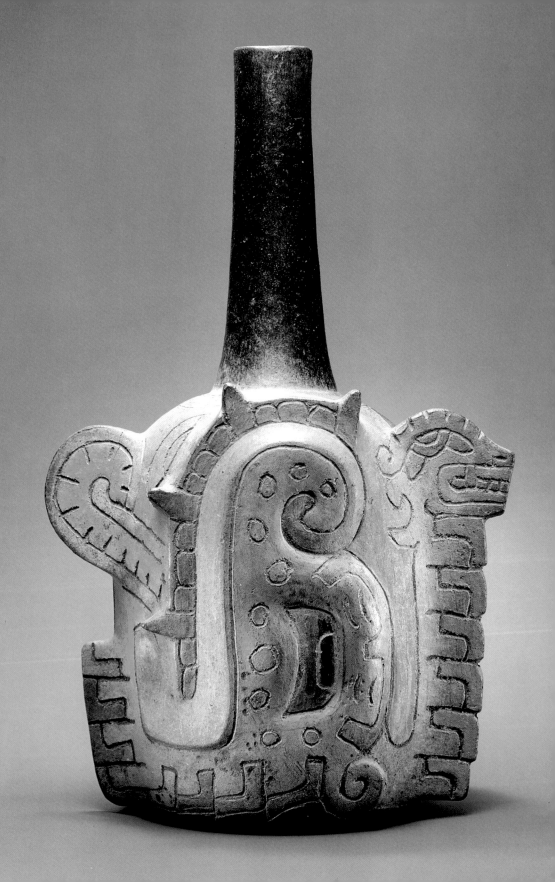

FOUR

The Andes: Cosmic Order in Space

70. Chavín-style vessel from Tembladera, Peru, showing a serpent head, 400–200 BC. Dark ceramic with resin paint, height 13″ (32.5 cm). The Metropolitan Museum of Art, New York.

All early Andean pottery is reduction-fired at low temperatures with little ventilation. This causes the carbon from the fire to combine with the clay so that the vessel becomes dark in color.

It was the natural richness of the ocean off the coast of Peru that provided the wealth on which the early monument-building centers of the Andes were based (FIG. 71). While the coast of Peru is desert, the ocean teems with fish in the cold Humboldt current. Consequently, the first areas to be richly settled were the coasts. Once irrigation agriculture was introduced in the fertile river valleys of the coast, a series of major cultural centers began to grow up. By contrast, the highland areas were populated by poorer potato farmers and llama and alpaca herders, whose trading caravans criss-crossed the area after 500 BC. The wool of the highlands was essential for textiles. One abundant resource in the highlands was stone: as a result, a great deal of art and architecture was made out of stone and this has been well preserved. The splendors of the coastal settlements are hard to imagine because the adobe (unbaked brick) used is often eroded or buried under sand drifts. The largest empires that attempted to unify the coast and the highlands in Peru originated in the highlands.

While the surviving art of Peru covers the same time span as art in Mesoamerica (c. 2500 BC–AD 1500), differences appear at the very first instance, and they remain throughout history. A good example of these differences are the clay figurines. Clay figurines, perhaps of Ecuadorian or Central American origin, found their way to Mesoamerica along with pottery and were one of the major types of ritual objects made from the Preclassic to the Postclassic periods. Such figurines were also introduced into Peru, but had no impact. The area had its own interests and those did not

71. Map of the Andean
area showing sites
mentioned in the text.

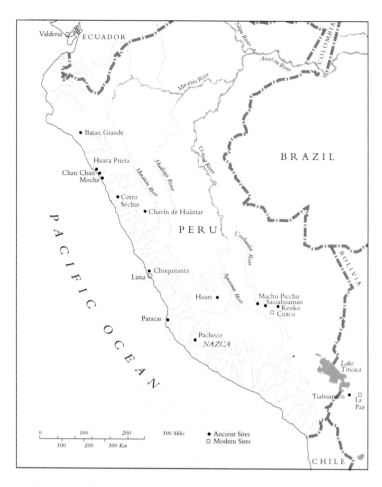

reside primarily in the representation of human images emphasizing the individual.

The history of Andean art is divided into periods of pan-Peruvian contacts and periods of regional isolation. The earliest periods with art and architecture are the Preceramic (3000–2000 BC)
and Initial (2000–1000 BC) periods. These are followed by the Early
Horizon (1000–200 BC), associated with the Chavín de Huántar
presumed religious cult (discussed in the next section). The empires
of the Andes, Tiahuanaco, and Huari, of the Middle Horizon (AD
600–1000), and the Inca, of the Late Horizon (AD 1400–1532), alternate with the regional diversity of the Early and Late Intermediate periods. As there are no dated monuments in the Andes,
all dates are archaeological and approximate.

Settled habitation and monumental architecture in the Andes
began before the introduction of pottery, and even before primary
dependence on agriculture in the Preceramic period. Some architectural complexes such as the mounds and rooms of Aspero (c.

2500 BC; seventeen mounds) or El Paraiso (c. 1750 BC; thirteen mounds) suggest the use of communal labor. At the time of the Inca, before the Spanish conquest, the state taxed people in labor rather than in goods. This system of labor taxation was called *mita* by the Inca and was the backbone of the state. There is evidence for a similar type of communal labor organization as early as the Preceramic period. Tasks were shared out: men built buildings, roads, and bridges, women spun and wove. Communal architectural projects can often be identified today by the visible differences in wall sections built by different groups of men.

Huaca Prieta was probably a typical Preceramic village on the north coast of Peru (2600–2300 BC). The inhabitants lived on the abundant shellfish, the shells of which they threw out in a ring around the village, making a big mound. Several finds in that garbage pile have proved to be very important. Huaca Prieta had neither pottery nor maize, but people grew cotton and gourds. It has been possible to reconstruct the designs of some of the two hundred textile fragments found, and a small number of the gourds were carved with designs.

Textiles were at all times one of the most important arts of the Andes, and it is significant that cotton was grown as early as 3500 BC (FIG. 72). Yarn itself had symbolic meaning. On his head, the Inca ruler wore not a gold crown but a fringe of red yarn; and, as has already been pointed out, the Andean recording device was not a book but a knotted string. Cotton was grown

72. Peruvian condor, from Huaca Prieta, c. 2000 BC. Cotton textile, length 8½" (21.6 cm). American Museum of Natural History, New York.

In this figure a snake is curled up on the chest of a condor. Thousands of textiles were found at this Preceramic site, about 200 of them with designs.

on the coast and wool came from the llama and alpaca of the high-lands. Interaction between the areas was a prerequisite for the development of the great textile traditions, which used both cotton and wool together. Cotton, which is sturdy, was often used for the warp, and wool, which can be dyed in brighter colors, was often used to create complex patterns in the weft.

As the making of textiles was one of the earliest and most fundamental of Andean arts, it is worth noting a few of its features. Unlike carving or modeling in clay, wood, or stone, in which shapes can be adjusted in the course of their making, textiles have to be visualized before they are woven and their forms and designs cannot easily be changed afterwards. In a simple textile a set of warp yarns is laid out; then weft yarns are woven over and under the warps to create the cloth and incorporate the designs. The yarns have to be counted and the design worked out in advance. Because warp and weft are at right angles to one another, most woven designs are angular and curved forms are hard to create. Textiles permit the expression of a highly structured, systematic, and conceptual point of view.

There were no markets in the Andes by which the exchange of products from different environmental regions could be organized. Various localities set up real or fictitious kinship relations with communities with whom they exchanged goods. A coastal village might have a highland "kin" community to get its wool yarn, and a tropical forest "kin" community to get colorful bird feathers or exotic medicines. This exchange system based on altitude has been termed the "principle of verticality." The later empires such as the Inca maintained and exploited this system and controlled it from the top. The Andean metaphor for existence was the kinship web rather than cyclical conflict. In art, the web was laid out spatially and its temporal dimension was secondary in importance. Later empires were to build road systems, which were metaphoric webs turned into reality.

Most of the designs on the Huaca Prieta textiles are animals – shore birds, marine life, or the condor. Rarely there is a human figure, represented frontally and turned into a geometric image like a robot. Occasionally there are predatory animals such as snakes or other birds of prey. Each creature is clearly laid out on a flat ground, as in a heraldic design. There is nothing to suggest deities or a complex iconography. The emphasis on birds and marine creatures suggests the bounty of the sea and a benign view of the universe.

It is still uncertain whether the carved gourds found at Huaca Prieta were made there or imported (FIG. 73). The designs of those

rigidly square faces and human figures are important in that they indicate that severe stylization and angularity of form were not just a function of the constraints of the weaving process, but a deliberate cultural and artistic choice. The design of the gourds is stylistically consistent with the textiles and indicates a preference for two-dimensional surfaces with highly abstract images.

73. Designs from carved gourds, from Huaca Prieta, Peru, 2600–2300 BC. Gourd, height 2" (5.4 cm). American Museum of Natural History, New York.

Some scholars believe that these decorated gourds were imported from Ecuador.

Chavín de Huántar: A Metaphysical Synthesis

Contemporaneously with the Olmec in Mesoamerica (c. 1500 BC), an image system developed on the Peruvian coast in which there was a predominance of deities in human form, with fangs and claws, and carnivorous animals. It seems very likely that these were metaphors for power. They are found on the adobe structures of the early temple and civic centers such as Huaca de los Reyes at Caballo Muerto on the north coast and on small portable works. Unfortunately, these centers are so poorly preserved or so little excavated that the complete programs and meanings cannot be reconstructed.

Chavín de Huántar is a late synthesis of many of these ideas at a central highland site, where the carvings are well preserved in stone. Moreover, it has been interpreted, quite convincingly, as a sacred center: an oracle. It may even be that, as in Inca times, the oracle had "branches" in different parts of the

74. The "Lanzón" sculpture, set in the old Temple at Chavín de Huántar, Peru, 400–200 BC. Stone, height 14'9" (4.5 m).

Placed at the end of a long, dark gallery, this remarkably large sculpture probably functioned as an oracle, with the priest speaking from a hidden chamber.

Andes – conceived, no doubt, in kinship terms, as the wives, siblings, or children of the main deity. Chavín de Huántar may thus represent a religious cult and forerunner of the expansionist political processes evident in the highlands.

The original site and its reconstruction have been devastated by earthquakes and landslides. There was one large masonry construction honeycombed with mysterious, torchlit interior galleries. In the back room of one of these there is a sculpture still in its original place, where a priest, hiding in the passages nearby, could speak in the god's name. The image itself is remarkable for its crudity. A naturally wedge-shaped stone, known as the "Lanzón," is set into the floor at one end and into the ceiling at the other (FIG. 74). In that dimly lit spot it must have been hard ever to see that on it, in relief, was carved a human figure with fangs in its mouth. It may well be that the rock was sacred before it was carved, and that its original form was not seriously changed in the carving. In comparison, the sculptures outside, in the various entry areas and façade of the temple, are precisely and exquisitely made. The roughness of the "Lanzón" is therefore intentional; this suggests that one way of representing the sacred was to leave the material close to its natural form.

Chavín de Huántar consisted of hidden interior rooms for the most sacred images and rites, sunken courtyards with beautifully carved plaques as exterior gathering areas, and gateways or doorways in between. The layout of many Andean sites is linear, with open rooms and courts followed by increasingly restricted areas. (The long row of rooms at Las Haldas, c. 1700 BC, is a particularly good example of this type of arrangement.) The plaques in the sunken courts represent raptorial birds and felines, as well as various versions of the fanged human being, who may be the central deity.

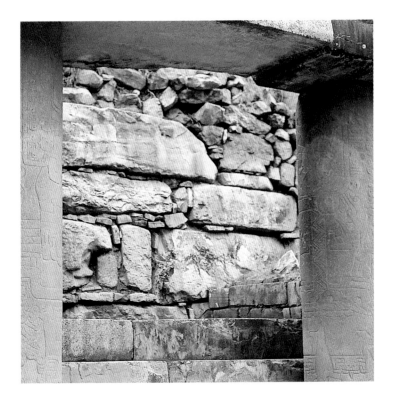

75. A view of the Black and White Portal of the New Temple at Chavín de Huántar, Peru, 400–200 BC. Light and dark granite.

The columns in the doorway are incised with the winged beings shown in FIGS 76 and 77, representing the totality of the cosmos and divided into male and female halves.

76. Rubbing of the north column of the Black and White Portal, showing a male figure with a hawk mask, Chavín de Huántar, Peru, 400–200 BC. Stone, height 7'5" x 6'3" (2.27 x 1.9 m).

The surviving gateway at Chavín de Huántar is the Black and White Portal, so called because it is carved from two colors of granite (FIGS 75 and 76). The Andeans had an appreciation of the esthetic of natural stone colors and imputed symbolism to the stones. Many of the carefully carved birds and felines were on the undersides of lintels and cornices, where they could not be seen in detail. Even the dark granite columns of the Black and White Portal were incised with figures, which, because they are on a vertical cylindrical surface, half of which is invisible because it is set into a doorway, are known only thanks to a modern drawing; evidently visibility was never important.

At first, the two winged beings holding staffs look identical. Each has a human face with fangs and a bird's beak protruding in front of it as if it were a mask. The stylistic layout of the figure

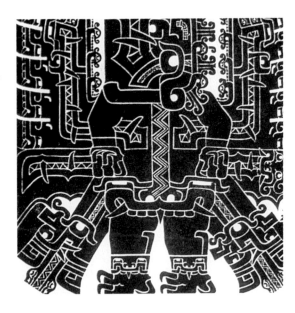

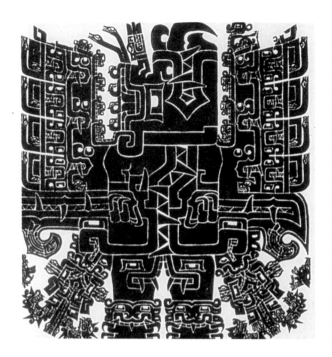

77. Rubbing of the south column of the Black and White Portal, showing a female figure with an eagle mask, Chavín de Huántar, Peru, 400–200 BC. Stone, 7'5" x 6'2_" (2.27 x 1.89 m).

The genitalia of both figures are shown metaphorically by masks, mouths, and fangs.

is very similar to the human figure of a Huaca Prieta textile, except for the various iconographic complications. It is impossible to determine whether this personage is a spirit or a human dressed as a spirit. However, the faces are in profile and the figures are winged, which elsewhere in Andean art signifies that they are attendants. Moreover, there are two of them, flanking the entrance, thus suggesting a position of "guarding" or "guiding" but not of being central images. It has recently been suggested that these "angel" figures are male and female. In one the fanged design on the torso divides it into two, suggesting a vagina, and in the other the fang of a mask hangs in a phallic position (FIG. 77). While these details may seem minor or questionable, male/female divisions recur in Chavín art frequently enough to support the validity of this thesis. The Andean emphasis on gateways indicates the importance of restricted access and of marking the very position of access by sacred imagery. The male/female duality of the "guards" is a reference to the totality of the universe, which in Andean thought is divided into male and female halves, like *yin* and *yang*.

Dual divisions in the Andes were also common in the communities, which were divided into two sections, called "moieties" by anthropologists. These were usually unequal, and referred to as "upper" and "lower." The populations of communities belonged to one or the other, with as little equivocation as adherence to the gender of one's birth. This practice of a dual division always implied competition, complementarity, and reciprocity.

Almost all the art of Chavín de Huántar is relief. The design is cut into the stone like a drawing or engraving and the background is cut away to allow it to stand out. There is, however, no modeling, no attempt to represent the figure in the round. The approach is entirely two-dimensional as on a textile. It is very likely that, like pottery vessels and later textiles, some or all parts of the sculptures were painted. There seems to be little deviation from the angular-human prototype, who is interesting only as the basis for added elements. One figure, known as the "Smiling God"

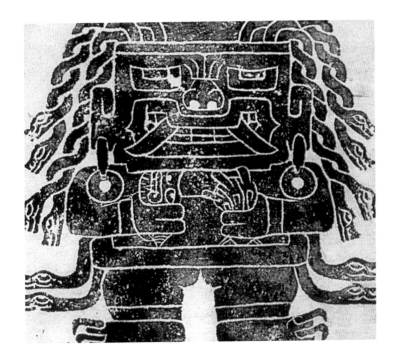

78. Rubbing of a smiling figure from the patio of the New Temple, Chavín de Huántar, Peru, 400–200 BC. Stone, 21 x 23" (53 x 58 cm).

Snakes for hair and the belt indicate that the figure is a supernatural. The shells he holds are types that come from the waters off the coast of Ecuador.

because of its upturned mouth, is relatively simple (FIG. 78). The body is divided into horizontal and vertical lines, which render it abstract and immediately comprehensible. The coiled snakes forming the hair are usually interpreted as a visual metaphor, meaning simply that the hair is like snakes. On various animals fur is also "like snakes." Another frequent visual metaphor is the mask-like, fanged face of the being. On the Black and White Portal each feather of the wing emerges from such a face. Sometimes the face is reduced to a band consisting of the mouth with its fangs, and it stands for anything from the backbone to a belt. When the details of Chavín art are interpreted in terms of these visual metaphors, it becomes evident that it is a highly organized system, without haphazard or idiosyncratic details. Everything has its place in the universe of meaning.

The "Smiling God" with the snake hair clutches two shells to its chest. One of them is a strombus conch shell, and the other is a bivalve shell. Each has a little face. Chavín de Huántar is in the north central highlands of Peru, nowhere near the ocean. These types of shells come from the coast, perhaps from as far away as Ecuador, whence the most prized shells were imported. Other items represented in Chavín art that were not indigenous to the highlands were a number of plants and animals such as cacti, which grow mostly on the coast. The jaguar, whose fangs are on the deity faces, is an animal of the tropical forest. The condor, which is

79. Drawing of the Tello Obelisk, Chavín de Huántar, Peru, 400–200 BC. Stone, height 8'3½" (2.53 m). Museo Nacional de Antropología, Arqueología y Historía, Lima.

A male and female caiman, possibly divinities in an origin myth, are shown with tropical plants such as manioc.

the most important raptorial bird represented in art, is from the highlands. Thus the major images of Chavín de Huántar bring together elements of the four major ecological zones: the ocean, the coast, the highlands, and the tropical forest. Chavín de Huántar appears to have presented itself and its cult as pan-Andean. While we cannot "read" the images more precisely, each one seems to be a total-izing and universalizing statement framed in the form of dual oppositions: male/female, more sacred/less sacred, ocean/desert, moun-tain/forest.

Many of these elements come together in the Tello Obelisk, a stone rather like the "Lanzón" and probably once very impor-tant (FIG. 79). Its original location is unknown. Like the "Lanzón," the stone carved on all four sides is very difficult to see and to "read." It seems to contain the entire cos-mic philosophy of the oracle center. There are apparently two caymans back to back, in reality two halves of one cayman. The cayman is a tropical forest creature of the headwaters of the Amazon. Gender is again indicated metaphorically. The male cayman or half has a serpent head ending in a stream or flowery branch to represent the genitals. The female cayman or half has a seed pod. Note that in the "Smiling God" relief the conch shell can be seen as male and the bivalve as female. On the Tello Obelisk a conch shell is on the male side next to the flowery branch. The caymans are associated with a wide variety of typical tropical forest plants, such as manioc. They hold them in their claws. This creature may rep-resent myths about the origin of plants. Its cosmic nature is also evident from the fact that the other important beings in Chavín art – the raptorial bird and the feline – are near the heads of the caymans. This one sculpture brings together all the elements seen separately in the others.

Chavín art does not deal with the world of men and women. Its subject is the cosmos, represented by plants and animals and supernaturals. Uniquely systemic and synthetic, Chavín art had

a universalizing concept of the sacred, presumably to be of value outside of its own domain. As an oracle cult center for many different polities, Chavín presented itself as a place of synthesis. It may have created great gods and a supporting mythology based on the harmony of different but complementary units and facets of life.

Paracas/Nazca: Variations on a Theme

Chavín-style objects are found throughout the Andes, no doubt because some elements of Chavín style and iconography spread through "branch" oracles or through elite objects that were eventually buried with the dead. The basic forms were modified by later cultures. Textiles and pottery vessels have also been found on the south coast with Chavín designs and features, such as the emphasis on two-dimensional imagery of supernatural beings (see FIG. 70 and FIG. 80). Nevertheless there are significant differences in the south coast cultures of Paracas and Nazca (1000–200 BC and 200 BC–AD 600). The major supernatural form depicted on pottery is not a fanged human being but a monkey-like creature with circular eyes, a wide grin, and a long tongue. Whether this being is on Paracas- or Nazca-style vessels the subject is the same: headhunting. On some Nazca vessels the deity seems to be sucking the spirit out of the mouth of a whole human victim (FIG. 81). On some vessels the victim is indicated by a head, a lock of hair, or only by the headhunting knife. In a number of burials in the south coast the bodies were found without heads, sometimes with pottery heads substituted for the real ones, proof of the practice of taking heads as trophies. This subject is common in the art of most of the Andes, but especially so in the south coast.

Wherever headhunting has been practiced in the world, certain features of it are contextually and symbolically similar. Headhunting is usually found in areas where many small groups live in proximity to one another in a situation of organized hostility. Instead of

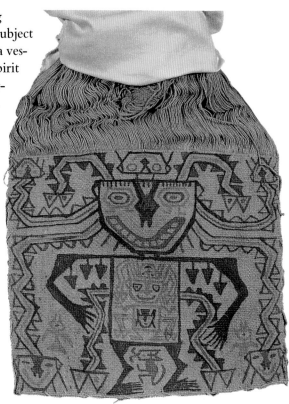

80. Paracas-Cavernas style painted textile mask from a mummy bundle, 400–200 BC. Cotton with brown paint, 9½ x 11" (24.5 x 28.2 cm). Textile Museum, Washington, D.C.

Long appendages and a grinning mouth characterize these supernaturals.

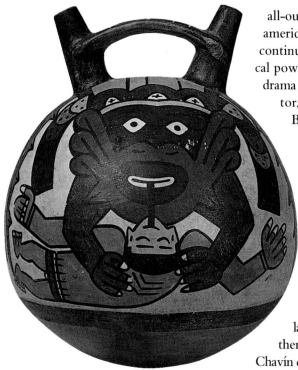

all-out warfare or even "conquest" in the Meso-american sense of the term, there is limited but continuous conflict that does not change political powers or territories. Conflict is not seen as a drama in human terms, with a victim and a victor, but in terms of its cosmic justification.

By taking the head of a person, in which all his powers and energy reside, one group removes that power store from their enemies and adds it to their own. Captured heads are usually believed to enhance the fertility of nature as well as that of man. A sequence is imagined in which energy passes between plants, animals, living humans, and deities via captured enemy heads.

The art of the south coast concentrates on depicting these cosmic interrelations, along with the headhunting that knits them together. Unlike the art of the oracle at Chavín de Huántar, which was the creation of priest-rulers with a coherent scheme of the universe in mind, the art of the south coast consists of endless variations on a theme made in a number of separate but interconnected centers. While the artists shared a general world view, their works are in detail endlessly variable, and the variations are as important as the system.

Preservation is good throughout the coastal region, especially in the south. The desert sands of the south coast are so dry that textiles, feathers, gourds, wooden objects, and mummified humans have been preserved. Perhaps this is why the tradition of elaborate burials was instituted in the first place. Moreover, the fact that the sand environment preserved objects dovetailed conveniently with the Andean concept of the afterworld, and may even have been the spur to the evolution of that concept. Insofar as some sixteenth-century texts refer to this specifically, the Andean afterworld was often regarded as a pleasant place in which the dead continued to enjoy an existence among family and friends. Cemeteries were built for the dead, in which, depending on the deceased's station in life, many goods were deposited. Burials were sometimes reopened for other offerings and rituals. This cult of the dead is very different from that in Mesoamerica. There, in most places, the dead were buried under the floors of their houses and not in special cemeteries. The afterworld to which they went had some unpleasant supernaturals and was not a good place. In Mesoamerica, the

81. Nazca-style double spout and bridge bottle, from the south coast of Peru, AD 200–400. Ceramic, 6 x 7¼" (15.2 x 18.4 cm). National Museum of the American Indian, New York.

This vessel is unusual in showing a whole human figure rather than just a trophy head. The transfer of energy is indicated by a line from mouth to mouth.

only life that really counted was life on earth. In the Andes, however, a great deal of time and energy went into the making of objects for funerary purposes to accompany the dead. Many of the textiles women spent years weaving and embroidering went into graves (FIG. 82). Some were deposited unfinished if the person for whom they were intended died unexpectedly (FIGS 83 and 84). Many useful objects, whether specifically made for burial or not, were placed with the dead; their removal from daily life necessitated the making of new objects.

In the highlands there was no such miraculous preservation. The bones of the dead were collected in round buildings without a great quantity of offerings. Some important people were not placed in a tomb but mummified and kept in a temple. At death

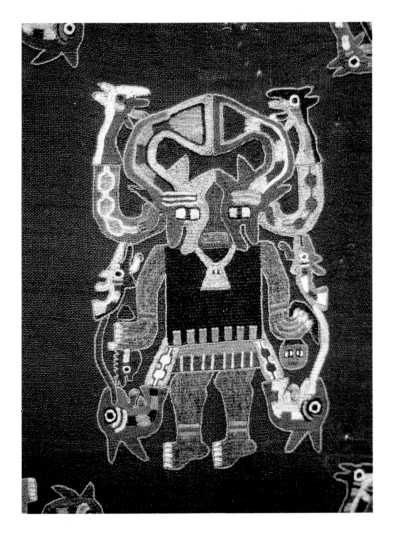

82. Paracas Necrópolis-style textile, from the south coast of Peru, 200 BC–AD 200 (detail). Wool and cotton yarns. Museo Nacional de Antropología y Historía, Lima.

Paracas embroiderers used a single stitch, the plain stitch, to create a variety of richly colored images, such as this figure with sharks on its face, holding a trophy in one hand and a knife in the other. The color scheme of each figure on the mantle varied.

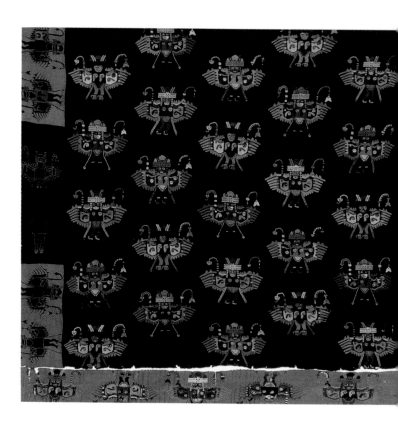

each Inca ruler, for example, was mummified and the mummy wrapped in textiles; it was brought out to be entertained at certain feasts and rituals. When the conquerors sentenced the last Inca ruler to die by being burned at the stake as a heretic, Atahuallpa pointed out that if his body was to disintegrate no mummy could survive and he could not continue his life in the afterworld and become an ancestor. He was therefore christened, whereafter his sentence was commuted to death by strangulation. As this historical event indicates, the prospect of the afterworld mattered to the living in this world. An enormous quantity of art work was buried, and material excavated from the graves is most familiar to scholars, although the exploration of sites indicates that similar textiles, pottery, and metalwork were also used by the elite in life (FIG. 85). Graves were the final repositories of the wealth of certain families.

In digging new graves Andeans often came upon old ones. Potters and weavers appear to have been fascinated by old objects and to have imitated them. Archaism is a pronounced feature of Andean art. Moche artists (200 BC–AD 600) imitated Chavín, Chimú artists (AD 1000–1470) imitated the Moche. The proximity and layering of the cemeteries made all this possible.

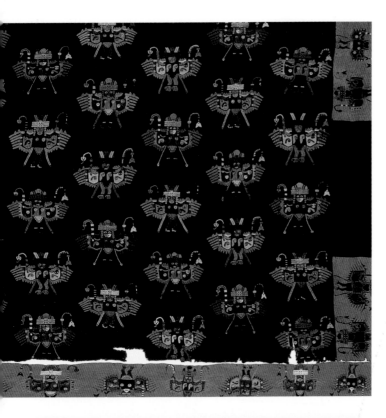

83. Paracas Necrópolis mantle, from the south coast of Peru, 200 BC–AD 200. Camelid fiber, 39¾ x 96¼" (101 x 244.3 cm). Museum of Fine Arts, Boston.

Mantles were worn like capes over loincloths and tunics in male attire. Often they were made in matching sets. This mantle was made for burial and not yet finished when the person died.

84. Paracas Necrópolis mantle (detail of FIG. 83).

Winged beings are here ornamented with trophy heads. The aim of trophy headhunting was to capture the energy of the enemy for one's own group.

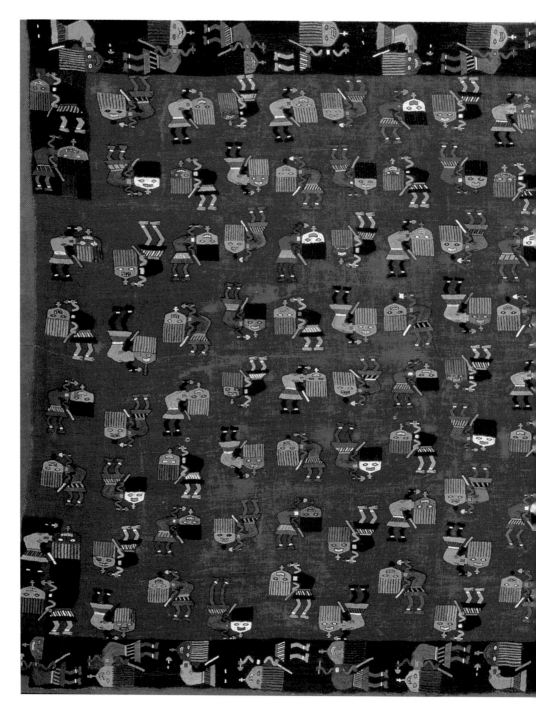

85. Paracas Necrópolis mantle, from the south coast of Peru, 200 BC–AD 200.
Camelid fiber, entire mantle 56 x 95″ (142 x 241 cm). Museum of Fine Arts, Boston.

These distorted figures are particularly dynamic because of the alternation of position
within and between rows.

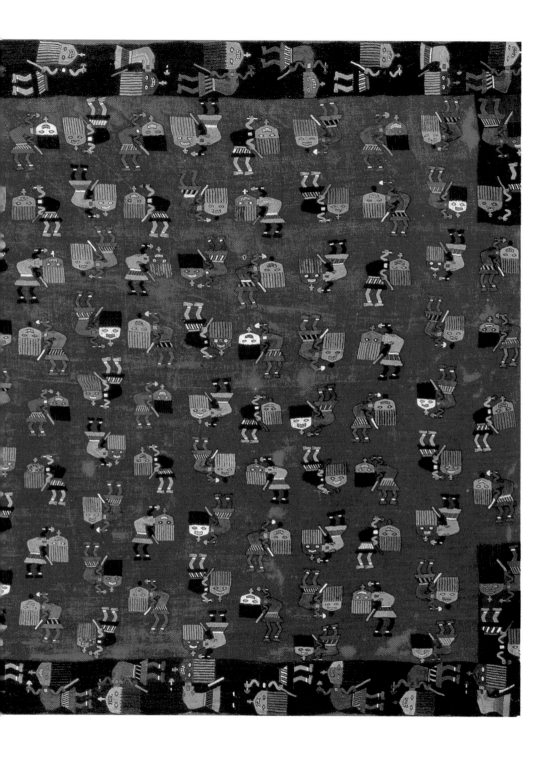

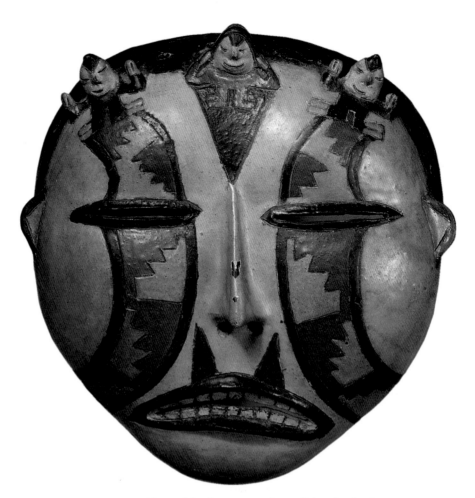

86. Paracas-style mask, from the south coast of Peru, 100–50 BC. Polychromed ceramic with resin paint, 10 x 9¼″ (25.3 x 23.6 cm). Dumbarton Oaks Research Library and Collection, Washington, D.C.

No one knows for certain what these masks were used for. One possibility is that they were the heads of some funeral bundles. Other Andean funeral bundle faces consist of textiles, metal, or featherwork.

Alongside the veneration of the dead, there was a strong reverence for tradition in the Andes. This is illustrated by the two basic vessel shapes, which remained quite unchanged for nearly fifteen hundred years. The favorite vessel form of the south coast was a globular vessel with two spouts and a bridge handle, known as a "double spout and bridge bottle" (see FIG. 81). Both the Paracas and the Nazca vessels are of this type. On the north coast of the Andes (Peru) the spout emerged from a semicircular handle on top of the vessel. This was known as the "stirrup spout." Stirrup spout vessels are often pleasing in form and attractively painted, but to the Moche it was the canonical form of the vessel that was its crucial aspect. Fantastic ceramic masks were also made in the Paracas style (FIG. 86).

In 1911 a dramatic find was reportedly made on the Paracas peninsula. According to some accounts a grave contained an elderly man and, next to his naked body, a most remarkable textile (FIG. 87). This textile, now in the Brooklyn Museum, has about

87. Paracas Necrópolis fringe figure, from the south coast of Peru, 300–100 BC. Needle-knit cotton and wool fiber, overall 58¾ x 24¾″ (149.2 x 62.9 cm). Brooklyn Museum, New York.

About a hundred individual figures border this textile, making it a veritable codex in cloth. They are distinguished by rich plant imagery and an interaction of plant, animal, human life, and headhunting imagery. This figure holds a sling and a fan and has vegetation in its headdress. This textile had a ceremonial function and was not meant to be worn. Found in 1911, this unique textile led to the discovery of the Paracas burials, in which over four hundred mummies wrapped in textiles were found.

one hundred small figures needle-knitted on its border, mostly various spirit beings of the south coast. The purpose of this textile is unknown: unusually, it is not a garment, and may be a devotional miniature. It is also exceptional in having so many different figures represented on it. There are men and women, llamas, felines, and some composite beings. As on the Tello Obelisk (see FIG. 79), these varied spirits are associated with plants. However, the associations are very much more varied and loose. A llama may have seed pods growing from its body. A tree may be growing through the body of a feline. Many figures have gold headdresses and mouth masks; some carry knife-shaped objects that seem to be related to headhunting. The idea of relationships is indicated by long streamers and appendages: long tongues, rows of beans. Bits of other similar textiles are known, each one having different beings on it. Although these textiles recall the codices of Mesoamerica, there is almost no standardization of the spirit world on the south coast of Peru. The multiplicity of spirits is perhaps most reminiscent of the *kachinas* of the Hopi and Zuni of the American Southwest. These were fantastic beings who were believed to combine the functions of ancestors and nature spirits. Hundreds of them are known, although a smaller number were represented in performances at any given time.

The find of the Brooklyn Museum textile led to the excavation of the Paracas peninsula, with the Cavernas and Necrópolis cemeteries, by Julio C. Tello in 1925. Over four hundred mummies were found in the Necrópolis burials (200 BC–AD 200). Each mummy was wrapped in many, sometimes nearly a hundred, layers of textiles. The largest bundles were those of men. The body was seated naked in a basket and the textiles wrapped around him or her. Almost all the textiles, whether used or made for the funeral, were items of clothing: loincloths, shirts, belts, mantles. Many were in matching sets.

The Cavernas burials appear to have been earlier (400–200 BC) and to have suffered slightly more damage because of soil conditions. But Necrópolis graves also included textiles in Cavernas style. Cavernas textile style resembles Paracas pottery in that it represents a grinning being with appendages ending in snake heads emerging from the head (see FIG. 80). The figure is drawn in outline and a miniature version of the full figure is in the body, with another miniature figure inside that, and so on. These figures do not have solid bodies but are made up of lines.

The textiles of Necrópolis have been extensively studied and illustrated. Figures are still sometimes depicted floating in odd positions on the backgrounds, but they are filled in with embroi-

dery and given a bodily existence (see FIG. 82). The appendages flow in elegant curves rather than zigzagging about the figure. There is an emphasis on costume detail as well as on the gold ornaments. The beings are much more than mere designs: they look as if they are impersonations of real people. A single figure is fantastic enough, but the profusion of figures on an entire mantle is even more astonishing. Most mantles had a chequerboard design, on which the embroidered figures alternated with areas of plain cloth (see FIGS 83 and 84). Adjacent figures are often upside-down or flipped sideways or both. Rarely, they remain in the same standing position. Nor is this the only variation that is played on them. The color scheme of the entire figure, from body to costume and trophy heads, is usually varied: large patterns are evident, as in alternating rows colored bluish or brownish. But even if some color pattern is evident, the small details, including elements such as facial paint, appear random until carefully studied.

How is one to experience a work of art of this sort that does not have a central scene or image? One can do it by feel, beginning at any point of the textile and mentally noting all the variations, then keeping these in mind while exploring the entire textile. This is a process that would resemble a listener hearing a musical theme unfold; it is a long way from the European tradition of looking at a painting. Another, more intellectual, approach is to create a "score" of all the themes and variations. The people of Necrópolis may not have looked at the textiles in either of these ways, but it is clear that they incorporated in their designs this contrapuntally rich fund of variations. The Boston Museum of Fine Arts textile with winged figures has an embroidery design that can be experienced in just such a number of ways (see FIGS 83 and 84). Some designs impress us with the complexity and richness of detail. Others are striking because they feature simple figures twisted into extraordinary positions (see FIG. 85). Occasionally an image such as a bird is amazing because of its naturalistic rendering.

There is a similar bewildering yet ordered proliferation of subjects. The figures oscillate between the human and the spirit. They often have feline or simian features, but often too they are winged. Many of them have heads or, in their place, head-hunting knives. It has been suggested that they are ancestors turned into spirits. Again, the numerous southwestern *kachinas* come to mind. There is no question that these images, which link various aspects of nature, are representations of the growth principle of the cosmos. (One bundle had several kilos of beans instead of a body at the core.)

Technically these splendid textiles are very simple. The designs, made on plain cloth, are embroidered, which is a technique as free in its possibilities as painting. In this form of embroidery, stem stitch alone is used, but in such a way as to outline and emphasize forms. The marvel of the textiles is not the technique but the designs. Technically complex textiles were also made, but not as garments of apparel.

It was at this time that the technique of discontinuous warp and weft was developed to its highest level of virtuosity (FIG. 88). This is a technique that does not have a set of basic continuous threads, in either the vertical or the horizontal direction. One way of doing this is to create a separate set of yarns to be used as "scaffolding" and then remove them. While most Peruvian weaving techniques are known in the world, the discontinuous

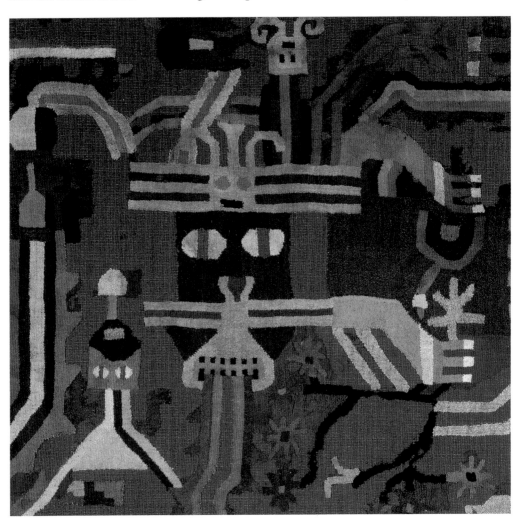

89. Drawings of Nazca geoglyphs, between the Palpa and Ingenio rivers, south coast of Peru. Length of bird, 443' (135 m) long.

The oxidized surface stones were removed to reveal the lighter stones beneath, making designs of lines and, on occasion, figures visible mainly from the air. Andeans liked such "conceptual arts" that they had to imagine to experience.

warp and weft technique was used only in Peru. Because yarn of the same color is used for both warp and weft, the weft does not have to cover the warp so densely. This makes for a cloth that is lighter and often of exceptionally rich color. Evidently these two factors, along with the texture of cloth, were considered important. Some of the designs are simple and geometric; others have an amazing array of full-figure supernaturals woven in this technique. Such cloths were probably hangings in shrines or elite residences.

Sherds of Nazca pottery have helped to date the famous geoglyphs on the plateau between the Palpa and Ingenio rivers close to both the Paracas and the Nazca areas (FIG. 89). Geoglyphs are symbolic designs made in the earth. Here they are gigantic lines and animal figures, visible to some extent from a nearby hill, but revealed fully only when seen from the air. The plateau is barren, and by moving to the side the dark top layer of stones the Andeans created these mysterious lines – which they themselves were unable to see in their entirety. Some of the animal and plant images are continuous designs that look as if they could have been laid out with a rope. The paths are wide enough to have been ceremonial walkways and perhaps that is what they were. Some of the lines point toward astronomical features. Like the textile designs, the lines are a bewildering pattern of variations one on top of the other.

Tiahuanaco/Huari: Conceptual Order

The first large conquest empires in the Andes emerged after AD 600 in the highlands. The capital of a southern empire that reached as far as modern Chile was at Tiahuanaco, now in Bolivia. The capital of a northern empire was at Huari in Peru. Since both

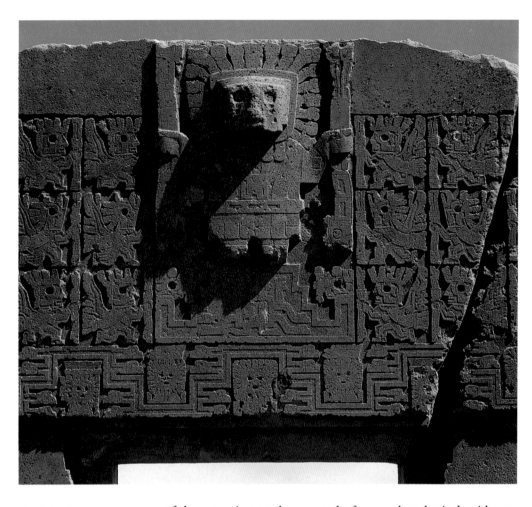

90. Gate of the Sun, Tiahuanaco, Bolivia, AD 500–700. Stone, height 9'10" (3 m).

The frontal Gateway is reminiscent of the gods of Chavín de Huántar. In both cases a great deal of emphasis is placed on a doorway, which is a restricted access from a more profane to a more sacred area. Winged figures similar in concept to those on the Black and White Portal flank the Gateway God.

of these empires are known only from archaeological evidence, little information is available on their detailed structure. Nevertheless, many aspects are reminiscent of the well-documented Inca empire. Religion seems to have dominated the manifestations of power at Tiahuanaco, a magnificent site of stone architecture and sculpture. Because many of the small stones used in construction were well cut and potentially useful, most were looted in the centuries after the demise of the site, leaving the large or carved monolithic blocks. The site is like a giant jigsaw puzzle with most of the pieces missing.

One of the most striking aspects of Tiahuanaco is its similarity to Chavín de Huántar, about 435 miles (700 km) away and built nearly a thousand years earlier. There is a large platform with several enclosed courts, including a sunken one. The sunken court even has tenoned heads (sculpted heads with a projecting stone set in the wall) similar to those of Chavín. Even more strik-

ing is the parallel of the Gate of the Sun (FIG. 90). This monolithic sculpture is no longer in its original location, but it was once a very important entrance. The carving on the lintel appears to represent the most important theme in Tiahuanaco art: a frontal deity flanked by profile figures with wings. The idea may be derived from Chavín art. It is difficult to know whether some aspects of Chavín art survived in the highlands, or whether the Tiahuanaco images are revivals and archaisms. On the Gate of the Sun this deity is not fanged, and its gender is ambiguous.

Rigid order is the most striking aspect of the gate. The style is angular and rectilinear, without the curving detail of Chavín art. Almost all of it is low relief, with the exception of the deity who is in high relief but rendered in cubic forms. The precision of cutting and the standardization are remarkable. The lintel has sixteen bird-headed figures, thirty-two human-headed figures and sixteen deity heads. Because of the almost mathematical precision of Tiahuanaco designs, various writers have been inspired to search for some kind of hidden numerical order in them. Their first investigator, Arthur Posnansky, thought in the 1940s that the gate was a calendar based on the number of figures and Andean months (FIG. 91). Gate of the Sun designs occur in other sculptures, such as the standing figures, and in these cases too all elements of the design, including the circles in the dress, have been interpreted as calendrical data. This is significant not only as evidence of the vagaries of research into Pre-Columbian art, but also because it pinpoints aspects of Tiahuanaco art. No one ever tried to find a calendar in the reliefs of Chavín. There is a

91. Arthur Posnansky pictured with the statue of "El Fraile," Tiahuanaco, Bolivia.

Posnansky was one of the early colorful explorers of Tiahuanaco. He believed that Tiahuanaco dated from about 10,000 BC and was the source of all civilizations on earth. The sculpture may represent a ruler of Tiahuanaco covered with religious designs taken from the Gate of the Sun.

quality of simplicity, reductiveness, and order in Tiahuanaco art that encourages speculation about a numerical meaning. Moreover, the number of subjects in Tiahuanaco art is extremely limited compared with that of Chavín. There are both bird- and feline-headed figures, but the Gate of the Sun design is the major motif in stone and it is repeated in variations on many images.

Tiahuanaco must have been as special a place as Chavín de Huántar, for the colossal architecture and sculpture at Tiahuanaco exists nowhere else in the southern empire. Because of the amount of destruction, it is hard to reconstruct the original position of the sculptures, but the pattern of gates and courts suggests the same concept of restricted access as was apparent at Chavín de Huántar.

The many varied image systems of the Early Intermediate period (200 BC–AD 600), such as those of Paracas and Nazca, were abandoned in favor of a more limited iconography, which, during the Middle Horizon period (AD 600–1000), was characteristically confined to Gate of the Sun and related motifs, both at Tiahuanaco and at Huari. By AD 1500, Inca art displayed still more limited imagery. The progression in Andean art was from elaborate and varied imagery to the almost complete disappearance of any kind of image. The standardization that typified the art of Tiahuanaco and Huari represented a mid-point in this continuum.

The Huari empire is in many ways less well known than Tiahuanaco, because it does not have a site with spectacular masonry and sculptures. The interpretation has been that Huari had a more practical function, perhaps of instigating or supervising construction or other utilitarian projects. Huari administrative and storage centers such as Viracochapampa in the northern highlands and Pikillacta in the southern highlands, built on grid plans and associated with roads, were the unmistakable forerunners of the Inca empire that came into being six hundred years later. Huari-style objects, from burials or offerings, bear images that are derived from or related to those of Tiahuanaco. Great urns from Pacheco on the south coast represent the Gate of the Sun god holding staffs, but here with the alternation of male and female versions of the image. As in the yin–yang duality of Chinese thought, the presence of a male and a female signifies cosmic totality and the principle of complementary opposites, rather than representing a specific male or female figure.

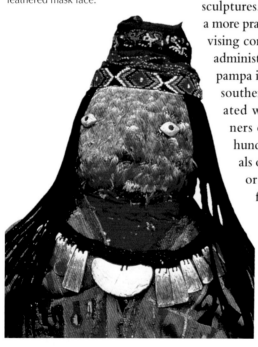

92. Huari-style mummy bundle, from Peru, AD 600–1000 (detail). Cloth, feathers, shell, and hair.

This mummy is an assemblage of Huari textile dress and hat over a feathered mask face.

Rather than making large sculptural monuments, Huari officials seem to have incorporated the sacred iconography into their dress. Some mummies have been found associated with tapestry tunics and the four-cornered hats worn by officials in the empire (FIG. 92). Tunics are usually woven in vertical strips, design and plain strips alternating. Most Huari tunics look like interesting abstract, Cubist, or Mondrian-like designs, in which stepped frets and eyes predominate (FIG. 93).

It has been shown by careful analysis of detailed drawings that in fact almost all designs, even the most abstract, are derived from the motif of the Gateway God's attendants. On one textile a staff-holding, feline-headed figure sits on what looks like its curled-up tail. The design alternates right and left, and has multiple color changes like the Paracas embroideries. That is not the only reason it is so hard to "see" this subject. One arm and staff are spread out over a large expanse, while the other hand and staff are compressed to just a few vertical lines. The opposite takes place in the reversed image.

Tapestry is a widespread and relatively simple weaving technique. The dyed weft threads are densely packed over the undyed warp to produce sections of intense color. In some of the finest Peruvian tapestries there are more than two hundred weft threads per inch (Gobelin tapestries usually have sixty threads per inch), and the threads are very light, so that some tunics weigh and feel as if they were made of silk. As was noted above, woven textiles were apparently valued for their lightness and color.

93. Huari tunic fragment, from Peru, AD 600–1000. Tapestry, cotton and camelid wool, 40¾ x 20" (103.5 x 50.5 cm). The Metropolitan Museum of Art, New York.

Huari textiles look like abstractions, but are complex expansions and contractions of sacred motifs. On this fragment a staff-holding feline is shown sitting on its tail.

94. Huari tunic, from Peru,
AD 500–800. Cotton and
camelid yarn, 39¾ x 40½"
(101 x 103 cm). Museum of
Fine Arts, Boston.

Starting with recognizable
supernatural figures, Huari
weavers eventually created
designs that, to the modern
viewer, look entirely abstract.
The designs' symbolic
importance may have been so
great, however, that they could
be distorted but not discarded.
The designs on this textile look
like stepped frets, faces, and
double-headed animals.

Because tapestry is densely woven, distortions of design
may arise. It is, however, quite obvious that, in the textiles dis-
cussed here, the strange expansions and compressions are entirely
intentional and help to make the image more complex, harder
to discern, and thus all the more interesting (FIG. 94). Huari iconog-
raphy was standardized, probably by state edict, and perhaps its
basic features could not be changed. Huari weavers therefore
did not vary the iconography much but instead reconceptual-
ized it structurally. Besides full-figure beings, they made frag-
mented images. When cut diagonally, these designs became reduced
to a head consisting of an eye and a mouth with fangs, and a curl-
ing tail. Quite a number of tunics show this version; when the
fragmented designs are also compressed and expanded and the cut
is not in the middle but off to one side, the rhythm is particu-
larly abstract and syncopated. No wonder these textiles were so

popular with Western collectors during the first half of the twentieth century when Modernist styles such as Cubism were popular.

It would appear from the nature of the textiles that in Huari times there may have been a religious, social, or ritual requirement to represent certain supernatural beings, if only in abbreviated form. However, designs could be manipulated so as to create complex and varied esthetic effects. Both weavers and their patrons seem to have been fascinated by the intellectual games that could be played with the designs. As long as they complied with certain rules, artists had great latitude in formal invention. Although each site offers different interpretations, there is a family likeness between the art of Chavín, Paracas/Nazca, and Tiahuanaco/Huari, in all of which there is a standardized set of motifs showing a deity with attendants and a focus on the representation of the supernatural, within an elaborate formal system. All neglect the human and the naturalistic. All have images that are invisible for one reason or another. In order to appreciate them, one must enter their complex intellectual and conceptual world.

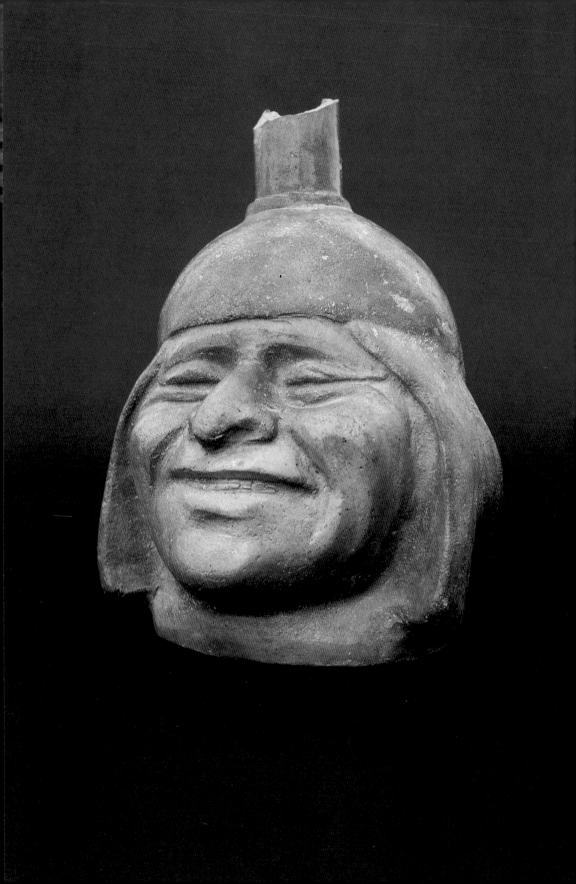

FIVE

An Alternative Path in Andean Art

The Moche: Portraits and Humor

In all of Andean art there is nothing quite like the Moche portrait heads. Each one is a mold-made stirrup spout vessel in the form of a head (FIGS 96 and 97). The faces are remarkable in suggesting the actual presence of a person. Some are idealized and "noble." Some are elderly and thoughtful. Some are heavy in the jowls. One mysterious head has a broad smile (FIG. 95).

The word Moche means in this context several things: a north coast kingdom (200 BC–AD 600), its culture, and the people who created it; the river alongside which the Moche culture flourished; and the site of the capital. Recently the site has been renamed Cerro Blanco but most texts still refer to it as Moche. Large adobe (unbaked brick) constructions now in ruins exist at the site of the capital. The two biggest structures were great platforms named the Pyramids of the Sun and the Moon by the Spanish. The Moche are known primarily for their ceramics and secondarily for metalwork and textiles. It is estimated over a hundred thousand vessels exist in collections.

Excavations at Sipán, to the north of Moche, brought to light a number of royal tombs, in which the most elaborate riches were of gold, shell, textile, and feather, not ceramic; and such ceramics as were found in these tombs were not, in the main, stirrup spout vessels. The rulers of the Moche valley probably had similar spectacular burials in such places as the Pyramid of the Sun at the site of Moche. The river was diverted in colonial times to destroy the adobe structure in the search for gold.

Many examples of portrait heads are known, featuring essentially fifty individuals, only one of which is likely to be a woman. They are found in many burials, not necessarily in the burial of

95. Moche smiling portrait head vessel, from Peru, AD 400–500. Terracotta, 6¼ x 5½" (16 x 14 cm). Museo Arqueológico Rafael Larco Herrera, Lima.

The expression makes this a unique head. Strangely enough, there is a smiling example among the Olmec colossal heads too.

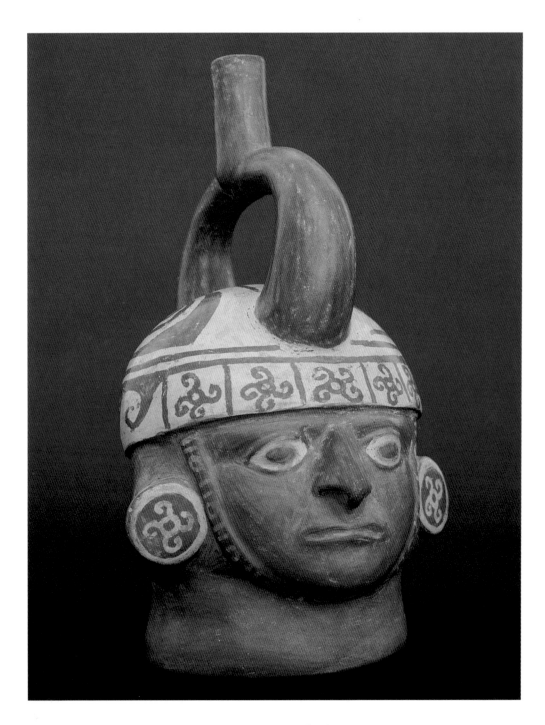

96. Moche portrait head vessel, from Peru, AD 300. Terracotta, height 10" (25.6 cm).
Museo Arqueológico Rafael Larco Herrera, Lima.

This vessel represents an early type of head before the full development of naturalistic modeling.

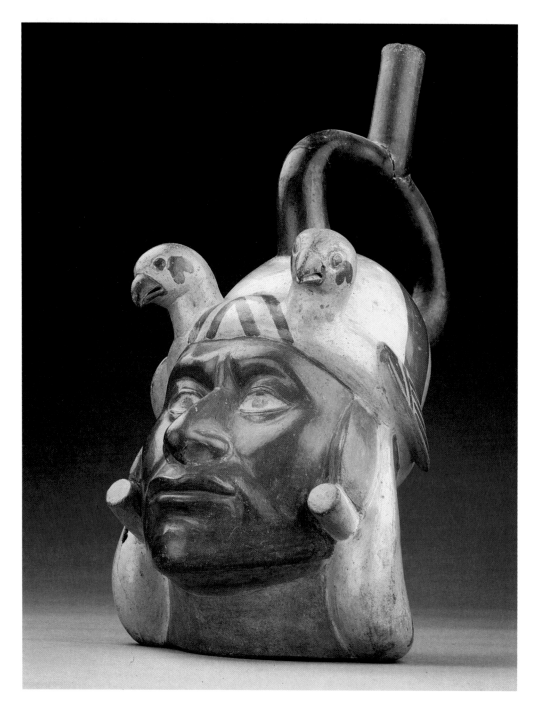

97. Moche portrait head vessel, from Peru, AD 400–500. Terracotta, height 12½ x
8¾" (31.7 x 22.5 cm). Museo Arqueológico Rafael Larco Herrera, Lima.

The idealized realism of this face suggests the presence of a real person.

the person depicted on the vessel. Because of the small number of individuals represented on the heads, the dignity and maturity of their facial expression, and their elegant headgear, it is generally believed that the heads represent Moche rulers. Attractive though the heads are to the modern eye, they were apparently not the most prestigious objects in their time and were possibly placed in what may have been the graves of officials who were expected to serve their lord in the afterlife. The burial of an important man, described as a "warrior-priest," in the Viru valley, south of Moche, was in a reed casket, which also contained twenty-seven vessels, one of them a portrait head. These heads were the first works of Andean art to receive European acclaim because of their naturalistic depiction. They are the works that give a "face" to Andean art and are often on the covers of books.

Where does this naturalism come from? Three-dimensional modeling of ceramic figures was always a more significant tradition in the art of the north coast of Peru than in the art of the south. Chavín-style vessels from north coast sites such as Chongoyape, Cupisnique, and Tembladera, from the Early Horizon period, represent many of the lively life forms found later in Moche art. The immediately preceding traditions, however, such as the Salinar, Gallinazo, and Vicús styles (c. 200 BC) are lively but far from naturalistic; indeed, some early Moche art looks like the stylized art of the latter two of these. The roots of Moche art were clearly in the local traditions: both older ones that had been revived and very recent ones.

The head of the figure holding a lime gourd (FIG. 98) has the elements of early style: large staring eyes, a big straight gash for a mouth, and geometric cap-like hair. The body with the asymetric hands is more like later Moche art in its tendency towards realism. The early vessels are handmade, the later ones are mold-made; consequently many more mold-made vessels survive. Only in the later vessels is there a sudden change in the rendering of the heads. While the stirrup is placed horizontally or vertically on early examples (see FIG. 96), it is tilted back vertically on the late ones (see FIG. 97). The neck of the late portrait heads is also tilted back, raising the face to view. The eyes, no longer so big, are half-lidded, the noses are smaller, the lips fleshier, the cheeks less smooth, the wrinkles more visible. This development was clearly due to the demands of certain patrons and the preferences of certain artists. It lasted perhaps a hundred years, within the Moche period, and ceased just as suddenly as it had begun, whereafter such heads were not made again in the Andes. The Moche portrait heads, like the Olmec colossal heads, demonstrate that naturalism is always a

possibility if there is a cultural need and a desire for it. It took only a few changes to the early type of head for its successors to come to life as individuals.

Early Moche art was relatively stylized. Seated figures, probably of ancestors, were common subjects. With the development of mold-making there was an enormous proliferation of types of ceramics. Besides portrait heads, there were full figures, figures set on top of vessels, painted vessels, and combinations of painted vessels with figures on top of them. Unlike the art of the south, which emphasized color, the ceramic art of the Moche was usually in two colors only – cream and red. Red clay slip was often used to paint the outlines of various figures and scenes. Some

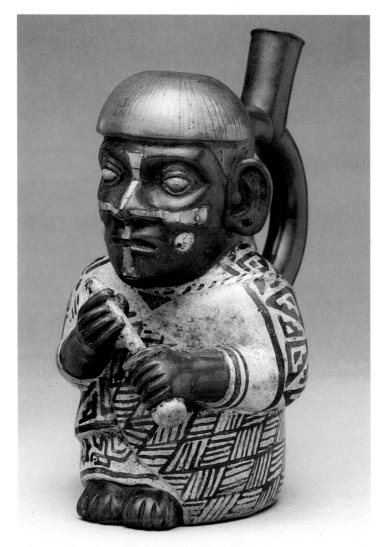

98. Early Moche handmade figure, from Peru, AD 200–450. Terracotta inlaid with turquoise, height 7″ (17.5 cm). Museo Arqueológico Rafael Larco Herrera, Lima.

The man is holding a gourd which contained lime which was mixed with coca leaves while chewing. Coca is still used in the highlands of Peru today.

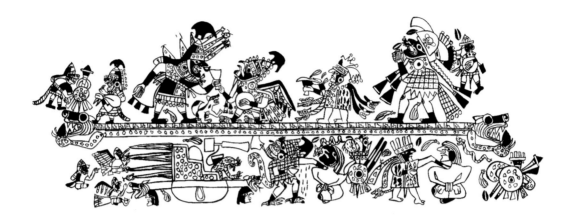

99. Rollout drawing of a Moche Presentation Theme on a stirrup spout vessel. Museum für Völkerkunde, Munich.

In the lower register, blood is drawn from the necks of naked figures with their hands tied. In the upper register, a figure with a round disk hands a goblet, presumably holding the blood, to the elaborately dressed figure to the left.

Opposite

100. Moche deer-headed warrior figure, from Peru, AD 450–550. Terracotta, 9¾ x 8″ (24.5 x 20 cm). Museo Museo Arqueológico Rafael Larco Herrera, Lima.

Deer-headed figures represent both warriors and captives.

of the three-dimensional figures were inlaid with turquoise, shell, and semi-precious stones and had gold ornaments.

As the early figures and portrait heads demonstrate, Moche art is clearly focused on the human world. Other vessels testify to an understanding that the human world signifies power. Many Moche men are shown carrying lethal-looking clubs and wearing appropriately protective helmets. Life-size naked prisoners in relief adorn the wall of the Huaca el Brujo structure found recently in the Chicama valley. Warfare was obviously a major subject in art. Other works depict captives tied up naked and being mutilated, or their blood drawn and presented as an offering in painted "presentation scenes" (FIG. 99). The subjects are just such as might be found in Mesoamerica: rulers, scenes of conquest, captives, sacrifice. All the figures and acts are portrayed in a setting. The strange projections on the vessel represent mountain peaks and the uneven groundline and vegetation the coastal terrain.

Not everything on Moche vessels belongs to the visible world, however. A great number of figures in Moche art have animal or supernatural heads, blended to the bodies as naturally and organically as if such figures actually existed. Only the Maya and Olmec created such convincing combinations in a naturalistic style. It comes as no surprise to see a deer-headed captive with a rope around its neck (FIG. 100), nor a fanged deity holding a shell. It is hard to know, in the case of the deer-headed figure, whether this is a special mythological spirit, whether the deer-head represents an allegorical quality, or whether it defines a group or family.

The major Moche deity is easy to recognize, because his representation is quite consistent. He seems to be a descendant of the Chavín deities, some of whom had coastal origins. He usually has fangs and wears serpent belt, serpent earrings, and a feline image in his headdress. Often portrayed holding a sea shell or fight-

101. Drawing of a Moche
painted scene on a vessel,
AD 300–600. Museum für
Völkerkunde, Berlin.

The fanged deity is shown
struggling with a sea
monster in the desert.

Opposite
102. Moche Mountain
Sacrifice Vessel, from Peru,
AD 300–600. Terracotta,
height 7" (17.9 cm).
Museum für Völkerkunde,
Berlin.

A fanged deity statue
presides over a scene in
which a naked victim,
painted on the vessel's
surface, is perhaps about to
be tossed off the cliffs.

ing with a sea monster (FIG. 101), he seems to be associated with the sea, although he can also be seen in a mountain setting (FIG. 102). The explanation for this, put forward by some scholars, is that he is the sun, rising in the mountains in the east and setting in the ocean in the west.

Moche art is essentially narrative. The figures themselves may be rudimentary, perhaps drawn in a simple red line, with some of their body or dress filled in in red. What is emphasized is action. No one is represented in a rigid pose on a level ground line; everyone is in motion even if standing still. The deity grasps the conch monster by the neck in a dramatic confrontation. Even on the relatively quiet Mountain Sacrifice Vessel, the naked victim lying at the foot of the deity or its image paradoxically makes the scene come to life.

This emphasis on life in funerary pottery is especially evident in the erotic vessels that were made mainly in the middle period of Moche art. Whether they depict animals or humans, the explicit representations of the sexual act, rendered with the same interest in detail and liveliness as other subjects, celebrate the supreme joys of living. Even more striking are combinations of eroticism with death – scenes such as women fondling the penises of skeletons – indicating the connection between death, the afterworld, and the forces of life. It would be reasonable to suppose that the Moche had some type of vitalist philosophy based on the power of organic life.

The only culture in the Andes thought to have had a writing system aside from the quipu is the Moche. Given the similarity between this and so many Mesoamerican arts, one expects to see these glyphs associated with the images of lords and captives, or texts explaining the mythic representations. The Peru-

103. A pair of Moche earplugs with bean
runners, from Peru, AD 300–600. Gold with
turquoise and shell inlay, diameter 3¾" (9.5 cm).
The Metropolitan Museum of Art, New York.

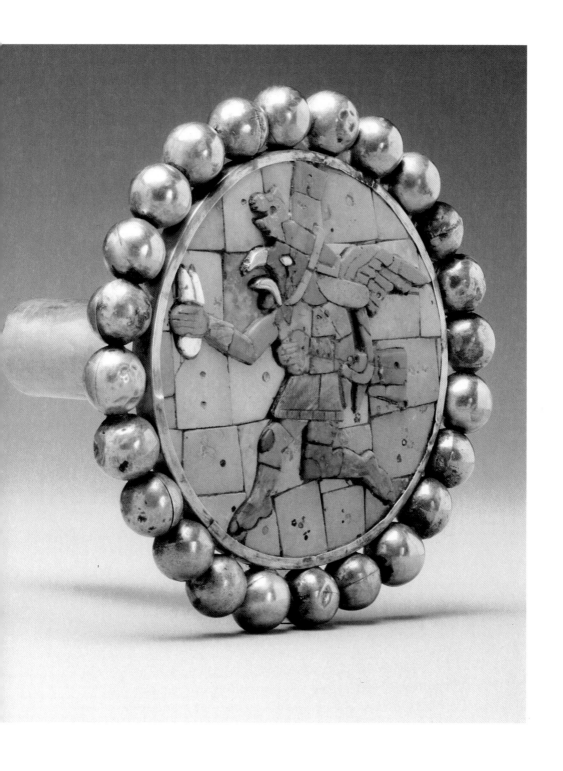

104. Drawing of beans turning into runners fom a Moche fineline vessel.

vian scholar Larco Hoyle thought that glyph-like symbols were cut into beans for messages. Many vessels and a pair of beautiful inlaid earplugs represent figures running on a desert "ground line" carrying little bags (FIG. 103). Their heads are often in the form of animals or birds, all of which are swift, thus suggesting an allegorical explanation for the combinations. The contents of the little bags seem to be beans, as bean designs are often scattered all over the background of such vessels. On one marvelous example the design spirals up the pot, starting out as beans and turning into bean-runners carrying bags (FIG. 104). The bag seems to be handed over to the figure at the end of the row, and then no more beans are represented. Evidently the message has been received.

There is no solid evidence for glyphs among the Moche, but they would seem to have been an appropriate accompaniment for the art. On the other hand, we do not really know what

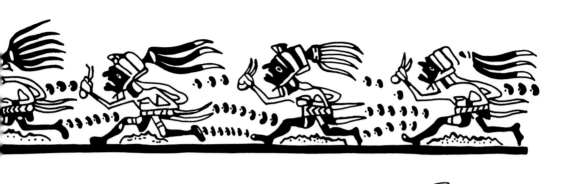

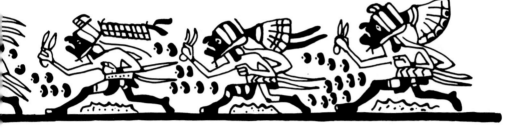

was in the bags and what they signified (FIG. 105). The Inca had a messenger system on their roads, with rest stops for changing runners. The Moche kingdom, which combined a dozen river valleys, had a road system that was later incorporated into the Inca system. Beans of various sorts could have contained messages recording certain types of numerical information.

One of the most engaging aspects of Moche art is humor. Historians tend to be so preoccupied with looking for politics and religion in ancient art that they often overlook the presence of humor. Moreover, humor is so deeply embedded in a culture, and often so hard to "get," even for members of that culture, that it is easy to read too much into the material. On the other hand, humor has played a major role in the rituals and religions of the past – many cultures have traditions of sacred clowns and carnivals that are entirely consistent with a serious religious position. It is a natural reaction to find the little beans that acquire feet

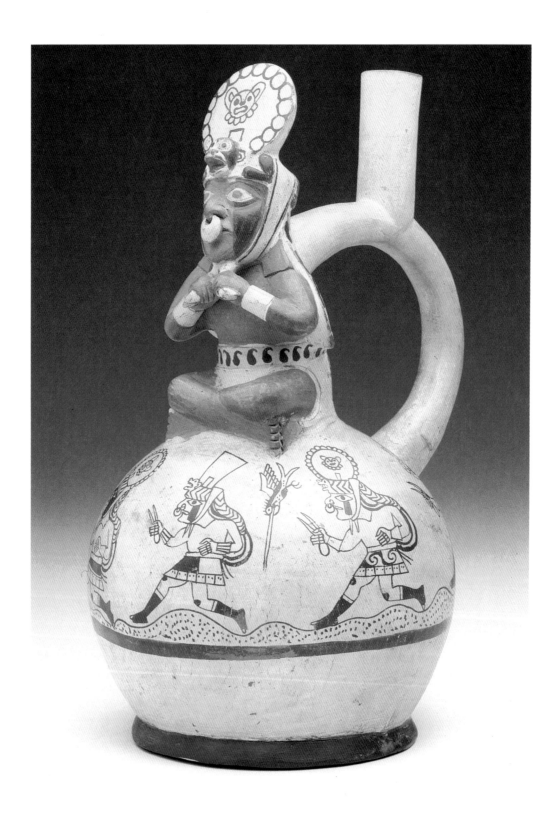

and turn into people funny and delightful, even if that means disregarding some deeper mythological significance. Many other Moche representations deal with inanimate objects that become animate – plates of food that walk on feet and jugs that pour without human intervention may be found on some vessels. A mural on the Pyramid of the Moon depicted a battle between humans and animated shields, spears, and implements. While these images may simply testify to a recognition on the part of their makers of an animist universe, in which everything is capable of having a soul, it is equally possible that devices such as turning objects into people and interacting with them are a form of play and thus indicate humorous intent.

What made the Moche so different from the rest of the Andean cultures? Moche appears to have been a centralized kingdom. The two large adobe complexes at the capital appear to have consisted of a temple (the Pyramid of the Sun) and a palace that was also an administrative center (the Pyramid of the Moon). Drifting sand still covers much of the city. Much of what is known about the Moche culture has been reconstructed from images in Moche art. There is precedent for the Moche representations of warriors and prisoners in the reliefs of Cerro Sechín (c. 800 BC) in a nearby valley. The Moche appear to have picked up a local tradition and developed it to an extent unimaginable in the rest of the Andes. Authority and power were the chief subjects of their art, suggesting a hierarchic and warlike society in which conflict was glorified rather than order idealized. In Moche philosophy, people who participated in this world, from rulers to weavers and curers, were commemorated as significant players. The supernatural was a notable element but there was also a strong attachment to the secular, although in fact secular and religious themes interpenetrated. From the paucity of information available, it cannot be said exactly when the rulers of Moche shifted their focus from the cosmos and political order to self-glorification, but the works of art that celebrate life with such vigor prove that this departure was vibrant and exciting. It is noteworthy that the experiment was short-lived – it reached its height in late Moche times, lasting perhaps a hundred, at most two hundred, years.

Opposite
105. Moche vessel with ritual runners, from Peru, AD 300–600. Terracotta, 10½ x 7¾″ (27 x 19.7 cm). Art Institute of Chicago.

SIX

The Disappearance of the Image

By the second millennium BC various Andean cultures had established an image and form system in different media. Human beings and the forces of the cosmos were represented, the latter particularly in the form of animal images. This evolution culminated in the very diverse styles of Moche and Nazca and in the powerful imagery of Tiahuanaco and Huari. In a striking new development after AD 1000, significant iconographic images of gods or humans or hybrid creatures disappeared from most of the arts of the Andean area. Attractive geometric designs, small-scale and benign images of birds, fish, frogs, and butterflies and of simple human beings remained. But both the mythological and the political complexity of earlier art vanished. It would appear that politics and religion either forwent dramatic imagery or used imagery in a different way.

In the Tiahuanaco/Huari tradition the image system was already greatly reduced to a few canonical forms, and broken up by weavers into intellectually complex fragments. As time went on, the fragmentation proceeded further, such that the earlier logic of the design was completely dispersed; designs were now mixed together in a way that was pleasing but non-systematic. At this point a motif appeared that is one of the hallmarks of Andean art in the late periods: the little bird. This is not one of the powerful raptorial birds that hold sway in the skies and cast terror into the creatures below, but the little birds of the seashore or the forest, which are entirely benign and do not appear to symbolize dangerous cosmic forces. All cultures of the later period – Inca, Ica, Central Coast, and Chimú – have this image in abundance (FIG. 106). It harks back to the Huaca Prieta culture, which incorporated local fauna in its designs.

106. Chancay, Central coast-style textile, from Peru, 1000–1521. Brocade and tapestry of cotton and wool, 27 x 17½–19″ (68.6 x 44.5–48.3 cm). Dumbarton Oaks Research Library and Collection, Washington, D.C.

Birds are shown traveling in reed boats on the bottom border.

The obliteration of the significant iconographic image in the late art of the Andes does not seem to be the result of iconoclasm, nor of a dislike or fear of images, since small figures do remain. Rather, it indicates a shift in a different direction in the use of the visual arts. The Mesoamerican pattern of late eclecticism is not unlike the wide range of the visual tradition in the Andes in the late period. But while Mesoamerican artists went on to create new images, those of the Andes picked up the ornamental and conceptual strands in their traditions and developed them at the expense of images.

Chimú/Sicán: The Power of Ornament

The largest kingdom the Inca conquered on their rise to power was that of the Chimú on the north coast. The capital of Chimú, Chan Chan, was located not far from Moche on the opposite side of the Moche river. Chan Chan too was an adobe city, but very different from Moche. Instead of large pyramidal structures, the laborers put up great enclosures, known as Ciudadelas. These were the palaces of the rulers while they lived and their tombs after they died. Each Ciudadela had a sector for living, audiences, and rituals, one for tombs, and one for gardens, wells, and retainers' quarters. The emphasis was on the palace, not on the temple. Great walls separated the palace from the insubstantial housing of the general population of the city. Chan Chan was remarkable in lacking a great central plaza for public gatherings. The plazas that did exist were in the Ciudadelas and offered very restricted access.

Although all the tombs were looted quite thoroughly – at one time shares were sold in companies that were to search the site for gold – a recent excavation has shown that the Chimú lord went into the afterworld accompanied not only by his servants but also by women, perhaps several hundred of them. The quantity of gold and "treasure" was probably equally staggering. These goods and sacrifices were placed in the tomb's central room with the body of the ruler and in the adjoining cell-like rooms. These treasure-filled rooms are reminiscent of the storage places built by the Huari empire in its administrative centers for the collection and redistribution of goods from its population. Here the "storage" is for the king in the afterworld.

There is a remarkable amount of information about the kingdom of "Chimor" in Spanish sources of the sixteenth century and early seventeenth century. When the Inca conquered the Chimú, they took the local ruler and many craftsmen with them to Cuzco. Cuzco was supposedly redesigned after Chan Chan. Some aspects

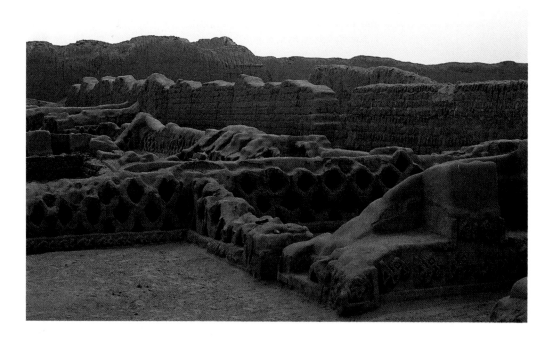

of Chan Chan rulership too were imitated by the Inca. For example, each Chimú ruler created his wealth, including the building of his palace, on the back of his conquests, and when he died he was buried in his palace. His wealth paid for the sustenance of his family, who continued to reside there. The next ruler inherited the title, but had to build his own palace and find his own wealth. The ten great Ciudadelas of Chan Chan seem to relate to the ten kings recorded in their histories.

The adobe walls of the Ciudadelas were ornamented, mostly on the inside, with reliefs – usually a single level cut away from the background (FIG. 107). These reliefs, however, tell us nothing about the Chimú kings and their exploits. They usually consist of fish, birds, diamonds, parallel lines, and sometimes small figures in repeating order. They are reminiscent of textiles. In fact, some actually imitate the rectilinear forms of figures woven in cloth – such as the little birds. Moreover, they are very similar to the designs in textiles of the same period from the coastal burials, in which repeated designs of birds or little figures in reed boats are common. It is characteristic of these designs that there is neither a complex iconography nor an elaborate formal design of the various elements. Their quality is ornamental, not signifying.

"Mere ornament" has had a bad name in twentieth-century aesthetics, in which meaning or simple functionality are regarded acceptable qualities. But ornament in many traditional cultures

107. Wall relief with pelicans in a textile style, from Tschudi compound, Chan Chan, Peru, 1300–1470. Adobe.

Chan Chan was the capital city of the Chimú empire. It consists of ten compounds which were the palaces and burial places of the rulers.

is a way of showing honor, indicating virtuosity, and displaying riches. As the architecture and archaeological excavations indicate, the Chimú lords must have been very powerful. Evidently they chose not to advertise this power in the form of images. They preferred representations of benign, innocuous creatures, and beautiful ornament for its own sake. They did not require displays of religious legitimation, nor did they show interest in intellectual games. Their designs are attractive – the birds on gauze cloth are splendid – but not much is required of the viewer in terms of decoding or mulling over the information presented. This preoccupation with deliberately simple ornament may have been a disguise, like a mask, for the real power of authority and the complexity of the state.

Unquestionably, the great art of the late period was metalwork, and much survives despite looting that dates back as far as antiquity. Goldworking has been known in the Andes since about 2000 BC. Generally there is more gold in the northern than in the southern areas of Peru, and there is a great deal associated especially with the Chavín, Moche, Chimú, and Sicán cultures (FIG. 108). Although by Moche times casting was known, the favorite technique in the Andes was to work silver and gold by hammering. This required sophisticated control over heating so that the different melting points could be determined. North coast metal workers were fully conversant with complex alloys, sophisticated surface-enrichment techniques, joining systems, and other aspects of the metallurgical process. Hammering results in a shimmering surface, which, with the addition of incised ornament and pendants, was evidently to the Andean taste. A light, textured, ornamentally intricate effect was sought.

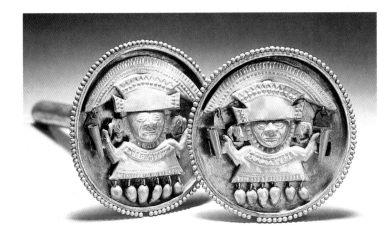

108. A pair of Chimú-style earplugs, from Lambayeque, Peru, eleventh–thirteenth century. Hammered gold alloy, length 3½″ (8.9 cm), diameter 2½″ (6 cm). The Metropolitan Museum of Art, New York.

Thin hammered gold and shimmering fringes are characteristic of Chimú metalwork.

In the Early Horizon (1000–200 BC), relatively small amounts of metal were fashioned mostly into headdresses, earplugs, and pendants of various sorts. Only in the Late Intermediate (AD 1000–1450) and the Late Horizon (AD 1450–1530) were quantities of vessels and cups made out of gold. The Inca had so much gold at their disposal that they even used it for revetment and decoration on some of their buildings, such as the Coricancha (Temple of the Sun) in Cuzco. Life-size humans and animals in gold were supposed to have been placed in the courtyard of the same temple, with gold turf beneath their feet. A huge amount of gold was collected at the time of the conquest as a ransom to retrieve the Inca king Atahuallpa from captivity by Pizarro. In the end, however, Atahuallpa was killed and the gold melted down.

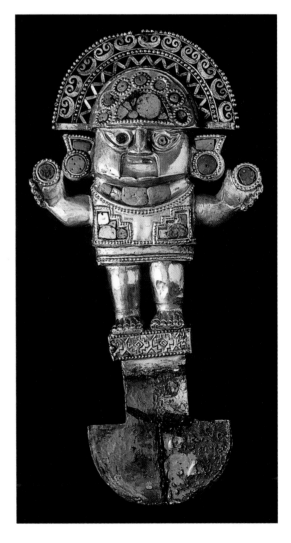

109. Sicán-style ceremonial *tumi* or knife, AD 850–1050. Gold inlaid with turquoise, height 15½" (39.5 cm). Museo Miguel Mujica Gallo, Lima.

Almost no large Inca gold pieces survive, but some conception of their appearance can be formed by looking at Chimú and Sicán works.

Although the Chimú imitated some aspects of Moche ceramics, their art consists of simpler images. A common theme, especially on metalwork, is a very generalized "lord," often with arms raised. In general concept, this figure is reminiscent of the Tiahuanaco Gate of the Sun deity, but in the absence of iconographic details there is no way of telling if the personage is human or supernatural. The wide headdress and the garment suggest a personage of importance. On the Chimú earplugs there are fringes of gold, which must have made an interesting display as the wearer moved. A similar all-purpose "lord" is seen on the knives found at the Sicán site of Batan Grande (FIG. 109). Inlaid with turquoise and cast in openwork, these are impressive images of power, although without any specific connotations.

Until recently, most metalwork from the late north coast culture was thought to be Chimú, but excavations have shown that a great deal has come from the area of the Batan Grande site, which dates from slightly before Chan Chan. The great masks from this site, which were once placed

inside graves, are now known to be mostly Sicán (see FIG. 6). Up to 19½ inches (50 cm) in width, these hammered masks are astonishing works of art. They are almost flat, with the features of the face rendered in linear relief. The tear-shaped eyes and the closed lips are characteristic. Many of the "lord" representations have similar eyes. A long needle projects from many of the pupils in the eyes with rows of beads on them. It is not known what this "piercing" glance might signify, but its effect on the modern viewer is surreal.

Most surprising of all is that the gold was covered with red paint. Twentieth-century Westerners are so enamored of gold that they would never paint over its natural surface. Andeans had different concepts about gold. Many "gold" objects were not pure gold, but alloys of gold and copper called *tumbaga*. To produce a surface finish that looked golden, the top layer of the copper had to be removed, by a process known as depletion gilding, which usually involved heating, hammering, and the application of an acid. Pieces found at burial sites are generally all crusted green on the surface because of the remaining copper, but modern depletion gilding can restore their former golden appearance. If the aim was to produce a golden effect without wasting gold, a copper object could have been covered with gold foil much more cheaply. Nevertheless this is something Andeans rarely did. Evidently it was important that there be real gold in the object, whether it was seen or not. This reverence for the essence of the material – even when covered with red paint – is reminiscent of the value attached to the purity and intensity of colors in the weaving of discontinuous warp and weft textiles. Unlike Mesoamericans, who were interested in theatrical effects and appearances, Andeans cherished objects for their essence. This attitude is evident not only in metalwork and textiles, but also in the uses of stone, especially by the Inca, who venerated naturally occurring outcrops that were significant in their mythology and history. The rock of Huanacauri, a place near initiation rites, was reputed to have been covered on one side with fabric and on the other with gold, thus bringing several essences together.

The Inca: Stone as Metaphor

Like the Aztecs, the Inca had a migration legend about their origins. They had also come from caves in their homeland to the southeast of Cuzco. Their first mythical ruler, Manco Capac, was turned to stone after his death. After coming into the Cuzco area, the Inca had to fight many battles to gain supremacy. Their

major enemies were the Chanca. In a decisive battle c. 1438 in which the Inca suffered severe reverses, the king's younger son, Pachacuti, prayed to the creator god, Viracocha, for aid. Then, according to Inca history, the very stones of the battlefield turned into armed soldiers and the Inca won. The Inca empire really began with the victory over the Chanca. After the battle, Pachacuti went around the battlefield collecting the stones that had helped to win the war and they were taken to Cuzco to be displayed in the Coricancha (Temple of the Sun). They were called, collectively, the Pururauca.

These are only two of the many references to stones in Inca myth and legend. Clearly, men could turn into stones, while stones could turn into men but never into woman. Stones in themselves were believed to contain spiritual power, in the form of a kind of essence. It is not surprising that the Inca built and carved in stone, since all the highland cultures did. What is astonishing is that the Inca revered stone and often left it in its natural form. Stones set up at the sacred centers of Machu Picchu and at Kenko are entirely irregular, natural blocks. That they are special and meant to be monuments is indicated by the fact that they are surrounded by well-made masonry walls, like diamonds set in a gold ring. There are precedents for the use of irregular stones and the veneration of them from as far back as the Chavín de Huántar "Lanzón." Nevertheless the earlier cultures emphasized the creation of an image out of the material, and not the material itself. Moreover, the Inca knew of Tiahuanaco and were very impressed by the ruins. They must also have seen the sculptures. It is said that the desire to rebuild Cuzco in stone was inspired by Tiahuanaco. It was not, however, the sculpture and the imagery that were imitated: Inca art is singularly devoid of the figurative.

It may be that figurative art did once exist in gold and silver but was melted down. Only little figurines remain, which were offerings placed with the dead or at sacred shrines (FIG. 110). Here again it was not the visibility of the gold or silver that was crucial but the fact that it formed part of the object – the figurines were usually dressed, although their costumes had often been taken by the time collectors and museums acquired them.

There was also little figurative art in pottery or textiles. Repetitive geometric designs, some-

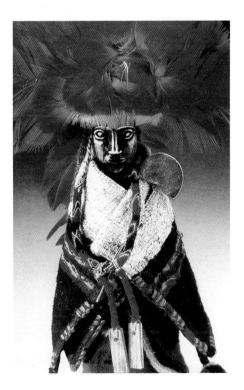

110. Inca silver figurine, from Mount Copiapo, Chile, c. 1500 (detail). Silver, feathers, textiles. Museo Regional de Atacama, Chile.

Such figurines were votive offerings to shrines. This figurine is dressed as a woman with a large pin

111. Inca tunic, from the south coast of Peru, c. 1500 (detail). Interlocked tapestry of cotton and wool, 35¾ x 30" (91 x 76.5 cm). Dumbarton Oaks Research Library and Collection, Washington, D.C.

The geometric sections are arranged randomly, giving the overall design a syncopated rhythm.

153

times with small creatures such as butterflies or dragonflies, ornamented pottery, now no longer as important an elite art as in the earlier periods. The weaving of tunics remained as highly developed as that of the Huari and was similarly abstract and rectilinear, but not based on life forms or obvious symbolic iconography. One possibly royal tunic has the most elaborate geometric design, which appears to be a compendium of various designs on other tunics, including the chequerboard pattern of a tunic known to have been worn by the royal guard (FIG. 111). The way in which this design subsumed so many other patterns may have signified something about the relative statuses, titles, or positions of people in society, or of some totality controlled by the ruler. Although the designs are severely rectilinear, they are sometimes combined in syncopated rythmns. According to the seventeenth-century book of the native writer Guaman Poma, textiles were undoubtedly a very important art and the royal patterns were remembered long after the collapse of the Inca empire.

The Inca are renowned for their organizational prowess. After the Chanca war the Inca began a series of conquests that left them with a coastline of 3,000 miles (5,000 km), from Ecuador to Chile. These were undertaken by Pachacuti's son Topa Inca (1471–93) and Huayna Capac (1493–1525). Huayna Capac divided his empire in two between Huascar and Atahuallpa who began to war among themselves just at the time Pizarro appeared on the scene in 1531. Great as the Inca empire was, it was short-lived. The entire empire was penetrated by a road system consisting of a coastal and a highland road with segments in between (FIG. 112). There were frequent rest stops and places to sleep at distances of a day's journey. Administrative centers with storehouses were built at strategic places for the collection and redistribution of goods. For purposes of tribute, the population was divided into groups of five, ten, fifty, a hundred, five hundred, and a thousand, each group headed by a local official. This system of hierarchical division is known as decimal organization; the quipu was used to keep track of it. The state controlled much of life. Young women, the so-called "chosen women," were collected into "nunneries" where they spent their time weaving until they were given away as wives. There were officials in charge of roads, of bridges, and of buildings. Here too necessary information was kept on the quipu. Vast numbers of *mita* laborers toiled on the roads, buildings, and cities. All the evidence points to highly centralized order: the grid pattern of the tunics seems to fit well into this type of system. But that is only one aspect of the Inca, functionally and artistically.

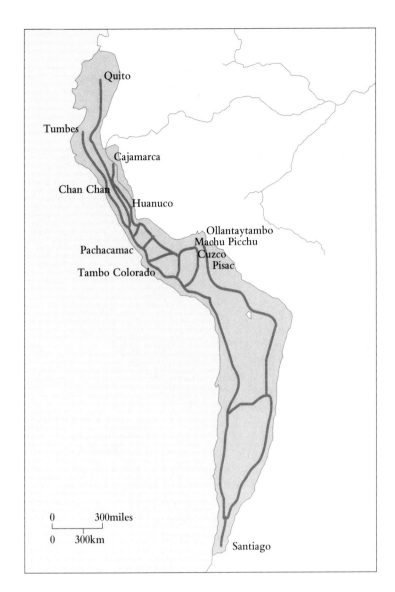

112. Inca road system, which extended from present-day Ecuador 3000 miles (4800 km) along the coast to Chile.

It has been noted that the huge Inca empire cohered because the Inca allowed local customs and local rulers to survive, and were greatly concerned with adaptability and suitability in everything they did. This attitude is reflected especially in architecture and stonework. It is surprising that the grid plans of Tiahuanaco, the Huari administrative centers, and Chan Chan were not followed in Inca architecture. Inca city plans are vaguely diamond or oval-shaped, apparently combining a grid plan with a radial plan that perhaps originated in the fortress plan of the highlands. The famous small sculpture in a diamond shape with trapezoidal segments that is said to be a plan of Cuzco is a case

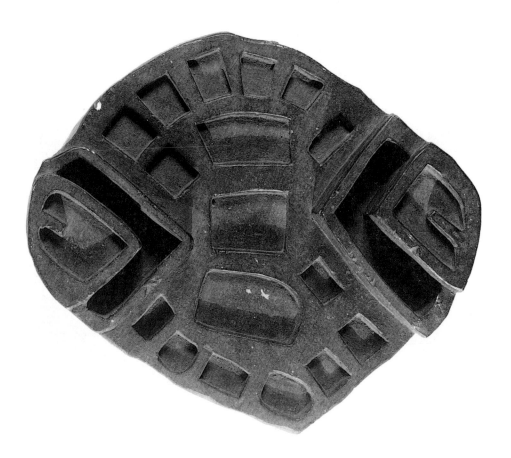

113. Inca cellular stone
slab from Cabana,
province of Pallasca.
Musée de l'Homme, Paris

in point (FIG. 113). Although scholars are not certain that it is a
model, it does parallel Cuzco's plan, with its central plazas and
the hill of Sacsahuaman at one end. All the stones are carved with
slightly curved lines and the modeling is soft and rounded.
Rigid precision is avoided. As a result, the stone conveys the impres-
sion that it is a living, breathing being.

The same is true of Inca masonry. Unlike the precisely cut and
exactly rectilinear stones at Tiahuanaco, Inca stones are always
slightly uneven, even in coursed masonry (FIG. 114). They have
a pillowy, convex outer bulge. There is nothing approximate about
their fit, which is as close as pieces of a puzzle, yet they look as
if they had been heaved up by natural forces rather than being
manmade.

The solidity of Inca architecture affected its fate during the
Spanish conquest. While all the thatched roofs of buildings
were burned and the tops of the walls were knocked down, the
lower walls and doorways were maintained for colonial buildings
to be built on top. The center of modern Cuzco retains the Inca
plan, and many of the streets still have the walls from Inca times.

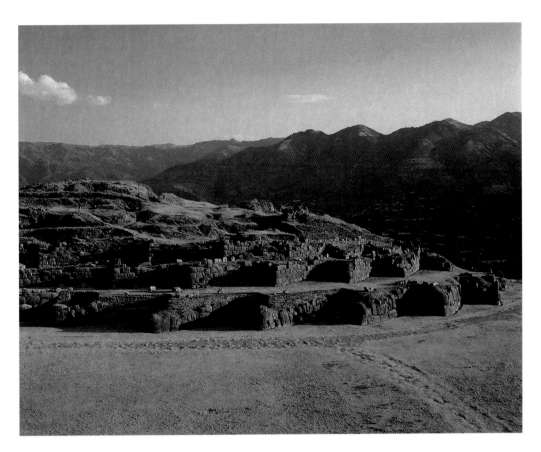

The Coricancha was turned into the church of Santo Domingo by superimposing on the Inca structure a thin colonial veneer – which readily fell down in a recent earthquake.

Neither Cuzco nor any other Andean city appears to have been a great urban metropolis like Teotihuacan or Tenochtitlán. Inca rulership depended not on a huge capital city but on the network of roads and small cities. Royal apartments were built in all the regional centers where the ruler stayed on his visits. Moreover, the rulers were constantly on the road dealing with political, military, and economic issues. Inca-style masonry in the provinces was a visual reminder to everyone in the area of the Inca presence.

Cuzco was not only the center of an imperial road network but also the hub of a ritual system called *ceque*, with its center on the Coricancha (FIG. 115). Shrines were placed along forty-one lines radiating from this center. A shrine could be anything from a building to a rock or a spring, and the last one in the series was sometimes not a thing at all, but the last place from which a view of Cuzco could be had. It is characteristic of the Andean

114. View of the Inca fortress of Sacsahuaman, Peru, 1450–1530.

Colossal stones from the base of the wall of this zig-zag construction.

115. Inca shrine system (*ceque*).

There were 350 shrines arranged along 41 radiating sight lines from the Sun Temple (Coricancha) in Cuzco.

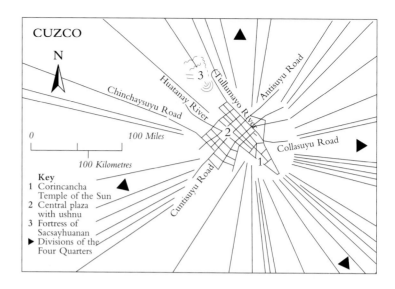

CUZCO

N

Huatanay River

Tullumayo River

Chinchaysuyu Road

Antisuyu Road

Collasuyu Road

Cuntisuyu Road

0 100 Miles

100 Kilometres

Key
1 Corincancha
 Temple of the Sun
2 Central plaza
 with ushnu
3 Fortress of
 Sacsayhuanan
▶ Divisions of the
 Four Quarters

116. Suchuna hill, Sacsahuaman, Peru, 1450–1530.

A limestone hill naturally striated by erosion was designated a shrine and seats were carved into it, paralleling the natural lines. The seats may have been for the Inca rulers or their mummies in ceremonies.

mentality to consider a view a shrine. Various family groups called *ayllus* looked after each shrine. Since there were close to 365 shrines, the calendar, the social organization, and the shrines were interconnected like a large quipu. Although lists of these *ceques* were prepared in the sixteenth century, recently scholars have been mapping them scientifically and have found that many shrines also had an astronomical significance. Like the geoglyphs of Nazca, the sys-

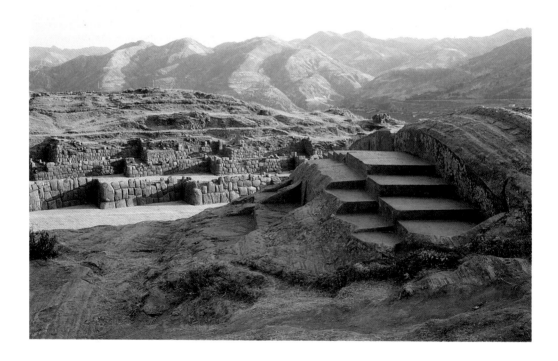

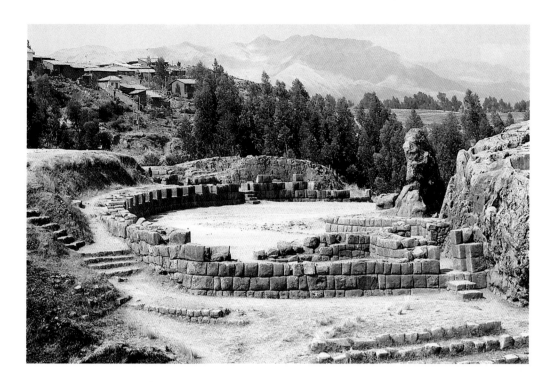

tem can be conceived in its entirety only in the mind: in practice, no one person can ever see all of it.

A few surviving shrines give an idea of Inca ritual stonework. Many shrines are thrones or seats carved into stone where either the living ruler or the mummy of a previous ruler was seated. The Suchuna rock is particularly spectacular because the simple seats are carved into the natural curves and striations of glaciated limestone. One does not even see them until one is almost upon them. The shrines of the hill of Sacsahuaman demonstrate that the Inca venerated all kinds of unusual stones and geological phenomena and adapted their carvings to them (FIG. 116). The Kenko shrine has many of the ritual aspects of Inca shrines: a circular plaza bordered by a finely made Inca wall, a tall, irregular stone set on a masonry platform, and a large outcrop of limestone carved on the outside with little seats and steps as well as channels for libations (FIG. 117). Moreover, the limestone outcrop is rent in half by a fault and inside it is a cave, in which a stone has been carved into the form of a throne. This shrine is reputed to have been the mausoleum of Pachacuti.

Circular forms seem to have been associated with sacred buildings by the Inca. The Coricancha has a circular wall, and one of the major ritual buildings of Machu Picchu is also a circular structure made out of natural stone and with a cave at the bottom

117. The Inca rock shrine of Kenko, Peru, 1450–1530.

This has all the elements of sacred Inca shrines: a circular courtyard, a tall, natural stone set up on a platform of masonry, a rock rent by a fault and covered with carvings, and inside a cave with a throne.

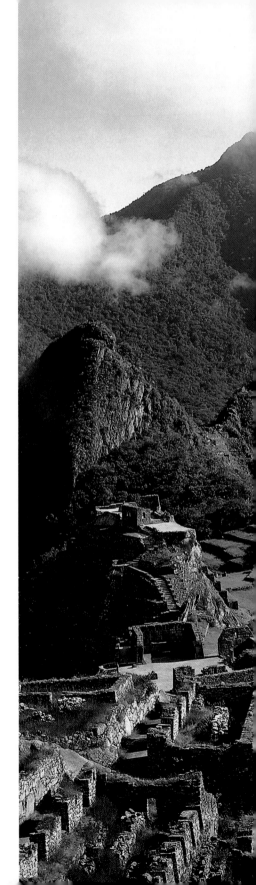

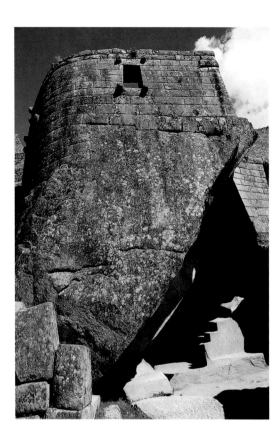

Above

118. The circular ritual structure at Machu Picchu, Peru,
1450–1530.

There are many sacred rocks at Machu Picchu. This one
is like Kenko in that it has a cave underneath and projects
up into a circular masonry structure.

Right

119. View of the Inca city of Machu Picchu, Peru,
1450–1530.

Set in a bend of the Urubamba river, Machu Picchu was
rediscovered in modern times only in 1911, by Hiram
Bingham of Yale. Never destroyed by the Spanish, the
entire city is well preserved. If the thatched roofs were
replaced, the houses would be habitable. According to
recent research, it was an estate of the ruler Pachacuti.

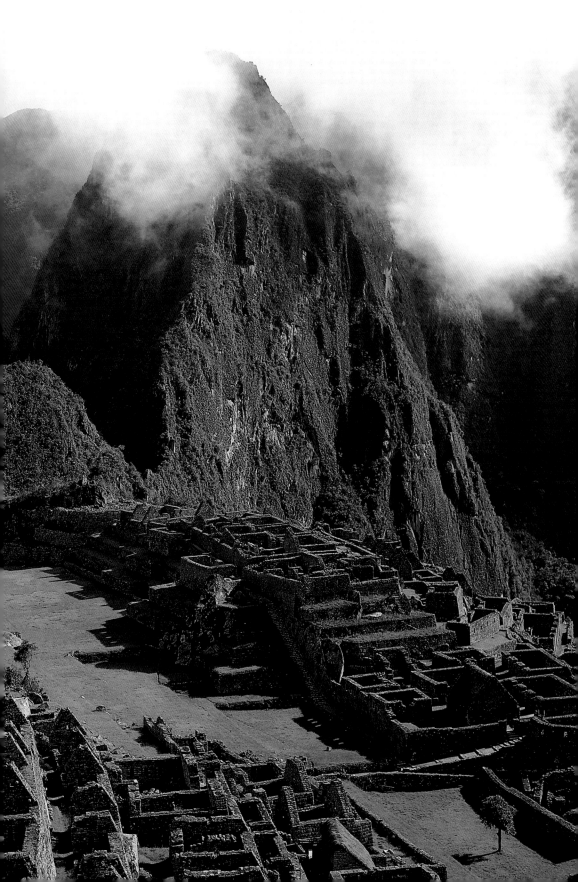

but with fine masonry at the top (FIGS 118 and 119). On entering the top part of the structure, one is amazed to find that irregular rock erupts from the floor, filling the entire interior of the round chamber.

It is evident from these shrines and buildings that the Inca used stone to express the various interrelationships of man and nature, where previous cultures had used combinations of plants, animals, or humans. A complete range of stonework is found, from entirely natural rock, to slightly and partially carved rock, to colossal, irregular masonry, and finally to fine coursed masonry, which is man-made and signifies royalty and high status. The less carved stone, on the other hand, is more sacred, although even a sacred stone is always modified by man in some way, if only by being set in

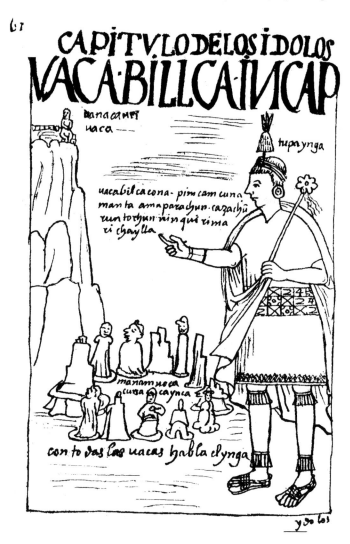

120. The Inca ruler Topa Inca admonishing the idols for bringing bad fortune. Ink drawing by Felipe Guaman Poma de Ayala, *El primer Nueva coronica y buen gobierno* (1615).

The Disappearance of the Image

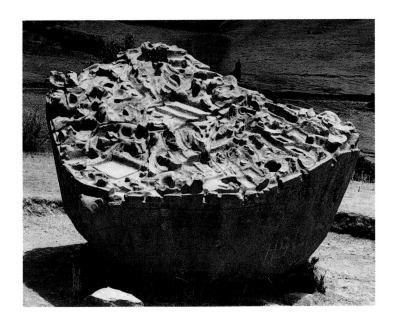

121. Sayhuite Stone, near Abancay on the road to Cuzco, Peru. Diameter 35'7" (10.85 m), height 7'6" (2.3m).

The heads of various animal figures on the stone may have been destroyed by the Spanish in the sixteenth century.

place or surrounded by masonry. That the Inca thought of their shrines as abstract forms in stone or mountain-shaped things is evident in Guaman Poma's drawing of the ruler Topa Inca admonishing the shrines (and the gods) for failing in their duties (FIG. 120). Each shrine is vaguely irregular and some are architectonic. A few are personified. It is hard to know what that meant. The Inca imagined their works in animated forms: Cuzco was supposed to be in the form of a puma, and the Kenko stone is supposed to represent a jaguar, but for the modern viewer the experience is a little like seeing figures in the clouds – they are essentially in the eye of the beholder.

Among all the unusual architecture of the shrines the Sayhuite Stone resembles a Moche mountain sacrifice vessel (FIG. 121). The lower half is plain, but on the top, among all the miniature courts and steps, crouch felines and other animals. Channels flow from the top to the edge of the stone. Although no sixteenth-century account exists to explain this stone, it sums up many of the features of Andean art. There is a strong respect for the form of the natural boulder from which it is carved, the architectural forms provide the honorific manmade aspect, while the animal figures refer directly to the powers of the cosmos. Man is not the subject of the monument. He is on the outside, performing the ritual in which the rock participates. Man creates the network, the system, the idea, and works through the organization and the essence of things rather than through his own theatrical appearance in images.

Conclusion

lthough the two main civilizations in the Americas reached similar levels of state organization they were characterized by entirely different cultures, ideologies and arts. Levels of cultural development can always be to some extent explained by analysis of material factors such as the environment, subsistence, and production. But it is very difficult to know the origins of ideological traditions and arts.

Why do the arts of Mesoamerica dramatize conflict and why do those of the Andes create harmonic structures? There is no identifiable condition for either of these particular biases, although some scholars have looked to geography and ecology for clues to the predisposing factors – the vulcanism of Mesoamerica, for instance, versus the regular pattern of coastal valley and mountains in the Andes. It is also possible that the earliest cultures in each of these areas adopted a particular theme that had some relevance at the time and that was, perhaps rather unquestioningly, perpetuated by later cultures in essentially the same guise but with certain variations and reinterpretations.

Strong as these traditions were, their influence was not universal. Both in Mesoamerica and Peru at least one major culture went so far against the grain of the prevailing tradition as to represent a spectacular negation of its values. It is assumed that these experiments in the arts had corollaries in the social and cultural realm. One of the most interesting facets of the comparison between the regions is that it shows that traditions can be radically changed and opposed for a time, even though their main underlying ideals may last for over a thousand years. It also shows that tradition is not an inexorable force, but can be turned aside, modified, or abandoned within successive cultures.

The two realms into which Mesoamerica and the Andes divide artistically and ideologically are remarkably similar to other ancient states. The emphasis on the world of humanity and human activity characterizes Egyptian and Mesopotamian art, in which victors and rulers are commonly represented in scenes of conquest and enthronement with the gods. The art of Egypt is particu-

larly reminiscent of the Maya in its preoccupation with the power of rulers over the people, while the art of Mesopotamia recalls the Aztec notion of rulers as servants of the gods.

A very different character is revealed in the arts of the Harappan civilization at Mohenjo-daro in India and in those of China under the Xia, Shang, and Zhou dynasties. Images of rulers are not present in any of these. The Harappan civilization, still largely a closed book, apparently had almost no figurative arts at all. The early arts of China consisted primarily of bronze ritual vessels used in the veneration of ancestors. Later, the arts of China typically celebrated nature in all its immensity rather than focusing on humankind. In both these aspects, Chinese culture was close in spirit to the Andean. They also shared an idealization of the balance of masculine and feminine forces. It is also interesting to note the parallel between the use of rocks among the Inca and in the oriental rock gardens of East Asia in later periods. A comparison of Pre-Columbian art with other early civilizations suggests that there may be two fundamental types of ideology in the archaic state – one that focuses on man and the actions of the elite and the other that focuses on the cosmos as a whole.

What, finally, is the most distinctive aspect of Pre-Columbian art and civilization? The answer is that all these remarkable works were created with stone tools. Every other ancient culture had a metal technology. Pre-Columbian Americans managed to create colossal and fantastic architecture and monuments with the simplest possible tools, such as flint and obsidian. Even the great stones used in Inca architecture were quarried with stone tools. Moreover, the fact that such a high level of art and civilization could be attained with nothing more than stone tools demonstrates effectively that technology is not necessarily the driving force of development. The nature of the art is determined by the social, political, and economic situation of the culture, rather than by its level of technological development. Moreover, Pre-Columbian America is proof that the evolution of a state may be arrived at by different routes. The cultures of the Andes and Mesoamerica developed separately from the Old World and are a useful test-bed for Western theories about art and society derived from Old World models. While we shall never know for certain the esthetic criteria of the Pre-Columbian civilizations, and while we see their art largely through varied western styles and preferences, the works themselves remain a challenge to interpretation and appreciation.

Bibliography

GENERAL

BRUNDAGE, B. C., *Two Earths Two Heavens, An Essay Contrasting the Aztecs and the Incas* (Albuquerque: University of New Mexico Press, 1975)

CORDY-COLLINS, A. (ed.), *Pre-Columbian Art History, Selected Readings* (Palo Alto: Peek, 1982)

CORDY-COLLINS, A. and J. STERN (eds), *Pre-Columbian Art History, Selected Readings* (Palo Alto: Peek, 1977)

DEMAREST, A. A. and G. W. CONRAD, *Ideology and Pre-Columbian Civilization* (Santa Fe: School of American Research, 1992)

FAGAN, B. M., *Kingdoms of Gold, Kingdoms of Jade* (London: Thames and Hudson, 1991)

The Journal and Other Documents on the Life and Voyages of Christopher Columbus, trans. by S. E. Morison (New York: Heritage Press, 1963)

KELEMEN, P., *Medieval American Art,* 2 vols (New York: Macmillan, 1943) [This was the first book in modern times written on Pre-Columbian art.]

KUBLER, G., *The Art and Architecture of Ancient America* (New York: Penguin Books, 1984) [The best art-historical survey.]

MILLER, V. E. (ed.), *The Role of Gender in Pre-Columbian Art and Architecture* (Lanham, Maryland: University Press of America, 1988)

PRESCOTT, W. H., *History of the Conquest of Mexico and History of the Conquest of Peru* (New York: The Modern Library, n.d.) [Classic nineteenth-century account.]

TOWNSEND, R. F. (ed.), *The Ancient Americas, Art from Sacred Landscapes* (Chicago: Art Institute, 1992) [Excellent short articles.]

WILLEY, G. R., *An Introduction to American Archaeology,* 2 vols (Englewood Cliffs: Prentice Hall, 1966 and 1971) [The best introductory archaeology text.]

MESOAMERICA

ALCINA FRANCH, J., *Codices Mexicanas* (Madrid: MAPFRE, 1992)

ANDERS, F. and M. JANSEN, *La pintura de la muerte y de los destinos* (Mexico: Fondo de Cultura Economica, 1994)

BENSON, E. P. and B. DE LA FUENTE (eds), *Olmec Art of Ancient Mexico* (Washington: National Gallery, 1996)

BERRIN, K. and E. PASZTORY (eds), *Teotihuacan: Art from the City of the Gods* (London: Thames and Hudson, 1993)

BLANTON, R. E., S. A. KOWALEWSKI, and G. FEINMAN, *Ancient Mesoamerica* (Cambridge: Cambridge University Press, 1981)

BRODA, J., D. CARRASCO, and E. MATOS MOCTEZUMA, *The Great Temple of Tenochtitlan* (Berkeley: University of California Press, 1987)

CLENDINNEN, I., *Aztecs* (Cambridge: Cambridge University Press, 1991)

COE, M. D., *The Maya* (London: Thames and Hudson, 1966)

—, *Breaking the Maya Code* (London: Thames and Hudson, 1992)

COVARRUBIAS, M., *Indian Art of Mexico and Central America* (New York: Alfred A. Knopf, 1957)

FLANNERY, K., *The Early Mesoamerican Village* (New York: Academic Press, 1976)

LEON-PORTILLA, M., *Aztec Thought and Culture* (Norman: University of Oklahoma Press, 1963)

MARCUS, J., *Mesoamerican Writing Systems* (Princeton: Princeton University Press, 1992)

Mexico, Splendors of Thirty Centuries (New York: The Metropolitan Museum of Art, 1990)

MILLER, M. E., *The Art of Mesoamerica* (New York: Thames and Hudson, 1986)

—, *The Murals of Bonampak* (Princeton: Princeton University Press, 1986)

NICHOLSON, H. B., with E. Q. KEBER, *Art of Aztec Mexico, Treasures of Tenochtitlan* (Washington: National Gallery, 1983)

The Olmec World (Princeton: Art Museum, 1995)

PASZTORY, E., *Aztec Art* (New York: Abrams, 1983)

—, *Teotihuacan: An Experiment in Living* (Norman: Oklahoma University Press, 1997)

REENTS-BUDET, D., *Painting the Maya Universe, Royal Ceramics of the Classic Period* (Durham: Duke University Press, 1994)

SAHAGÚN, B. DE, *Florentine Codex: General History of the Things of New Spain*, trans. by A. J. O. Anderson and C. E. Dibble, 10 vols (Santa Fe: School of American Research, 1950–78)

SCARBOROUGH, V. L. and D. R. WILCOX (eds), *The Mesoamerican Ballgame* (Tucson: University of Arizona Press, 1991)

SCHELE, L. and M. E. MILLER, *The Blood of Kings* (New York: Braziller, 1986)

SCHELE, L. and D. FREIDEL, *A Forest of Kings* (New York: William Morrow, 1990)

SHARER, R. J. and D. C. GROVE, *Regional Perspectives on the Olmec* (Cambridge: Cambridge University Press, 1989)

STEPHENS, J. L., *Incidents of Travel in Yucatan*, 2 vols (New York: Dover, 1963)

TEDLOCK, D., *Popol Vuh* (New York: Simon and Schuster, 1985)

TODOROV, T., *The Conquest of America* (New York: Harper and Row, 1983)

THE ANDES

ADORNO, R., *Guaman Poma: Writing and Resistance in Peru* (Austin: University of Texas Press, 1986)

ALVA, W., *Sipán* (Lima: Cerveceria Backus Johnston, 1994)

ASCHER, M. and R. ASCHER, *The Code of the Quipu* (Ann Arbor: University of Michigan Press, 1986)

BENNETT, W. C., *Ancient Arts of the Andes* (New York: Museum of Modern Art, 1954)

BENSON, E., *The Mochica* (New York: Praeger, 1972)

— (ed.), *Pre-Columbian Metallurgy of South America* (Washington: Dumbarton Oaks, 1979)

BERRIN, K. (ed.), *The Spirit of Ancient Peru: Treasures from the Museo Arqueologico Rafael Larco Herrera* (San Francisco: The Fine Arts Museums, 1997)

BINGHAM, H., *Lost City of the Incas* (New York: Atheneum, 1965)

BIRD, J. B. AND J. HYSLOP, *The Preceramic Excavations at Huaca Prieta, Chicama Valley, Peru* (New York: American Museum of Natural History, 1985)

BOONE, E. H., *Andean Art at Dumbarton Oaks*, 2 vols (Washington: Dumbarton Oaks, 1996)

BRIDGES, M., *Planet Peru* (New York: Kodak Aperture, 1991)

BURGER, R. L., *Chavín* (London: Thames and Hudson, 1992)

COBO, FATHER B., *History of the Inca Empire*, trans. by R. Hamilton (Austin: University of Texas Press, 1979)

—, *Inca Religion and Customs*, trans. by R. Hamilton (Austin: University of Texas Press, 1990)

Coleccion de arte y tresoros del Peru, several vols (Lima: Banco de Credito del Peru, 1977–96)

D'HARCOURT, R., *Textiles of Ancient Peru and their Techniques* (Seattle: University of Washington Press, 1962)

DONNAN, C., *Moche Art and Iconography* (Los Angeles: University of California Press, 1976)

—, *Moche Art of Peru* (Los Angeles: Museum of Cultural History, 1978)

— (ed.), *Early Ceremonial Architecture in the Andes* (Washington: Dumbarton Oaks, 1985)

GASPARINI, G. and L. MARGOLIES, *Inca Architecture* (Bloomington: Indiana University Press, 1980)

GUAMAN POMA DE AYALA, F., *El primer nueva coronica y buen gobierno*, J. V. Murra and R. Adorno (eds), 3 vols (Mexico City: Siglo Veintiuno)

HEMMINGS, J. and E. RANNEY, *Monuments of the Inca* (New York: Graphic Society, 1982)

HYSLOP, J., *The Inca Road System* (Orlando: Academic Press, 1984)

JONES, J., *The Art of Pre-Columbian Gold: The Jan Mitchell Collection* (New York: Metropolitan Museum of Art, 1985)

KIRKPATRICK, S. D., *Lords of Sipán* (New York: William Morrow, 1992)

KOLATA, A., *The Tiwanaku: Portrait of an Andean Civilization* (Cambridge, Mass.: Blackwell, 1993)

LAPINER, A., *Pre-Columbian Art of South America* (New York: Abrams, 1976)

LUMBRERAS, L. G., *The Peoples and Cultures of Ancient Peru* (Washington: Smithsonian Institution, 1974)

MORRIS, C. and A. VON HAGEN, *The Inca Empire* (New York: Abbeville, 1993)

MORRISON, T., *Pathways to the Gods: The Mystery of the Andes Lines* (New York: Harper and Row, 1974)

MOSELEY, M. E., *The Maritime Foundations of Andean Civilization* (Menlo Park: Cummings, 1974)

—, *The Incas and their Ancestors* (New York: Thames and Hudson, 1992)

MOSELEY, M. E. and K. C. DAY, *Chan Chan, Andean Desert City* (Santa Fe: School of American Research, 1982)

PATERNOSTO, C., *The Stone and the Thread: Andean Roots of Abstract Art* (Austin: University of Texas Press, 1996)

PAUL, A., *Paracas Ritual Attire* (Norman: University of Oklahoma Press, 1990)

PROTZEN, J. P., *Inca Architecture and Construction at Ollantaytambo* (Oxford: Oxford University Press, 1993)

ROWE, A. P., *Costumes and Featherwork of the Lords of Chimor* (Washington: Textile Museum, 1984)

STONE-MILLER, R., *To Weave for the Sun: Andean Textiles in the Museum of Fine Arts Boston* (Boston: Museum of Fine Arts, 1992)

—, *Art of the Andes* (New York: Thames and Hudson, 1995)

ZUIDEMA, R. TOM, *Inca Civilization in Cuzco* (Austin: University of Texas Press, 1990)

Picture Credits

Productions, Chicago

16 Instituto Nacional de Antropología e Historia, Mexico City

17 Studio Beatrice Trueblood, Mexico City, photo by Nadine Markova for Mexican Photo Archive

18 Instituto Nacional de Antropología e Historia, Mexico City, Coordinación Nacional de Difusión, Projecto México, photo by Ignacio Guevara

20 Dumbarton Oaks Research Library and Collections, Washington D.C. (B-20)

22 Munson-Williams-Proctor Institute Museum of Art, Utica, New York

23 Instituto Nacional de Antropología e Historia, Mexico City, Coordinación Nacional de Difusión, Projecto México, photo by Carlos Blanco

24 Photo by Rafael Doniz, Mexico City

25 © Merle Green Robertson, 1976

26 Photo by Emma Gregg, London

27 Staatliche Museen zu Berlin - Bildarchiv Preußicher Kulturbesitz, Museum für Völkerkunde, photo by Dietrich Graf

28 © Merle Green Robertson, 1976

29 Robert Harding Picture Library, London, photo by Robert Frerck / Odyssey Productions, Chicago

30 Photo by Emma Gregg, London

32 Getty Images, London, photo by Olaf Soot

33 © Merle Green Robertson, 1976

34 © Merle Green Robertson, 1976

35 Photo by Esther Pasztory

36 Photo by Emma Gregg, London

37 Rubbing © Merle Green Robertson, 1972

38 © Merle Green Robertson, 1976

39 © Merle Green Robertson, 1976

40 Dumbarton Oaks Research Library and Collections, Washington DC (B-146)

41 Photo by Robert Frerck / Odyssey Productions, Chicago

42 Photo © Justin Kerr

44 Dumbarton Oaks Research Library and Collections, Washington DC (B-54)

page 65 detail of figure 51, Instituto Nacional de Antroplogía e Historia, Mexico City, Coordinación Nacional de Difusión, Projecto México, photo by Ignacio Guevara

45 South American Pictures, Woodbridge, Suffolk, photo by Tony Morrison

46 Robert Harding Picture Library, London, photo by Robert Frerck / Odyssey Productions, Chicago

47 © Pre-Columbian Art Research Institute, San Francisco, photo by Irmgard Groth

48 Photo by Michel Zabé Thiriat, Mexico City

49 Instituto Nacional de Antropología e Historia, Mexico City

50 © Merle Green Robertson, 1976

51 Instituto Nacional de Antropología e Historia, Mexico City, Coordinación Nacional de Difusión, Projecto México, photo by Ignacio Guevara

52 Biblioteca Apostolica Vaticana, Rome

page 75 detail of figure 68, Dumbarton Oaks Research Library and Collections, Washington D.C. (B-70)

53 Robert Harding Picture Library, London, photo by Robert Frerck / Odyssey Productions, Chicago

54 British Museum, London (1902.3-8.1)

55 Biblioteca Apostolica Vaticana, Rome

56 Instituto Nacional de Antropología e Historia, Mexico City, Coordinación Nacional de Difusión, Projecto México, photo by Carlos Blanco

57 Real Casa, Patrimonio Nacional, Palacio Real, Madrid

58 Getty Images, London, photo by David Hiser

59 © Merle Green Robertson, 1976

60 © Pre-Columbian Art Research Institute, San Francisco, photo by Irmgard Groth

61 Photo by Robert Frerck / Odyssey Productions, Chicago

62 Getty Images, London, photo by David Hiser

63 Ancient Art and Architecture Collection, Pinner, Middlesex, photo by G Tortoli

64 Robert Harding Picture Library, London, photo by Robert Frerck / Odyssey Productions, Chicago

65 Photo by Debra Nagao, Mexico City

66 Robert Harding Picture Library, London, photo by Robert Frerck / Odyssey Productions, Chicago

67 Dumbarton Oaks Research Library and Collections, Washington D.C. (B-70)

68 Dumbarton Oaks Research Library and Collections, Washington D.C. (B-70)

69 Museum der Kulturen, Basel (Ivb 631), photo by Peter Homer

70 The Michael C Rockefeller Memorial Collection, purchase, Nelson A Rockefeller Gift, 1967, The Metropolitan Museuem of Art, New York (1978.412.203)

page 99 detail of figure 82, South American Pictures, Woodbridge, Suffolk, photo by Tony Morrison

72 American Museum of Natural History, New York (328612)

73 American Museum of Natural History, New

York (330557)

74 Photo by Fernando La Rosa
75 South American Pictures, Woodbridge, Suffolk, photo by Kathy Jarvis
80 The Textile Museum, Washington D.C. (91.973)
81 National Museum of the American Indian, New York (22/5604)
82 South American Pictures, Woodbridge, Suffolk, photo by Tony Morrison
83 Denman Waldo Ross Collection, Museum of Fine Arts, Boston (16.34)
84 Denman Waldo Ross Collection, Museum of Fine Arts, Boston (16.34)
85 William A Paine Fund, Museum of Fine Arts, Boston (31.501)
86 Dumbarton Oaks Research Library and Collections, Washington D.C. (B-487)
87 JT Underwood Memorial Fund, The Brooklyn Museum of Art, New York (8.121), photo by Justin Kerr
88 Edwin E Jack Fund, Museum of Fine Arts, Boston (67.313)
90 South American Pictures, Woodbridge, Suffolk, photo by Kimball Morrison
91 From *Tiahuanacu: The Cradle of Ancient Man*, Arthur Posnansky (New York, 1948)
92 Photo by James Vreeland
93 The Michael C Rockefeller Memorial Collection, bequest of Nelson A Rockefeller, 1979, The Metropolitan Museuem of Art, New York (1979.206.393)
94 Charles Potter Kling Fund, Museum of Fine Arts, Boston (1978.46)
page 129 detail of figure 103, gift and bequest of Alice K Bache, 1966 and 1977, The Metroploitan Museum of Art, New York (66.196.40-41)
95 Museo Arqueológico Rafael Larco Herrera, Lima, photo by Diego Alvarado
96 Museo Arqueológico Rafael Larco Herrera, Lima
97 Museo Arqueológico Rafael Larco Herrera, Lima, photo by Diego Alvarado
98 Museo Arqueológico Rafael Larco Herrera, Lima

99 Drawing by Donna McClelland
100 Museo Arqueológico Rafael Larco Herrera, Lima
102 Staatliche Museen zu Berlin - Bildarchiv Preußicher Kulturbesitz, Museum für Völkerkunde, photo by Dietrich Graf
103 Gift and bequest of Alice K Bache, 1966 and 1977, The Metropolitan Museum of Art, New York (66.196.40-41)
105 Buckingham Fund, The Art Institute of Chicago (1955.229)
106 Dumbarton Oaks Research Library and Collections, Washington D. C. (B-493), photo © Justin Kerr
page 145 detail of figure 111, Dumbarton Oaks Research Library and Collections, Washington D.C. (B-518)
107 Robert Harding Picture Library, London, photo by Graham Birch
108 Jan Mitchell and Sons Collection, Gift of Jan Mitchell, 1991, The Metropolitan Museum of Art, New York (1991.419.65-66), photo by Justin Kerr
109 Robert Harding Picture Library, London, photo by Robert Frerck / Odyssey Productions, Chicago
110 Museo Regional de Atacama, Copiapó, Chile
111 Dumbarton Oaks Research Library and Collections, Washington D.C. (B-518)
113 Musée de l'Homme, Paris, photo by J. Oster
114 South American Pictures, Woodbridge, Suffolk, photo by Tony Morrison
116 South American Pictures, Woodbridge, Suffolk, photo by Tony Morrison
117 © Sue Bergh
118 South American Pictures, Woodbridge, Suffolk, photo by Tony Morrison
119 South American Pictures, Woodbridge, Suffolk, photo by Tony Morrison
120 South American Pictures, Woodbridge, Suffolk
121 Photo by Edward Ranney

Index